Chicago Lincoln Statue, Lincoln Square

Louis Sullivan
and the Polemics of
Modern Architecture

Louis Sullivan and the Polemics of Modern Architecture

The Present against the Past

DAVID S. ANDREW

University of Illinois Press

Urbana and Chicago

This book is printed on acid-free paper.

Publication of this book is made possible in part by a grant
from the University of New Hampshire.

LIBRARY OF CONGRESS CATALOGING IN PUBLICATION DATA

Andrew, David S. (David Stevenson), 1943-
 Louis Sullivan and the polemics of modern architecture.

 Revision of thesis (Ph.D.)—Washington University,
1977.
 Bibliography: p.
 Includes index.
 1. Sullivan, Louis H., 1856–1924. 2. Architecture—
Philosophy. I. Title.
NA737.S9A9 1985 720'.92'4 83-18164
ISBN 0-252-01044-2

For Nathan T. Whitman and Norris K. Smith,
who got me thinking about architecture

Contents

Illustrations

Preface

I have written this book knowing full well that it might seem impudent to proffer yet another study of Louis Sullivan and his work. Several scholarly and general appreciations of the man have already found secure purchase in the literature of American architecture and intellectual history, and one might wonder justifiably if there is anything left to be said about Sullivan. I, for one, am persuaded that the subject has yet to be exhausted.

This study differs from its predecessors in that it does not take a polemical stand in support of what I refer to as "the legend of Louis Sullivan." On the one hand, Sullivan's fame is undeniable. Zealous proselyting on his behalf or on behalf of the Chicago School would be, in this day, truly supererogatory. On the other hand, it seems that the often rehearsed legend has been told almost entirely from the architect's own point of view. It has followed quite closely, in fact, the somewhat contrived script that Sullivan assembled in the 330 pages of his *The Autobiography of an Idea*. In suggesting emendations of that script, I like to think I am acting on good authority: Sullivan himself frequently exhorted his reader to strive to apprehend "the reality behind appearances." Hence I will try to identify and to discuss, from an admittedly "nonorthodox" perspective, the ideas and intuitions that led Louis Sullivan to his somewhat heady self-definition as the father of democratic architecture in the modern era. This book therefore constitutes an effort to assess in a new light the significance of his contribution to American life by a selective and critical consideration of his buildings and his theoretical writings.

As the reader will quickly discover, I am of the opinion that Sullivan's questionable polemic of architecture was the product of his disdain for and condescension toward history. For him history was obsolete and well-nigh useless in solving the problems of a modern technological democracy,

and in all probability he would have agreed with the spirit of Henry Ford's characterization of history as "bunk." He wanted to be a man outside of history: one who lived in an eternal, utopian present. The drama of historic man as a wayfarer in a strange world would be replaced by Sullivan with an essentially undramatic condition in which the satisfaction of man's "needs" is assured by the building of "a clean, well-lighted place."

Thus, somewhat ironically, I have entitled this volume with a phrase from Sherman Paul's book on Sullivan. Professor Paul says that "the underlying issue, as Sullivan knew, was that of the present against the past, of life against death." The pairing of the past with death is a curious way to consider the dramatic career of the wayfarer! Yet surely it is a characterization to which Sullivan would have warmed. He said the same thing himself countless times using other words. It was his belief that we "moderns" could make the world over from scratch; that we could ignore the strivings of those before us and simply reinvent the significance of life, which Sullivan called democracy.

It appears to me that we are living in the dull November twilight of that particular human dream. I have written this book as a way of arguing that conviction. I have written also to suggest that such men as Louis Sullivan might be regarded, not so much as heroes in their childlike technological optimism, as allegorical figures in a Faustian object-lesson. Their driven pursuit of "power" has left the western world exhausted and bewildered in its efforts to define man on the behaviorist model, essentially as an animal whose "needs" must be "satisfied." Faust's Sullivanian incarnation may be worth discussing in this connection.

Decisions having to do with organization and method in this book were not easy. The matter of Sullivan's architectural development, of his intellectual journey, or of the purely biographical aspects of his story had all been taken up more or less systematically by others. In any event, it didn't seem that an essentially chronological exposition of the Sullivan legend would bring the reader to the particular vista I wanted him to see. Therefore, the format is somewhat of a hybrid: partly a biography, partly an *explication de texte,* partly a critical analysis of word and building, and partly a suggestion for ways of thinking that are alternative to Sullivan's ways. But there is a binding element, and that is theme. Each chapter concerns a specific problem that I would take to be basic to the interpretation of Sullivan's story and to the question of assigning significance in his career.

Some of the chapters may be of greater interest than others, depending upon the background of the reader. Chapter 3, "Sullivan's Theory of History," for example, might interest someone concerned with the popular uses of Darwinism in the late nineteenth century but might be of no ac-

count to someone whose aim is to discover as much as possible about the development of the steel-frame building in Chicago in the 1880s. Yet an exposition of Sullivan's beliefs about how history happens is critical to an understanding of Sullivan's self-definition: the particular moment and place he thought he was living in and the cause he believed himself to have undertaken. Such an exposition is also fundamental to the effort I make in the final chapter, "The Architect in the Modern World," which is a synthetic chapter and which tries to place Sullivan within a particular tradition or category.

My placement of Sullivan in that category is something to which he and his partisans would certainly take exception, for it is one that contains all advocates of a world view and a theory of man that have failed us totally. Sullivan, who died in 1924, even lived to see the nightfall of the "old modern age" as Walker Percy calls it: the destruction, during the 1914–18 war, of the three-centuries-old tradition of the rational enlightenment. But Sullivan, unlike his contemporary Henry Adams, was unaware of the passing of the old modern age. He thought he was living through a brief hiatus in the inexorable march toward democratic-technological utopia. Therefore, the conclusions reached in the final chapter depend very much on matters discussed in chapter 3 (and, indeed, in all the other preceding chapters). My hope is that others will also think it necessary to ponder the self-proclaimed heroes of the old modern age who have bequeathed us terrain so morally uncertain.

Several people have been especially helpful and inspiring as I wrote this book. Ruth Schoneman and Annette Fern of the Burnham Library, Chicago, and Adolf Placzek of the Avery Library, Columbia University, were all gracious in offering assistance and suggestions as I read and thought about the Sullivan documents in the collections overseen by them. Many faculty members of the department of art and archaeology at Washington University in St. Louis were likewise instrumental, especially to the formulation of this book in its first state, as a doctoral dissertation. Professors Lawrence Steefel, Buford Pickens, Robert Jordan, and Norris Smith all offered important comments and made invaluable suggestions for further reading. Professor Smith was particularly important for his extensive criticisms of the text: I learned much from him about matters philosophical as well as architectural. I am also indebted to the department of art and archaeology at Washington University for awarding me a grant that helped to defray the cost of my research. Furthermore, I should not fail to acknowledge my dependence upon the resources of the Missouri Historical Society in St. Louis. The staff there was of great help as I searched for Sullivan's tracks in St. Louis.

Since taking up the teaching of art history full time at the University

of New Hampshire, I have encountered a problem familiar to many academics: finding time and energy for the continuation of research and writing. But the difficulties have been made to seem less awesome with the help of the Graduate School of the University of New Hampshire, whose directors kindly awarded me a research grant so that I might continue my work on Sullivan. I must also mention names of people who, through encouragement, argument, and recommendations for yet further reading and investigation, have helped keep me on the track. Thanks for various reasons go to Professor Charles H. Leighton, to Bob and Jeanne Blank, and to my good friend Marianne Leavenworth. I owe a great deal to them (who for the most part don't believe in the old modern age either) and to my parents, Reed and Lillian Andrew.

Louis Sullivan and the Polemics of Modern Architecture

Indeed the process by which man was reduced to his present insignificance was carried on with actual joy.

—Joseph Wood Krutch
The Modern Temper (1929)

1. The Legend of
Louis Sullivan

We tell ourselves stories in order to live.

Joan Didion[1]

But start to analyze those ideas and you will find that they hardly reflect in any way the reality to which they appear to refer, and if you go deeper you will discover that there is not even an attempt to adjust the ideas to this reality. Quite the contrary: through these notions the individual is trying to cut off any personal vision of reality, of his own very life. For life is at the start a chaos in which one is lost. The individual suspects this, but he is frightened at finding himself face to face with this terrible reality, and tries to cover it over with a curtain of fantasy, where everything is clear. It does not worry him that his "ideas" are not true, he uses them as trenches for the defense of his existence, as scarecrows to frighten away reality.

—José Ortega y Gasset[2]

In 1840 Thomas Cole, the leading artist of the Hudson River School, made a painting called *The Architect's Dream* (Plate 1) at the behest of Ithiel Town, an acquaintance who was himself an architect. Town is shown musing atop a gigantic column as he surveys a landscape vista filled with ideal specimens of ancient and medieval building. One easily imagines him in a sublime state as he witnesses in one vast setting the grandeur of the western tradition in architecture.

Whatever else it may mean, the painting seems to be a kind of riddle intended for "modern" architect Town. He sees before him examples of Egyptian (both Old Kingdom and New), Greek, Roman, and Gothic building, each a "pure" style and each unique to its time and place. Modes that some nineteenth-century observers, with their penchant for neat cate-

gories and classifications, might have called "impure" or derivative (Renaissance and Baroque, for example), are omitted. The styles Cole does include are carefully arranged within the perspective scheme so there is a correlation between their spatial and temporal distance from the viewer. Hence the closest building, the romantically presented parish church of the Gothic era, is also the most recent.

What is peculiar about the picture is that one of the richest periods in the history of architecture is ignored completely. There is not the least hint that Palladio, Mansart, or Wren ever lived or that anything "true" or "pure" occurred in architecture after the late Middle Ages. Cole seems to be challenging Town to bring an end to the hiatus, to produce an American architecture as appropriate for its time and place, as truly sui generis, as the Temple of Amun-Mut-Khonsu had been on the Nile in the second millennium before Christ. Had Cole put the riddle into words, he might have posed it this way: "Inasmuch as every great civilization has had its unique architectural expression, and whereas you are an architect who finds himself at a special moment here in the New World, how then will the civilization of the United States truly and appropriately be bodied forth in its architecture, and what will your buildings look like so they may express this unique position?"

It turned out that Ithiel Town both refused the painting (it lacked for him a certain "poetic" or "literary" quality[3]) and, from a modernist's viewpoint, failed to solve its implicit riddle. His own buildings were dependent upon the very archetypes that Cole illustrated in his didactic historical survey, as one can deduce from Town's Parthenon-like Customs House in New York or his Tudor pavilion for New York University. Evidently the architect willing to accept Cole's challenge and able to solve the riddle was yet to appear on the American scene.

In 1856, sixteen years after Cole executed his allegory, a man was born in Boston who would one day boldly assert that he had solved the riddle and that, by having done so, he had brought into being virtually single-handedly a truly and profoundly democratic architecture. That man was Louis Henri Sullivan (Plate 2). Though born in the East, Sullivan spent most of his professional life in the bustling and undisciplined settlement on lower Lake Michigan known as Chicago. His death there in 1924 marked the end of a career devoted to the presentation, in architecture and in the written word, of the essence of what he took to be the democratic impulse. Not only was it Sullivan's conviction that his work signaled the advent of a new stage in the Hegelian sequence implicit in *The Architect's Dream,* but he also believed that this new stage was the most important of all, because it heralded the achievement of evolution's ultimate goal: democratic Man. Today Sullivan is celebrated as a hero of modern

culture, a father of the skyscraper, the author of a democratic "testament of stone," and a veritable Walt Whitman of architecture.[4]

Sullivan is one of America's best known architects. His buildings, such as the bank in Owatonna, little known before the Second World War, are now announced by signs posted on routes into town that read "architectural masterpiece ahead." Great preservation battles rage whenever Sullivan's creations are threatened with demolition, and nowadays those battles are more often than not won by preservationists. His works are extolled in histories of architecture, not only because of their striking ornament, but also because they are seen as crucial first steps taken in the infant movement called "modern architecture." Sullivan's skyscrapers are touted as the progenitors of Mies van der Rohe's glass and steel prisms of more recent times, and the claim is made that they combined utilitarian and aesthetic considerations in a particularly satisfying way, thus showing a bright path to a brave new urban architecture. Furthermore, Sullivan's contributions to the education of Frank Lloyd Wright and other young architects in his office also add lustre to his reputation.

But there is something in the aura surrounding Sullivan's name that cannot be explained by his architectural efforts alone or by his influence on the buildings of other men, and that something is what Hugh Morrison alludes to in the title of his 1935 monograph on Sullivan. When Morrison says that Sullivan was a "prophet of modern architecture," he means not only that his buildings were forward looking but also that his efforts on behalf of a supposedly underdog but legitimate movement were literally heroic and that Sullivan had access to special, almost oracular knowledge in doing and saying the things he did.

What is it about Sullivan, among all the Chicago architects who designed noteworthy buildings in the 1880s and later, that makes him seem to Morrison and others uniquely inspired? His relations with clients were often not good, and those with his colleagues were usually worse. He was egocentric; he found it difficult to acknowledge his dependence on the ideas and creations of others; and his familiarity with the practical matters of architectural construction (usually left to his partner, the engineer Dankmar Adler) was not expert. What then underlies this reputation for transcendent wisdom that now accompanies his name?

Sullivan, unlike most of his colleagues, possessed certain mythic ideas about the destiny of American civilization; and he felt compelled to write about them, publicizing his visions at length in addresses before professional gatherings, in journals, and in books. He was, in fact, the first important American architect to do much writing at all, particularly in relation to extraarchitectural matters. He claimed to glimpse the larger picture; and especially after 1895 his writings indicate that he thought of

himself as a democratic poet and philosopher, a heroic bard who could see beyond individual buildings to perceive their role in the inexorable journey of civilization along the path of progressive social evolution toward pure and final democracy. He wrote about Chicago's tall buildings as if they were profound demonstrations of the democratic urge: no mere business ventures these! They were assertions of man's capacity for beneficent creation. They were examples of democratic poetry.

Through his paeans to the Chicago "spirit" of architecture, Sullivan became the first American example of what might be termed *the messianic breed of architect,* a type that offers to replace traditional, institutional methods of regulating community life with technological and sociological ones, claiming to do so with vast cultural oversight. Names of others belonging to the same breed are also familiar: Ledoux in the late eighteenth century and Wright, Le Corbusier, Mies van der Rohe, and Soleri in the twentieth century.

Sullivan's interpretation of the Chicago story enjoys wide acceptance today. It is treated as gospel in schools of design and in textbooks of architectural history, and it is one of the chief factors that contribute to the heroic reputation he now enjoys. He is the cultural hero, and the others— Daniel Burnham, Cass Gilbert, Stanford White—are the antiheroes. Sullivan's adopted city is now a Mecca for architectural pilgrimages, with celebrants daily passing before Richardson's Glessner House, Sullivan's Auditorium Building, Jenney's Leiter Store, Root's Monadnock Building, and Wright's Robie House as if they were sacred relics with expiatory powers, capable of wresting our cities from ugliness and decay. Chicago's architectural luminaries have also become the protagonists of fanciful novels dealing with eccentric genius, such as Ayn Rand's *The Fountainhead.* Sullivan's contribution to this legend, both in buildings and in storytelling, is considerable.

It is difficult to say just when the reputation of Louis Sullivan took on its statuesque aspect. In his last years Sullivan wrote much that implicitly argued for his right to a legendary position in American history. But it was really his draftsmen and disciples who, even before Sullivan began his autobiography in 1922, proposed that he had been possessed of a profound calling. His young friend and fellow architect, Claude Bragdon, for example, convinced Sullivan that he should revise his serially arranged *Kindergarten Chats* so that it could be published in book form in 1918. Bragdon thought the work and the man so important that he pleaded the cause of both for years, personally overseeing the publication of *Kindergarten Chats* in 1934 after the failure of the earlier plans. In the foreword to *The Autobiography of an Idea* (1924), Bragdon paid Sullivan a high honor indeed when he proclaimed that "his aim has been to declare certain

truths, to publish certain principles, so vital, so fertile, so fundamental and necessitous that I mentally couple him with Whitman and Lincoln."[5]

Frank Lloyd Wright, whose early buildings and concerns clearly show the influence of the older architect, also played an important role in the apotheosis of Louis Sullivan. By referring to his mentor as *"lieber Meister,"* Wright set Sullivan apart from other contemporary architects; and when it came time for him to write his own artistic and philosophical testament, Wright found it convenient, even necessary, to provide himself with an impeccable modernist pedigree by linking himself to one of the fathers of the movement. By the time Wright wrote *An Autobiography* (1932) and, later, his remembrance of Sullivan, *Genius and the Mobocracy* (1949), his own reputation was such that the name of the older architect could only profit by the association in the minds of proper modernists. In Sullivan they found "an old master" of realism in architecture, as Fiske Kimball put it in 1925, the year after Sullivan's death.[6]

Viennese modernist Adolf Loos must have seen Sullivan in precisely this august role when he offered him the position as head of the architecture school he was planning to set up in Paris in 1920.[7] Loos, who had come on an architectural pilgrimage to the midwest United States as a young man, was an important agent in the spread of Sullivan's fame in western Europe, but he was not the first. By virtue of the publication of Wright's buildings in the famous Wasmuth edition of 1910 in Berlin, the Sullivanesque impetus became a distinct element in the newly forming European consciousness of radical modernism in American architecture. The Dutch architect Hendrik Berlage, also an early twentieth-century visitor to the United States, likewise recognized in Sullivan a potent force, perhaps to the degree that his own architecture reflected Sullivan's influence.[8]

Whatever Sullivan's reputation was among members of the architectural establishment in America at the time of his death, it is clear that the younger men of the radical movement both here and abroad were claiming Sullivan as their spiritual or actual mentor, partly because it was an advantage to base their own legitimacy upon the authority of an established "old master" of modernism. A twofold, if also somewhat involuted, purpose was therefore served by the adulation. The younger men were able to assert their own validity; and Sullivan, who was by no means a popular hero in America in 1924, was at least assured a secure place in the pantheon of modernism, a movement that was to become triumphant in America and almost everywhere else by the early 1950s.

The high regard in which Sullivan is generally held today seems to depend on at least two assumptions or critical judgments: (1) that through his skyscrapers he made a crucial contribution to the development of modern, "progressive" architecture, thus showing himself to be a seer of things

to come; and (2) that the philosophical defense Sullivan offered on behalf
of his buildings and on behalf of his way of viewing the world was an
adequate and valid one. Eager to find appropriate dramatis personae for
a polemical exposition of the drama of modern architecture, cultural and
architectural historians have often cast Sullivan as the first romantic-tragic
hero of that drama, and he has therefore been accorded the particular
distinction that comes to allegedly misunderstood and rejected prophets.
The majority of those who are interested in such matters have chosen to
accept at face value Sullivan's telling of his own life story and also his
apologies for certain ideas and causes as if he not only told the truth all
the time but also as if his convictions were justified by an apodictic ethical
position. Vincent Scully has called Sullivan "the great, perhaps the only,
humanist architect of the late nineteenth century";[9] and Maurice English,
Sherman Paul, and others[10] have gone to considerable lengths to demon-
strate that Sullivan's "humanism" was grounded in the great nineteenth-
century traditions of nature worship and sacred individualism celebrated
by Emerson, Thoreau, and Whitman.

Today we continue to cloak Sullivan in mythic garb. A recent install-
ment of the National Public Radio program *All Things Considered* con-
tained a report in which the correspondent described current efforts to
preserve Sullivan's Guaranty Building in Buffalo. The reporter blithely it-
erated several of the not altogether accurate clichés about Sullivan and his
work: that his architecture was based upon "natural" (and therefore nec-
essarily good) principles; and that the Guaranty Building itself had influ-
enced "hundreds" of later American skyscrapers (something of an exag-
geration) and is, for that reason, worth preserving.[11] In a similar case
Lewis Mumford extolled Sullivan on public television for the architect's
contributions to the development of the skyscraper in Chicago after the
Civil War. Curiously, Mumford had harsh words for those who have made
the skyscraper flourish in recent times and who have thereby helped to
make our cities inhospitable and unattractive, but to the "father" of the
skyscraper he gave unqualified kudos.[12] In this, like so many others, Mum-
ford follows Sullivan's own story line more or less uncritically, but I would
argue that other approaches to an assessment of that plot are possible.

Sullivan on Sullivan

The facts of Louis Sullivan's life have been set forth in varying degrees of
detail in several instances. For years the standard treatment has been Hugh
Morrison's *Louis Sullivan: Prophet of Modern Architecture,* which ap-
peared in 1935. It does not contain an exhaustive biography, for much
attention is given to analyses of individual buildings and to a discussion

of Sullivan's architectural theory. Nonetheless, it is an important contribution, for it brought together photographs, building lists, and bibliography as no work had done previously.

The most comprehensive work from a purely biographical standpoint is Willard Connelly's *Louis Sullivan as He Lived* (1960), which follows a straightforward chronological program. For Connelly, Sullivan was the unacknowledged "Vitruvius of America."[13] Others have focused on a particular aspect of their subject, often for scholarly, but sometimes also for polemical, reasons. Frank Lloyd Wright's *Genius and the Mobocracy* (1949), for example, is hardly a biography in the ordinary sense. It is a somewhat casually organized remembrance of Sullivan as teacher that combines personal anecdote with Wright's own interpretation of Sullivan's philosophy of architecture and democracy. It also includes illustrations of Sullivan's ornamental drawings, many of which had been bequeathed to Wright by his *lieber Meister*. The prose bristles with righteous indignation at the rejection of Sullivan by the architectural establishment, but one can just as easily read these passages as indicative of Wright's injured pride for a similar rejection of himself by the same people. Sometimes Wright seems to project his own concerns upon Sullivan; yet in other instances he deliberately sets himself apart, criticizing Sullivan for unhealthy personal habits, for "baying at the moon" in his writings,[14] and for his narcissism. But Wright also praises Sullivan and thanks him for his "gift to me," which was "his practice '*of-the-thing-not-on-it*,'" Wright's summary phrase for Sullivan's theory of "organic" design.[15]

Sherman Paul has tried to show that Sullivan earned a place of distinction in turn-of-the-century American letters and philosophy. In *Louis Sullivan: An Architect in American Thought* (1962), Paul argued that Sullivan belongs squarely in the tradition of Emerson, Thoreau, and Whitman, and that his was the true architectural expression of the transcendentalist/romantic urge in nineteenth-century America. Paul, in fact, belongs to a fairly large group of scholars (among them John Szarkowski, Maurice English, Donald Egbert, and Paul Sprague[16]) that defines Sullivan's significance chiefly in terms of his being a heroic, romantic poet, though none of them has written a full biography of the man.

In one way or another, however, the works cited above owe a great debt to Sullivan's own telling of his life's story, and it is this telling of it that is the most intriguing, if not also the most inclusive or scholarly. In *The Autobiography of an Idea*, one discovers Sullivan hard at the business of making a legendary figure. The *Autobiography* was originally published in installments in the journal of the American Institute of Architects during 1922 and 1923. Sullivan had been encouraged by the journal's editor, C. H. Whittaker, to submit his autobiography, and the correspondence

between the two is preserved in the Burnham Library. In 1924, not long before Sullivan's death, the work appeared in book form and carried the imprint of the A.I.A. Press. It has been reissued twice.[17]

In the *Autobiography* Sullivan gives an account of his life that is more or less chronologically ordered up to the year 1893. It is a rambling, sometimes cantankerous, and often self-congratulatory book that is composed of fifteen chapters and a "retrospect," which together number 330 pages. Only the last two or three chapters concern themselves with Sullivan the professional and philosophical adult. The others pertain to his life prior to joining forces in 1879 with the famous Chicago engineer, Dankmar Adler, when Sullivan was twenty-four.

Somewhat surprisingly, the greatest part of the book is concerned with Sullivan's childhood and adolescent years, before he moved from Boston to Chicago in 1873. The *Autobiography* is therefore a somewhat lopsided book. It lingers on details of childhood that were no doubt charged with significance for the person who experienced them but cannot be appreciated fully by others. But Sullivan apparently thought the reader would find them as interesting as he did, and he dwells upon his youth in a mood of reverie and self-absorption. The rhapsodies on his mother at the piano, the mock-seduction by a teenage temptress named Minnie, the childhood fantasies of creative omnipotence while wandering his grandparents' farm: one finds such details somewhat overemphasized in a book that purports to be the autobiography of one of the leading architects of the late nineteenth century.

The last entry of Sullivan's narrative deals with the Chicago World's Fair of 1893. This is one of the most interesting facts about the book, because Sullivan's career was hardly at an end at this point. In fact, most of his writing and many of his famous buildings still lay ahead. What did he omit, and why did he omit it?

Sullivan chose to say nothing about the final two-fifths of his life because it was characterized by personal misfortune and professional decline. After the dissolution of his partnership with Adler in 1895, Sullivan's architectural career shriveled gradually until the early 1920s, by which time it was virtually moribund. The same years had seen his brief, unsuccessful marriage, the loss of many of his treasured belongings at the auction block, and the drift into alcoholism. But, most of all, Sullivan must have been disheartened by what he would have seen as the abandonment of the Chicago spirit of "functionalism" by most of his colleagues. One can imagine him believing that his own best prophecies were coming to naught.

By 1922, when Sullivan began writing the *Autobiography,* he must have been possessed of the dread that no biographer would come forward

to tell his story as Mrs. van Rensselaer had done in 1888 for H. H. Richardson, the only architect (other than himself) whom Sullivan truly admired, according to Wright. The absence of a properly enthusiastic biographer was no doubt suffered all the more keenly by Sullivan as he witnessed the adulating treatment given his nemesis in Charles Moore's *Daniel H. Burnham, Planner of Cities* (1921). (Sullivan saved some of his most vitriolic prose for Burnham in the final portions of the *Autobiography*.) In effect Sullivan compensated for this lack of recognition by composing his own *Heldenleben*.

Nineteenth-century evolutionary theory is the leitmotif of Sullivan's autobiography, and he employs it not only to show that his own life had been a textbook case on the Darwinian model, but also to demonstrate that American technology and democracy were the ineluctable products of natural evolution (and that they were therefore morally good). The Chicago skyscraper, as part of the evolutionary/technological process, assured Sullivan's own important place in this deterministic world-drama. It was a beautifully simple argument. Evolution is natural and therefore good. Technology, particularly in one of its more significant modern forms, the tall office building, is part of the evolutionary scheme. Hence I, Louis Sullivan, the architect of tall office buildings, am on the leading edge of a beneficent evolutionary wave.

By its very title, *The Autobiography of an Idea* suggests one of Sullivan's truly telling conceits: his life is the story of the search by an absolute, abstract intelligence ("An Idea") to discover, know, and fulfill itself. Sullivan conceives of life not as a tragic drama in the classical sense, in which one is presented with alternatives for action at certain crossroads and then must live with the consequences of choices that are almost always based on incomplete information and wrong ideas. Instead Sullivan posits an impersonal force, a kind of purely ideational impetus (cast, it would seem, in a rather Hegelian mold) that unfolds and develops in answer to the laws of deterministic evolution.

Hence, while Sullivan often uses the word *drama* in his autobiography, his telling of the story is not a particularly dramatic one, because human will, choice, and imperfection seem beside the point. The various characters go about acting in accordance with the dictates of an evolutionary scheme, not a human drama. The outcome is certain at the beginning, at least as far as the development of Sullivan's genius is concerned, because Darwinian theory posits invariable laws of causality.

Throughout the opening chapters of the *Autobiography*, Sullivan speaks in phrases that imply this determinism. His childhood self constantly experiences revelations from a beneficent but as yet vaguely glimpsed Idea that yearns to take shape. Even the most unremarkable

events are charged with meaning once grasped by the mythic Idea: "Once in a while . . . there came periods of relative calm within the pervading tempest, and now and then he was not wholly unlovable. A rising sun seemed to be dawning within him. He became interested in his bath."[18] (Sullivan uses the convention of the third-person narrative in a somewhat eccentric way, referring to himself as *Louis* or *he*.)

Sullivan was born in Boston in 1856, the second of two sons. His father, Patrick, was an Irishman who conducted a dance studio; his mother, Andrienne Francoise List, was French-Swiss. They met in America at mid-century, shortly after they both emigrated. After their wedding, Sullivan's mother, who was a pianist, assisted in the dance classes. Sullivan's brother Albert, who was two years his senior, is almost totally absent in the architect's writings. Indeed, Sullivan says relatively little about his family or his relations with others. He evidently found himself to be, by far, the most interesting subject of study. A psychohistorian could no doubt make much of Sullivan's fragmentary references to his parents and family in the *Autobiography*.

Sullivan describes his lineage, for example, in a tone that he apparently intended to seem tongue-in-cheek or self-effacing (perhaps both) but that strikes one as arrogant, resentful, or merely eccentric: "it may be well to give an outline of his mongrel origin. . . . He was born of woman in the usual way." His father was "indifferent" to him, had an "excessive Irish face" and "the eyes of a pig," married Andrienne List "as a business asset," and "was an enthusiast regarding hygiene" (a trait Sullivan himself borrowed from his father; he would later become obsessed with bodily health). In sum, there was "nothing in the record to show that [Patrick Sullivan] loved others, or that he loved himself. He was merely self-centered—not even cold," an assessment that Wright would later make of Sullivan himself.[19]

Sullivan's mother "seemed French, but was not wholly so. She had the typical eyelids, expressive hazel eyes, an oval face, features mobile. She was a medium stature, trimly built, highly emotional, and given to ecstasies of speech." This reference, like most to his mother, is considerably more lyrical and loving than any to his father, which tend to be laconic and rich with innuendo. Patrick was possessed of a "grim determination," but Andrienne opened for Sullivan worlds of intense feeling. Sullivan tells of a kind of "primal scene" between himself and his mother:

> It seems one afternoon she was at the piano playing a nocturne with the fervor and melancholy sweetness that were her sometime mood. Lost in dreamland she played on and on, when of a sudden she seemed to hear a voice low-pitched like a sigh, a moan. She stopped, looked, listened; no one there. She seemed mistaken; then from under the very piano itself, came a

true sob, a child sob and sigh. Why tell what happened? Her precious son in her arms pressed tight to her bosom; tears, tears, an ecstasy of tears, a turmoil of embraces, the flood gates open wide, a wonder, a joy, a happiness, an exultation, an exultation supreme over all the world. The child did not understand. Why did he, unnoticed, enter the room; why secrete himself where he was found; why was he overcome and melted into lamentation? Had anyone else been playing, would he have thus responded? Had a new world begun to arise, this time a wonder-world within himself? Had there been awakened a new power within this child of three—a power arising from the fountainhead of all tears?[20]

"The fountainhead of all tears" is Sullivan's expression of the Oedipal drama and its impasse, revealed with mock-guilt. ("Why tell what happened?") What is interesting is, not that Sullivan sensed longings at age three to possess or re-merge with his mother, inasmuch as such childhood longings seem to be the common lot of man, but rather that as an adult he should not recognize them as ordinary and should choose to display them in the pages of a professional journal.

Quite possibly the effort Sullivan devoted to his career had its source in deflected or sublimated autoerotism. Wright himself implied as much when he exclaimed, "Ah, that supreme erotic adventure of the mind that was his fascinating ornament!"[21] His preoccupation with the business tower would seem an almost laughably obvious expression of this facet of Sullivan's character. In "The Tall Office Building Artistically Considered" (1896), he says that it should be "every inch a proud and soaring thing." One wonders if the ithyphallic aspect of the skyscraper ever occurred to him. Evidently not, for he speaks of the tall building as one who believes himself to possess the most serious, sacerdotal role in its behalf.

An enduring life with a mature woman seems to have eluded Sullivan, and he clearly had more time and energy to give over to his essentially isolated self-investigation than any of his colleagues would have had. The voluminousness of his writing attests to this fact, and his consuming self-idealization suggests the degree to which his energies were put to narcissistic ends. In the second chapter of the *Autobiography,* entitled *"There was a child went forth every day,"* Sullivan identifies himself unabashedly as the subject of Whitman's poem of the same name. His obsessive self-absorption finally becomes a barrier to his reader. One tires of it and wonders if Sullivan's self-publicized intimacies are not of greater interest within a Freudian than a Darwinian framework.

Sullivan spent much of his youth, not with his parents, but with his maternal grandparents on a small farm near South Reading. "In short they loved him, and kept him bodily clean," he says of them. He seems to have soaked up the affection of these elders, who unlike his mother and father

had abundant time and interest to care for him. But he also spent hours alone roaming the farm and making friends with trees. "He became infiltrated, suffused, inspired with the fateful sense of beauty," familiarizing himself with plants, fruits, and animals, while he marked the boundaries of his own self-sufficient cosmos. Like a young god resting after his creation of arcadia, "he contemplated for a while, and saw that all thus far was good." And like a good Emersonian transparent eyeball, he "became part of sunrise even as this sunrise became forevermore part of him." Of course, there were early experiments with construction (a dam of fieldstone, mud, twigs, and grass) that foreshadow his work as an architect; but in general the *Autobiography*, in its early chapters, stresses those things that make Sullivan a "wonder-child," a sensitive correspondent of nature, and one apart from others: "Was there to be no end to the sweet, clamorous joy of all living things, himself the center of all? Could he stand it any longer?"[22]

Of his school years in Boston and elsewhere, Sullivan tells us that he excelled, and he describes the ways in which the Idea within him was defining its proper concerns. At Boston English High School he is taught by Moses Woolson ("*At last a Man!*"), an expert in the scientific method. At MIT he enrolls in the architecture course taught by Professor William Ware (of the firm of Ware and Van Brunt) but is quickly bored by drawing the five orders of classical architecture and decides to quit school, "for he could see no future there. He was progressive, aggressive, and impatient. He wished to live in the stream of life. He wished to be impelled by the power of living."[23]

After a brief stint in the office of the eccentric and crotchety Frank Furness in Philadelphia,[24] a job that was cut short by the Panic of 1873, Sullivan went to Chicago, where his parents had moved in 1869, purportedly in the interest of his mother's health. There Sullivan went to work as a draftsman for William Le Baron Jenney, under office foreman John Edelmann, who introduced him to German music and philosophy. Jenney later became the architect of the world's first skyscraper.

Still the "stream of life" seemed to run elsewhere, and in July 1874 Sullivan crossed the Atlantic and began a stay in Paris that was to last slightly less than a year. Like Richard Morris Hunt and H. H. Richardson before him, Sullivan enrolled in the École des Beaux Arts. Once again he was entranced by the seeming authority of scientific thought and objective inquiry, whose further acquaintance he made under the direction of a mathematician named Clopet, who told Sullivan that he would teach him proofs of geometric theorems that would "*be so broad as to admit of NO EXCEPTIONS.*"[25] (Young Sullivan's text had shown problems followed by exceptions and special cases.)

With the help of Monsieur Clopet, the Idea developed further. "If this can be done in Mathematics, why not in architecture?" Sullivan mused. "It can, and it shall be! *no one has—I will!*" Sullivan's search for an architectural principle "so broad as to admit of no exceptions" seems to have begun here in the capital city of rational classicism. His fascination with the concepts of evolution and process-determinism ultimately would lead him to the formulation of his famous (and variously interpreted) aphorism, Form follows function, a dictum that seems akin both in tone and in sense to Clopet's.

During the stay in Paris, Sullivan studied architecture in the studio of the Romanesque revival architect, Emil Vaudremer, who evidently helped to inspire Sullivan's own lifelong interest in the large, heavy arch, one of the chief elements of his own formal vocabulary. The French interlude was to be short, however; for the École des Beaux Arts possessed for Sullivan (or so he remembered in 1922) "a fatal residuum of artificiality," and it "lacked the profound animus of a primal inspiration."[26]

Sullivan returned to Chicago in 1875, where he continued his acquaintance with John Edelmann. Although Edelmann was barely older than Sullivan himself, he served as the young draftsman's intellectual guide, revealing to him further vagaries of the scientific method and those of German metaphysical idealism.

Sullivan's investigation of Charles Darwin, Herbert Spencer, John Draper, and other nineteenth-century evolutionists, whose works he read at this time, seems to have had a profound effect on his own self-definition. Through them he discovered the concepts and vocabulary of progressive evolution, the beneficial applications of the scientific method, and finally the subject of his own creative urge, his Idea: the development of a new genus of building, the skyscraper. Thus Sullivan embraced the romance of engineering, raising almost to apotheosis the likes of Captain James Eades, designer of the first bridge to cross the Mississippi at St. Louis (1867).[27]

> In childhood his idols had been the big strong men who *did* things. Later on he had begun to feel the greater power of men who could *think* things; later the expansive power of men who could *imagine* things; and at last he began to recognize as dominant, the will of the Creative Dreamer: he who possessed the power of vision needed to harness Imagination.[28]

Naturally Sullivan's position in this hierarchy of creative potential, as dictated by his scheme of self-idealization, was at the pinnacle. He was a creative dreamer, and it is as such that Sullivan made his bid for heroism and immortality. In the end he asserted his national and even *natural* prominence by virtue of this credential.

The great theoretical chapter of the *Autobiography of an Idea* is en-

titled "Face to Face." In it Sullivan momentarily desists from the prolix account of his childhood and adolescence and puts on the robe of democratic philosopher. His first job is to demonstrate historic man's fantastically inaccurate appreciation of himself. Philosophers and theologians "of all times," he tells us, "turned their backs upon Man" and "evolved . . . a series of phantoms" whose "reality" was "to be depraved." But even during the darkest ages, the innate Imagination and creative spirit of man were "incessantly," even unconsciously, "at work."[29]

Certain "inversions" of these age-old mistaken ideas were inevitable, especially with the advance of scientific inquiry. The inversion of the old Ptolemaic idea that the sun revolves around the earth, for example, results in the correct statement of the situation. The long series of inversions is finally leading us to the moral condition of choice. "*This one word, Choice, stands for the sole and single power; it is the name of the mystery that lies behind the veil of all human appearances.*"[30] In modern times, Sullivan argues, we begin to encounter "*Man the Reality:* Container of self-powers: A moving center of radiant energy." Thus we have the birth of what Sullivan calls "the super-power of Democratic Man."[31]

Sullivan hastens to qualify his definition, however: "To envisage Democracy as a mechanical, political system merely, to place faith in it as such,—or in any abstraction, is to foster an hallucination, to join in the Dance of Death; to confuse the hand of Esau with the voice of Jacob. The lifting of the eyelids of the World is what Democracy means."[32] He seems to posit a democracy without politics, or at least one in which politics (about which he was uninformed and for which he cared not at all) were not very important. Civilization would evidently appear as the inevitable and smooth blooming of a flower, even as he believed that his buildings had. For a man who does not concern himself with the gritty particulars of political and public life, it is no difficult matter to rhapsodize as Sullivan does. He needs never take responsibility for what he advocates, because in a way he advocates acquiescence to natural forces that lie beyond our power to change in any event. But at the same time he can also claim the role of true and profound American philosopher: optimistic, progressive, undogmatic, and fundamentally suspicious of entrenched institutions. It doesn't cost him anything. He needn't pledge his fortune or his sacred honor to anything but his own solipsistic "child's dream of power," as he calls it.

If, in his imagination, Sullivan was a democratic sage who had demonstrated that America was the true Promised Land, then he could finally assert a kind of unlimited citizenship in Nature herself; that is, if (as he contended) it isn't institutions that make for democracy, then it is Nature

that does, and that is the realm in which he wanted citizenship. His role as a self-proclaimed "organic" architect seems to have assured him of that cosmic integration. In an article of 1896 entitled "The Tall Office Building Aristically Considered," Sullivan ventures to opine that the modern skyscraper "is one of the most stupendous, one of the most magnificent opportunities that the Lord of Nature in His beneficence has ever offered to the proud spirit of man."[33] Thus he sees that "modern miracle," the steel skeleton structure, as a fundamentally natural problem. Both in this article and in the closing sections of the *Autobiography* he talks of buildings as if they were organic specimens: they have "circulatory systems," and their forms are shaped by their functions much as in the Darwinian model of evolution, where "the oak tree expressed the function oak."

From Sullivan's perspective, architecture was the true and legitimate outcome of evolutionary forces. The steel-frame building, he reminds us, "was given first authentic recognition and expression in the exterior treatment of the Wainwright Building, a nine-story office structure, by Louis Sullivan's own hand."[34] It is not surprising, furthermore, that Sullivan should entertain a low opinion of the so-called nonorganic architecture of others. It is in his assessment of the predominant mode of design at the Chicago Fair of 1893 that he employs his bitterest rhetoric. Here is the spurned creative dreamer whose Transportation Pavilion was dwarfed by the neoclassical Great White Way of Daniel Burnham and who now trundles out the lexicon of pathology and de-evolution that he had learned from his readings:

> Meanwhile the virus of the World's Fair ... began to show unmistakable signs of the nature of the contagion. There came a violent outbreak of the Classic and the Renaissance in the East ... all sense of reality was gone. In its place had come deep-seated illusions, hallucinations, absence of pupillary reaction to light, absence of knee-reaction—symptoms all of progressive cerebral meningitis: The blanketing of the Brain. ...
>
> The damage wrought by the World's Fair will last for half a century from its date, if not longer. It has penetrated deep into the constitution of the American mind, effecting there lesions significant of dementia.[35]

The *Autobiography of an Idea* effectively ends on this dismal note, with Sullivan now scorning the very people whose democratic greatness he had prophesied. Yet a thorough reading of Sullivan's written works discloses the extent to which he was an American jingoist. His own genius needed to be matched by a collective national greatness, or else his life would have been a false dawning at best, a useless mutation at worst. His partisans have tended to understate this theme of his writings, inasmuch as it is a modern, timeless, utopian architecture that they would have him

fathering. Yet in 1894 what American millennialist would have disagreed with Sullivan when he said:

> Think deeply of the French Revolution and Democracy—the utterance of freedom, the beginning of the Individual Man. Think now of our own age with its machinery, its steam power, its means of communication, its annihilation of distance. Think of the humanitarianism of our day. Think, as we stand here, now, in a new land, a Promised Land that at last is ours. Think how passionately latent, how marvelous to contemplate is America, our country. *Think that here destiny has decreed there shall be enacted the final part in the drama of man's emancipation: the redemption of his soul!*[36]

Sullivan's pronouncements in this vein seem to cloud the popular and single-minded notion of his being the forerunner of modern architecture in its "functionalist" or mainly utilitarian phase, a phase that is not uniquely American but that serves European, Oriental, African, and American businessmen equally well or badly. Indeed, it would seem that the philosophical and "prophetic" side of Sullivan's life requires further study.

The Relation of Thought to Buildings

It is largely a mythologized Louis Sullivan that one encounters when, in an age of diminishing natural resources and urban collapse, one searches for a "usable" hero. Scrutiny of his career leads, in fact, to difficult questions. What of the unevenness of his own designs and writings? What is one to make of his distinctly aristocratic air in light of his democratic ejaculations[37] or of his celebration of a city he knew to be filled with hordes of cheap immigrant labor, dreadful working conditions, and broken lives? How is one to consider the beautiful ornament: the indescribable elegance of the Schlesinger-Meyer entranceway in the heart of the world's hog butcher or the extravagant temple-bank in the modest Minnesota farming town? Why all the rhetoric that has supported Sullivan and his ilk, the Alexander Bells, Henry Fords, and other pioneers of the technological era?

One of the central problems of Sullivan's career has to do with what I see as the great difficulty he encountered in his effort to create a vital and humane architecture for the modern city. It is a problem that is compounded by the fact that Sullivan defined his own aims in ways which made it unlikely that he could have been aware of that difficulty. A certain naïveté about the relation between architecture and culture led him to a peculiarly incomplete assessment of the role of the architect; and, as I will try to show, the problem arose out of Sullivan's commitment to a vaguely

conceived notion of an ideal modernity that actually obscured the matter of the architect's reason for being.

The confusion in Sullivan's thought stems largely from his making of two contradictory assumptions. The first may be deduced from his frequent assertion that the architecture of a culture is the direct expression of the thought of that culture, for "as a people thinks concerning Architecture, so it thinks concerning everything else."[38] Sullivan held that the coherent and unified body of beliefs of a society are clearly manifested in the buildings it raises. The second and, I believe, contradictory assertion is a result of Sullivan's observation that the architecture of the United States was in fact not the true representative of democratic "thought." As he surveyed various examples of architecture in his own day, Sullivan concluded that something quite alien to the American spirit was present in them. Hence American architecture was not the faithful expression of American thought, and since this was somehow the case, he set about to create an architecture that would be consistent with that thought.

The contradiction is clear, though Sullivan himself seems not to have been aware of it: if culture is the cause, then architecture is the effect, and it stands to reason that the reverse cannot also be true. Yet this is exactly the goal Sullivan set for himself: to reverse the cause and effect relationship, so that American architecture would be consistent with American thought. Buildings, Sullivan believed, are the direct expression of a culture; but since he would have claimed that the works of, say, Richard Upjohn or A. B. Mullett were not American even though raised in America, he took it upon himself to create single-handedly an architecture that *was* American, hoping thereby to demonstrate that this country could actually build in the same high-minded way that its people were thinking. In fact, however, he implies that America was not thinking as it should and that the course of the thought itself could be set aright by a truly indigenous architecture. Sullivan seems not to have grasped a significant corollary of his own thesis: that, given its architectural heterogeneity, perhaps America was not composed of a coherent and unified people who thought alike or even gave much thought at all to architecture. If that were the case, then by rights he should not have expected a homogeneous expression in the architecture.

This raises the question of just what it was that Sullivan took to be American about America. It can be answered quickly and definitely: America was the true embodiment in the world of the modern spirit. For Sullivan this spirit was characterized chiefly by two things: democracy and its handmaiden, scientific and industrial technology. With the coming of the latter, the fulfillment of the former would be assured. Therefore impediments to the advent of the modern spirit (impediments typified by

Upjohn's Gothic churches or Mullett's Second-Empire post offices) ought to be dislodged for the same reasons that would inspire one to fight a resurgence of medieval aristocracy or monarchic absolutism in the United States. Sullivan was certain that there was something about America and her times that was unique, that surely here and now the mistakes and the misery of historic man would be rectified once and for all. Given this condescending interpretation of premodern history, it is little wonder that he disparaged American architecture that seemed to him unmodern or not "of its time."

Indeed, Sullivan's reputation has profited from the fact that many historians have shared his polemical views on the significance of modernity. Their generally flattering appraisals of his career are based on an acceptance of Sullivan's own ultimate assumptions: that the drift of history is away from the old patterns of hierarchy and obligation that characterized most societies before the late eighteenth century; that the meaning of the world is to be apprehended mainly through physical externals; and that man should define his proper relationship to the world by adjusting himself to the operation of those externals and not by exercising his powers of speculative, metaphysical, or moral thought. Hence by noting that nature "progresses" by the agency of evolution, Sullivan believed that man, too, was duty bound to imitate or adjust himself to the workings of that progressive agency. In this belief lies Sullivan's devotion to the modern, because modernity is the product of natural causes. The imitation of historical models in the creation of new architecture is therefore not only foolishly sentimental or unmodern; it is also unnatural.

It is not surprising then that historians as varied as Fiske Kimball, Henry-Russell Hitchcock, Richard McLanathan, William Jordy, Albert Bush-Brown, Montgomery Schuyler, and H. H. Arnason agree on the one Sullivan building to which superlative descriptions should apply. It is clear that the agreement hinges on specific aspects of design, which these authors take as positive "givens" in the development of modern architecture. The Buffalo Guaranty Building of 1895 (Plate 3) is the structure; and, to a man, these critics are impressed with its "expression" of internal steel construction and its open, cagelike quality.[39] Three of them call the building a masterpiece and Hitchcock is particularly taken by what he sees as Sullivan's anticipation of Le Corbusier in the treatment of the ground story with its "embryonic" *pilotis*.[40]

But even for Jordy, who sees the building as a mixed success, the features that make the Buffalo Guaranty Building worthy of inspection concern neither their appropriateness as emblems of a commercial institution nor even their overall compositional effectiveness, but rather their "progressive" tendencies. Thus Jordy lavishes more attention on an imperfect

building that, nonetheless, predicts future practice than on less progressive ones that, on the other hand, seem to him to have been more successful in their own day (the Wainwright Building in St. Louis, for example).

In any event, the building seems to interest these men less as a discrete entity worthy of admiration in itself than as a member of a serial progression leading toward what we now think of as the modern tall building. But because Sullivan's understanding of history led him to assume a special cultural significance for his buildings, it seems necessary to account for them with a scheme that transcends merely structural, stylistic, or historiographical considerations.

To be sure, most appraisals of Sullivan's career have been careful not to paint the picture of a utilitarian monomaniac, despite their fascination with his "functionalist" polemic. One scholar has contended, for example, that Sullivan can be found guilty of a total of only six "mechanistic" statements in his entire verbal output,[41] thus rendering them inconsequential within the context of his overwhelming devotion to what are termed "vitalistic" (and therefore "romantic") principles.

Jordy has gone to considerable effort to define what he believes was Sullivan's creative ethic,[42] and he has devised a chart that purports to graph the development of the human being from inchoate creative impulse to beneficent world power as, he says, Sullivan understood the process. In so doing, Jordy has chosen not to follow his own intuition, having already mentioned that the formulation of such a diagram "may seem foolhardy." What is implicit in his apologia is that he, like other Sullivan scholars, has been at pains to discover within the architect's writings a consistent and clearly presented argument concerning buildings, principles of design, institutional or metaphoric matters or nature—all of them subjects of importance to Sullivan.[43] He therefore acts as the architect's partisan, finding it necessary to clarify the written statements, to render them more accessible and attractive than they actually are, and to purge them of their emotional excesses and/or feebleness.

Such authors usually stipulate the existence of a gem of considerable worth imbedded in the rough of Sullivan's rantings on democracy and feudalism, dishonesty in architecture and in business, and political graft.[44] They view his harangues as heroic, especially when seen against the supposedly unprofessional treatment accorded him by his own colleagues.[45]

It is not surprising that Sullivan's interpretation of some of the supposedly crucial events in the development of modern architecture have been accorded great significance. His telling of the story of the Columbian Exposition of 1893 is a good example. I will try to show that his account of the events that led to the building of the Great White Way in Chicago is somewhat at variance with historical fact. In all likelihood his dubious

interpretation (written in 1922, almost thirty years after the doors of the fair had closed) was meant to bolster his own sagging self-esteem. Yet Sullivan's view of the matter not only enjoys a reputation for accuracy but also has been used as an important link in the chain of arguments that claim an exclusive legitimacy for the modern movement in architecture.

Much architectural criticism has tended to isolate the architect and his buildings from the social and institutional context within which all architects work. Buildings such as Sullivan's have been analyzed mainly with an eye to their external appearance or with the goal of showing certain stylistic developments. But since compositional or stylistic analysis by itself tends to treat a building as if it were a specimen of abstract or non-referential painting or sculpture and therefore tends to remove the building from its cultural setting, I propose to address somewhat broader matters here, as I believe Sullivan himself tried to do and as I believe he encouraged others to do.

I said earlier that one of the problems Sullivan encountered in his work was the inability to define very clearly the relationship between the architect and his public. Indeed, it might be argued that Sullivan isolated himself from the very institutions that were his patrons, thereby precluding the establishment of *any* sort of relationship with them. He thought of his buildings as presenting ideas that, in fact, were often unrelated to the institutions housed within them. In his effort to define the meaning of his life and work, he tended to ignore the fact that architects do not work in isolation; that it is in the very nature of their profession that they give identifying shape to, and to a great extent act as partisans of, the various organized bodies that employ them.

By claiming his buildings were important chiefly as exemplars of natural or organic principles of design, Sullivan failed to see that his own purposes were often different from those of his patrons. In essence he tried to define the significance of his buildings without regard for the mainly conservative traditions of the mercantile and religious groups for which he worked, and I believe his confusion is apparent in the buildings themselves. Sullivan asked that his designs carry a crushing weight of extra-institutional significance that had little to do with the realities of life in Chicago in the 1890s. In a sense he seems to have asked the wrong questions.

2. Sullivan
the Writer

. . . how much he accomplished of his grandiose scheme in the sense of proclaiming the vision, of realizing substantial parts of it, and of inspiring even where he left his own statement incomplete. "NOW BEGIN": he capitalized his imperative at the close of the *Kindergarten Chats* as the final message of a "Spring Song" written in the garden near Biloxi. . . . And again at the end of *Democracy: A Man-Search,* Sullivan repeated his exhortation, this time buttressed with punctuation: "NOW BEGIN!"

—William Jordy[1]

No linguistic form which [the graphomaniac] can give to his thought-phantoms satisfies him; he is always conscious that the phrases he is writing do not express the mazy processes of his brain; and as he is forced to abandon the attempt to embody these in words, he seeks, by means of notes of exclamation, dashes, dots, and blanks, to impart to his writings more of mystery than the words can express.

—Max Nordau[2]

Louis Sullivan was not the first American architect to write seriously about architectural theory. Thomas Jefferson, Benjamin Latrobe, Robert Mills, A. J. Downing, Horatio Greenough, and even Henry David Thoreau had preceded him in that role. But Sullivan was the first to write so much, to be published so regularly, and to be read so widely outside the world of professional architecture. Indeed, writing became a passion for him, despite his often proclaimed mistrust of words.[3] Therefore, it is essential to say something about the concerns, chronology, and sources of his writing.

Sullivan's Writings

Between 1885, the year in which Sullivan's first published article appeared, and 1895, when the firm of Adler and Sullivan was dissolved, the architect

composed several relatively short pieces and letters. They fall into what may be considered, for convenience, three categories. The first is typified by the treatment of some specific architectural matter, such as ornamentation, structure, or lighting and ventilation. The recent republication of "The High-Building Question"[4] has made available a hitherto unnoticed yet representative member of this group. It argues forthrightly for the adoption of the "set-back" arrangement in the upper stories of very tall buildings, a practice much in evidence in certain New York City skyscrapers executed in answer to that city's famous building code of 1916. Another member of this group is the published transcript of an architectural symposium in which Sullivan was a participant in 1887. The subject of the panel was "What is the just subordination, in architectural design, of details to mass?" Though Sullivan's contribution to the discussion is less specific than that of the other panelists in that it does not advocate a single style of ornamentation, it is still concerned with clearly architectural matters.[5]

A second group presents titles that at first promise equally precise treatment of clearly defined subjects but that often evade the proposed matter of concentration and instead muse discursively about certain lofty issues, often the artist's origin in nature. In such works Sullivan may variously assume a poetic, prophetic, philosophical, or patronizing tone—or all four—much to the delight of some of his readers.[6] "Ornament in Architecture" is typical of this group of the early writings.[7] Its title is uncomplicated, but the body of the article treats of no specifically technical or "design" procedures. Instead, it speculates on the roles of the emotions, "sympathies," nature, and the human spirit in the creation of good ornament. The article could not be used by an artisan seeking models from which he might fashion a window moulding. It is to the poetic and hortatory aspects of these efforts that Sullivan's admirers point when seeking evidence to deny his status as a merely utilitarian builder, yet such prose can strike one as an evasion of the issue at hand. "Emotional Architecture as Compared with Intellectual" is perhaps an even better example of this genre.[8] In an article that does not mention a single building, Sullivan paraphrases in grand terms Emerson's charge to American artists to be original (as in "Self-Reliance"), but he does not hint at the devices or procedures by which such an appropriately indigenous creativity might be tapped. The work is inspirational, not expository.

The third strain of the early writings is actually composed of a single tripartite prose poem, one on which Sullivan worked continuously throughout the last two decades of the century. It is called *Nature and the Poet*. Its first part, "Inspiration," was finished and published in 1886.[9] It does not deal with architecture in any explicit way, and my discussion of

it and its companions will therefore be limited. But it is an important work because it bears the unmistakable influence of Sullivan's idol, Walt Whitman. Furthermore, it forecasts the increasingly poetic and speculative preoccupations of Sullivan's literary endeavors after 1900 and also seems to belie its author's avowed mistrust of words.

With the exception of a handful of important commissions, Sullivan's architectural career followed a disheartening decrescendo after the breakup of his partnership with Dankmar Adler in 1895. Much has been made of the irony of this decline, with Sullivan, as the story goes, witnessing a national sellout to the tastes of eastern establishment architects after he himself had enjoyed a meteoric rise, only to be reduced to executing a few small midwestern banks in the lengthy afternoon of his life.[10] The circumstances surrounding this decline will be discussed later; but, whatever it meant for his architecture, it allowed him much more time for a second vocation, that of writer and philosopher, the composer of jeremiads on the weakening tradition of democratic building. From this period (1896 to 1924) come his most famous and difficult works.

Comparatively straightforward articles continued to be produced during this period, but with diminishing frequency. What Jordy calls "the only sure bridge between his words and his buildings,"[11] an article called "The Tall Office Building Artistically Considered," appeared in 1896.[12] It was published in several journals, and it proclaimed a direct (and, for Sullivan, an almost dogmatic) scheme for articulation of the various features and functions of the tall commercial structure. It is an often quoted piece and is one of those documents art historians like to cite because they seem to indicate a close correlation between what an artist has said and what he has done, i.e., between theory and practice. In addition to "The Tall Office Building Artistically Considered," there was something of a rush of articles at the end of Sullivan's life dealing with specific architectural matters: one on the competition held for the design of a new office tower for the *Chicago Tribune*, in which Sullivan chastised the selection committee for having awarded first prize to the wrong architects;[13] and two others, in which he discussed Frank Lloyd Wright's Imperial Hotel in Tokyo, both of them declaring the building's superior design, construction, and aesthetics, thus confirming the reconciliation of the once estranged friends.[14]

This smattering of relatively direct writings is overshadowed by Sullivan's major efforts after 1900, works in which the tones and concerns of the second two categories of the early writings became progressively mixed with one another, though not necessarily blended in the fullest sense. The themes of nature, democracy, the accession to benevolent power by "the People," and their mystical correlatives in architecture, be-

came obsessive and were reiterated in four large works, basically without variation or development, and in mood skidding constantly and precariously between deep despair and unbounded hope.

The single unpublished essay among these is entitled "Natural Thinking: A Study in Democracy," a manuscript now in the Burnham Library. It was composed in 1905 and was delivered before members of the Chicago Architectural Club that year. Propounding ideas that appear in the other major books, it is of less historic importance, since it has not been available to a wide audience, though it will receive attention here. Of greater interest, at least insofar as the Sullivan legend is concerned, are his two most famous books: *Kindergarten Chats,* which appeared serially in the pages of an obscure trade journal in 1901 and 1902, was revised in 1918, and was later published in book form in two separate editions;[15] and the *Autobiography of an Idea,* which was discussed at length in the previous chapter.

Kindergarten Chats, which is effectively Sullivan's treatise on education, takes the form of an extended dialogue in several installments between a naïve but properly eager student of architecture and his master, an older man who laments the course of recent building and guides his charge, sometimes gruffly, toward "organic" principles. The master, who is well-meaning but irascible, is, of course, Sullivan himself. The dialogues occasionally drift into verse, and they often burst forth with sustained rages and diatribes. The criticisms of buildings are often based on somewhat arbitrary criteria and the use of language is not always precise, but the overall purpose (i.e., a celebration of that mysterious structure, the democratic building) has been applauded widely.

The *Autobiography of an Idea,* though in many ways questionable with regard to historical accuracy, is perhaps the most readable of Sullivan's longer works, despite its eccentric narrative style. Furthermore, it is a major source of our knowledge about the architect's literary, scientific, and philosophic delvings and borrowings.

Probably the most sprawling and undisciplined of the large works after 1900 is *Democracy: A Man-Search;* it is also the most recent to have seen print.[16] Though broken into sections and subsections, this curious essay seems not to possess a true program. It laments a vaguely defined past in which men's souls were captive in feudal situations, and it exults in a brave new epoch that supersedes the old: what Sullivan refers to as the "cock-crow" of democracy, a force that is heralded by the technology of modern civilization and that will at last allow men to be free in the fullest sense. But the literary devices used to advance this never-too-precisely defined process have precluded a large readership. *Democracy* is overly long and brims with heavy-handed poetry and curious, primordial

mise-en-scènes. It is full of manic-depressive ups and downs; and even in its more accessible passages, it is never able to cast off a tone of petulance and sarcasm. Nonetheless, in spite of its virtually methodical avoidance of matters architectural, *Democracy* contains passages that are crucial to Sullivan's revelations about history and the nature of man. It offers information not found in his more popular works; and it will therefore be of some help in the attempt to form an overview of his architectural intentions.

While *Democracy* typifies the more diffuse, speculative side of Sullivan's later works, one other publication should be noted which juxtaposes the philosophical with the concrete in a single volume without effectively bridging the space between. This is the small folio of ornamental drawings, *A System of Architectural Ornament according with a Philosophy of Man's Powers,* which was published by the American Institute of Architects in 1924. It is a collection of some of Sullivan's best drawings executed in 1922 (none of them intended for an actual building). The drawings are preceded by a philosophical essay whose direct bearing on the designs or on the "system" from which the drawings are derived is not altogether clear.

In a way *A System of Architectural Ornament* is typical of Sullivan's handling of the connection between ideas about buildings and the creation of the actual structures themselves. The ideas are always optimistic, assuming the best possible outcome for man in a universe whose guiding mechanism is progressive evolution. But the ideas are also always vaguely stated: their application to specific material problems is anything but self-evident. Because they are couched in broad, "romantic" terms, it is not easy to see how they may be related to commercial or other institutional goals and practices. The sentiment is noble and the ornament is attractive; but how the latter issues from the former and what the latter has to do with the values propagated by the institutions that the ornamented buildings might house are matters with which Sullivan chooses not to bother himself. He is satisfied with the inspirational tone of the essay and presents the drawings as if they were the natural outcome of the precepts developed verbally; but he leaves the reader to discover the connection. This gap in his writings has made Sullivan's architectural thought somewhat elusive of formulation, and it also tends to support the conclusion that Sullivan failed, indeed, to grasp the relation between architecture and the corporate bodies that make architecture necessary.

A word on chronology is in order at this point. Most of Sullivan's ideas about history had been formed by the time he designed his first skyscraper in 1890. The writings in which those ideas are most fully elucidated were composed by 1907 at the latest, and the written works that appeared after that date do not introduce new ethical or architectural con-

cepts. Thus the question of the development of Sullivan's philosophy is not a particularly troublesome one. The ideas propounded in his earliest essay, "Characteristics and Tendencies of American Architecture" (1885), underwent elaboration in subsequent works, but they did not change or develop significantly. His convictions regarding history and architecture as presented in his last work are couched in precisely the same terms of biological and social evolution that one encounters in the first work. Certain *idées fixes* appear over and over, no matter when they were comitted to paper. It will be my approach here to define those convictions as they were articulated, regardless of chronology, inasmuch as Sullivan's philosophy was essentially complete by the time the Auditorium Building was erected (1889). It could be argued that Sullivan's intellectual development stopped, in fact, at a fairly early age.

If there was development of any sort in Sullivan's writings, perhaps it occurred in his style, which tends to be more accessible at the end of his career. Wallace Rice noted in 1924 that, because as a young man Sullivan had arrived at the curious conclusion that "most words were worthless," he had really not left "himself enough to express his most cherished conceptions adequately." But during the composition of the *Autobiography,* Rice says that Sullivan changed his mind and accepted the advice of professional writers. "The suggestion that etymologies were necessary for the full grasp of any word was instantly accepted, and all his subsequent writing [was] done with the huge volumes of the New English Dictionary within his easy reach for constant reference." Rice opines that "the change in his style was remarkable. Chapters from the earlier work on Democracy and 'The Autobiography of An Idea,' if compared, will hardly be thought the work of the same pen. The former is as jejune as the latter is rich." [17]

Sullivan's Intellectual Background

It is not one of the purposes of this chapter to track down exhaustively the ideas and theories Sullivan borrowed in forming his own philosophy. Others have tried to do something of the sort and have met with uncertain results.[18] Rather, I want to say something about the *way* in which Sullivan used his sources. The sources themselves are not difficult to uncover: one finds them identified by Sullivan in his own writing or in the course of rudimentary sleuthing. We know which works were in Sullivan's library in 1909, because they are listed in an auction catalog.[19] We also know which books Sullivan was familiar with as a young man in Chicago, for many of them are recorded in a notebook he kept at the time and about which there will be more to say. In the end, of course, it is impossible to state with completeness just what Sullivan read or what he understood. Even men

who knew his work very well or who knew him personally are in disagreement over the amount of reading he actually did. Hugh Morrison said "He read a great deal." George Grant Elmslie, who was Sullivan's partner in the later years and preserved many of his drawings, commented, "Strange he read so few books."[20]

One certainty, however, is that as a philosopher Sullivan was an extreme eclectic. He argued the cause of modernity from shifting viewpoints that one would variously label as Zarathustran, Darwinian, Comptean, Whitmanesque, or Schopenhauerian. He unabashedly enlisted both the rhetoric of romanticism and the data of empirical science in his effort to demonstrate the overriding significance of the present. Sullivan seems not to have realized that the viewpoints of romanticism and science are in important ways irreconcilable. The result in Sullivan's writing is an often baffling admixture of unintegrated streams of thought, which because of the many non sequiturs prevents him from maintaining a coherent view of the world. Sullivan's philosophy is an unconvincing pastiche precisely because of the uncritical way in which he used his diverse borrowings.

As a technological optimist, Sullivan was hardly touting a minority position in the late nineteenth century. While Thomas Jefferson and other intellectuals of the early republic had argued for the retention of an essentially agrarian America, with the development of machine technology limited by its reservation to individual farms, the main tendency in America after the Revolution had been toward greater and greater industrialization, partly on the patriotic grounds that real freedom would come only after Americans had made themselves independent of English manufactured goods.[21] Sullivan's writings, which argue for a crucial interdependence between technology and democracy, place him directly at the center of this American tradition that saw history "as a record of continuous improvement" made possible by mechanical invention.[22] In all likelihood he would have cottoned to the optimistic oratory of Edward Everett, a Harvard president, a statesman, and the first American to earn the Ph.D. at Göttingen (1817): "We live in an age of improvement . . . what changes have not been already wrought in the condition of society! what addition has not been made to the wealth of nations and the means of private comfort by the inventions, discoveries, and improvements of the last hundred years!" Like Sullivan, Everett found it impossible to conceive of an end to the benefits of technological invention: "There is no goal; and there can be no pause; for art and science are, in themselves, progressive and infinite. . . . Nothing can arrest them which does not plunge the entire order of society into barbarism."[23]

Conversely, Sullivan would have had little to say to members of the dissenting tradition, who were very much in the minority by the 1840s.

Hawthorne's parody of progressivist doctrine, "The Celestial Railroad" (1843), could contribute little to Sullivan's philosophy. He would have had no use for Hawthorne's attack on missionaries of technological perfectionism who assured "their prosperous followers that moral and social progress could be achieved through external contrivances instead of individual virtue and effort."[24]

Indeed, Sullivan's relation to the American transcendentalists, a group with whom he is often linked philosophically, is uncertain. While Emerson as a young man seems to have been attracted to the "romance" of machinery, it appears that Hawthorne, Thoreau, and even Emerson himself, as a mature man, very much doubted the efficacy of treating technology as a mode of salvation. Works by members of the Concord group do not appear in the 1909 inventory of Sullivan's library; neither do they appear in the reading list assembled for Sullivan about 1875 by his friend John Edelmann. Sullivan would surely have reacted badly to Thoreau's anti-industrial and antiprogressivist convictions, for example, his opinion of that marvel of communication, the telegraph: "We are in great haste to construct a magnetic telegraph from Maine to Texas; but Maine and Texas, it may be, have nothing important to communicate."[25] Furthermore, while Sullivan's paeans to nature may seem Emersonian in spirit, there is reason to believe that he did not truly embrace that spirit.

Sullivan's Sources

It is not difficult to discover which scientists, philosophers, and poets Sullivan took to heart. In chapter 13 of the *Autobiography,* entitled "The Garden City," in which Chicago is extolled as a kind of heavenly Jerusalem on Lake Michigan, Sullivan identifies several of his intellectual mentors. "In Darwin he found much food," he tells the reader. "The Theory of Evolution seemed stupendous." He was also fascinated by the seeming breadth and profundity of Herbert Spencer's synthetic philosophy, a classic of nineteenth-century process-determinism that is little read today but that had a considerable influence upon the development of social Darwinism. "Spencer's definition implying a progression from an unorganized simple, through stages of growth and differentiation to a highly organized complex, seemed to fit his own case," Sullivan says in a self-propagandizing passage. Indeed, it seems to have been Spencer, far more than Darwin himself, who introduced Sullivan to the idea of progressive *social* evolution. But Darwin and Spencer were not Sullivan's only progressivist mentors.

In 1877 Sullivan's father had given him a two-volume work by John Draper entitled *The Intellectual Development of Europe.* In 1922 Sullivan

characterized it as "still a notable work of the day." It was one among many supposedly learned works on intellectual history written in the second half of the century that trace western man's emergence from darkness into light: from fetishism, superstition, and religion into the Age of Reason. In effect, such works continued the polemics of eighteenth-century rationalists who believed that the physical universe is all there is, that it is ultimately knowable, and that man's penchant for metaphysical speculation is useless. Draper's telling of the "war between science and religion" evidently had a profound impact on Sullivan. His copy of Draper is preserved in the Avery Library, and from the underlinings and asterisks, it is possible to determine the passages that most affected him. Many of these passages have to do with the inexorable nature of historic and social processes, but many also discuss the failings of the medieval Roman church. Sullivan himself was later to rail against Catholicism for its opposition to the workings of beneficent progressive evolution.

From another book by Draper, *A History of the Conflict between Religion and Science,* Sullivan learned of the significant role played by the Arabic world in the preservation of scientific inquiry during the Middle Ages.[26] In the fourth chapter, Draper notes that the Saracenic love of the inductive method guaranteed a continuation of the Aristotelian methods that had regrettably died out in western Europe. It is probably no accident that Sullivan's own quasi-Islamic style of ornamentation has its roots in a culture that he considered heroic for its advancement of the mathematical, astronomical, and medical sciences. Sullivan may also have been touched by Draper's exposition of the Averroistic doctrine of absorption, the instrument of restitution that returns the individual soul to a "universal Intellect" at the moment of death. Unable to believe in the God of the Jews and Christians, Sullivan preferred to speak of ultimate causes as "the Infinite."

At Boston English High School, Moses Woolson had introduced Sullivan to the work of Hyppolite Taine on English literature. Taine was a nineteenth-century French critic and philosopher of art, and it is through his work that Sullivan says he was introduced to the idea of culture, which "had hitherto possessed no significance for him." Taine showed him that a people's culture "was their own expression of their inmost selves, as individuals, as a people, as a race."[27]

Sullivan was to encounter Taine once more in Paris, where he bought the three-volume set "devoted to the Philosophy of Art in Greece, in Italy, and in the Netherlands." From this source Sullivan took the notion that "the art of a people is a reflex or direct expression of the life of that people; . . . that one must become well acquainted with that life in order to see into the art."[28] It would be but a short step from Taine's precept to Sulli-

van's own regarding the art of architecture: "At no time and in no instance has it been other than an index of the flow of the thought of a people."[29] As I noted in the previous chapter, it is precisely this aspect of Sullivan's polemic that is so troublesome. Norris Smith has put it this way: "The principle [of intrasocietal homogeneity] he tried to apply to all earlier societies, which he had not known at first hand, turned out to be inapplicable to his own."[30] It was the fact that American architecture did not seem to express the democratic thought of the American people that so perplexed Sullivan. Such a situation violated the laws of the cosmos.

Sullivan's ideas about the ordered nature of the universe were complicated by the rhetoric of German metaphysical idealism. John Edelmann, his friend in the office of William Le Baron Jenney, introduced him to the music of Wagner (whereupon "Louis became an ardent Wagnerite"[31]) and also to the world of Arthur Schopenhauer. Edelmann was a leader of the Lotos Club, a loose association among himself, Sullivan and his brother Albert, and others who participated in an informal program of cerebration and athletic contests along and in the Calumet River in Chicago. Readings by members of the club, as well as athletic events, are recorded in the Lotos Club Notebook.[32] It is Edelmann's architectural drawings and aesthetic musings that one encounters in this notebook. Sullivan's contributions are scant by comparison: an abortive treatise on decoration (fewer than three pages), a few caricatures and grotesques, and a small number of botanical drawings. One easily sees the origin of Sullivan's own decorative sense in the romanticized Victorian medievalisms of this "profound thinker"[33] who was actually only three years his senior. Edelmann dominated Sullivan as his personality also dominates the Lotos Club Notebook.

Sullivan says that Edelmann warned him to stay clear of the vagaries of metaphysical systems and of the mysteries of the Kantian *Ding an sich* (the ultimate thing-in-itself on which the universe rides), but he seems not to have heeded that advice. He tells us often in the *Autobiography* that he was searching for "that which lay behind appearances," the noumena of the cosmos.[34] In the "Prelude" to *A System of Architectural Ornament,* Sullivan captions a simple drawing of a dicotyledonous seed with a description of three paragraphs in which this search is clearly stated. In sentences that lie between aphorism and simple description, Sullivan says: "The Germ is the real thing; the seat of identity. Within its delicate mechanism lies the will to power: the function which is to seek and eventually to find its full expression in form."

This last quotation suggests that Sullivan's reliance upon German philosophy, even in his choice of words, was extensive. Phrases such as "the will to power" will sound familiar to those who have even a cursory acquaintance with Arthur Schopenhauer's *The World as Will and Idea*

(1819), a metaphysical interpretation of the universe that posits a single, pervading Will, "an endless striving, a blind urge or impulse which knows no cessation," and that is characterized as "the Will to live."[35] Sullivan, whose library contained three volumes of Schopenhauer essays,[36] seems to have been convinced of the veracity of the concept of metaphysical will. He would have been in particular agreement with Schopenhauer's exaltation of creative genius, even if it is a rather negative definition of that genius: it is through the arts, particularly music, that we escape, however temporarily, our condition of biological servitude to the Will.

If Sullivan's system begins with this German idea, he clearly modifies it for use in the New World. The ultimate role he assigns the Will as *Ding an sich* is the striving after democracy, which he treats as the inevitable outcome of evolution as well. The Will for Sullivan is an essentially positive impulse, not, as for Schopenhauer, a nagging drive from which we have respite only in death. It is an impulse that has the fulfillment, not the frustration, of the individual as its end. The German metaphysicists tended toward an amoral interpretation of history and its processes, but Sullivan sees the Will as a decidedly ethical force, not a "blind impulse." Here is a good example of Sullivan's habit of selecting aspects of another's philosophy that seem to have a place in his "democratic" scheme, while at the same time ignoring, rejecting, or misunderstanding other aspects.

The same might be said of his "use" of Nietzsche. No fewer than five authors say that Sullivan possessed a "well-worn" copy of *Thus Spoke Zarathustra*,[37] and although Sullivan does not mention Nietzsche in the *Autobiography of an Idea,* it is clear in the writings after 1900 that he appropriated the prophetic tone and penchant for the setting of misty scenes that typify this revolutionary German work. That *Zarathustra* was "disastrous for Sullivan's style" is observed by one critic.[38] Sullivan used the first English translation of the work, which was by Alexander Tille, who tried to render the deliberately archaic language of the original in a quasi-Biblical tone that sounds merely sententious. It also contains archaisms not justified by the German text.[39] The spirit of levity that one often encounters in *Zarathustra* seems to have escaped Tille altogether, and the tone proposed by his translation is one of unrelieved and certainly unnecessary sobriety.

It is possible that some of Nietzsche's more difficult ideas (the eternal recurrence of events, for example) may not have been grasped by Sullivan because of the language used to present them. On the other hand, many of Nietzsche's ideas were not compatible with Sullivan's own evolutionary convictions, so it is doubtful that he would have accepted or incorporated them had he understood them. Nietzsche assumed that empirical evidence would bear out his theory of the cyclical nature of history, a conclusion

that one would not imagine Sullivan reaching, since it implied a kind of dynamic stasis that was anathema to Darwinism.

Sullivan may well have found himself in sympathy with Nietzsche's glorification of creative genius, but there is precious little in *Zarathustra* that he could have used in support of his own modernist vision. Far from being a prophet of democracy, Zarathustra preached against the doctrine of equality among people, believing it to be the vengeful bite of tarantulas who are envious of their betters.[40] In short, he despised measures of political reform, for they are essentially unheroic and mean and threaten to plunge humankind into ochlocracy. While aping Nietzsche's style, Sullivan seems to have misunderstood him profoundly. He was probably attracted to *Zarathustra* for its hortatory, as opposed to systematic, argument. He himself seems to have conceived of democracy in largely noninstitutional terms and, in reality, lacked a democratic "program" of any sort that could implement his goal of equality among men.

The same might be said of Walt Whitman, an equally devoted democrat, and an equally apolitical one. Whitman was Sullivan's great American hero, and in 1887 the young architect was bold enough to send Whitman the first part of his long prose poem, "Inspiration." In a letter rife with expressions of reverence for the poet, Sullivan asked Whitman to comment upon his effort and assured him that "there is at least one . . . who understands you as you wish to be understood."[41] Whitman was touched. He instructed his friend Horace Traubel "to keep it [the letter] near you: use it now and then when it comes in just right." But there is no record that Whitman responded directly to Sullivan or took his poem seriously. In a later chapter I will have more to say about the poem itself, for I believe there is a relation between the unrestrained floridity of its language and the effusions of Sullivan's architectural ornament.

Sullivan discovered Whitman's *Leaves of Grass* in 1886, about the time he and Adler began work on the Auditorium Building. He was drawn to its warm sympathy for "Nature and Humanity" and to an author "who sees good in all." The populist sentiment must have attracted Sullivan, but beyond this he also saw himself to be the kind of person Whitman was writing about, as is made clear in the *Autobiography*. In effect, Whitman's poetry became the medium into which Sullivan projected his own idealized self. His own poetry bears the unmistakable mark of Whitman's style and vocabulary.

Sullivan also knew Whitman's *Democratic Vistas* (1871), whose title he used as a virtual battle cry in the *Autobiography*.[42] In daily life Sullivan was probably incapable by temperament of achieving Whitman's catholicity of affections, but he did accept Whitman's faith in "the People" as an

ideal. *Democratic Vistas* abounds with appreciations of the "aggregate" of the American citizenry:

> I know nothing more rare ... than a fit scientific estimate and reverent appreciation of the People—of their measureless wealth of latent power and capacity, their vast, artistic contrasts of lights and shades—with, in America, their entire reliability in emergencies ... far surpassing all the vaunted samples of book heroes or any *haut ton* coteries, in all the records of the world.[43]

Sullivan echoed this estimate throughout his own writings. The People are ultimately responsible for everything that happens, even their own enslavement, he argues. It would appear, in fact, that this dynamic of self-determination can have dire implications for the People within Sullivan's system, however, inasmuch as he attributed to them a feudal rather than democratic conception of architecture in his own day. Indeed, one frequently encounters Whitman's opposition of feudal and democratic polarities in Sullivan's own prose.

Sullivan's reading of Whitman was evidently sketchy, as was his reading of everyone else. He saw in Whitman what he wanted to see. An argument crucial to the entire sense of *Democratic Vistas* has to do with finding the proper relationship between the private man and the state: "The mass, or lump character, for imperative reasons, is to be ever carefully weighed, borne in mind, and provided for. Only from it, and from its proper regulation and potency, comes the other, comes the chance of individualism. The two are contradictory, but our task is to reconcile them."[44] Sullivan was aware of the importance of the "lump character," but hardly ever did he take on the difficult task of trying to define the just balance between the claims of the aggregate and those of the individual. His conception of history compelled him to view events from the standpoint of a mass sociologist and almost never from that of the private citizen struggling to effect associations with other individuals. Maintaining this viewpoint, it is perhaps not surprising that he devoted most of his architectural energies to the creation of the anonymous and impersonal form of the commercial skyscraper.

This section on Sullivan's sources concludes with one further identification. This is a German named Max Nordau, who in 1895 wrote a somewhat grotesque treatise called *Degeneration*. Sullivan owned the translation and through it became familiar with the glossary of pathology and of evolution on the back-slope, so to speak: of devolution. It is a vocabulary that came into play when Sullivan sought scapegoats for the apparent rejection of his own democratic architecture. The final sections

of the *Autobiography* make liberal use of this lexicon in defaming the other architects of the 1893 Chicago Fair, particularly Daniel Burnham.

It was Nordau's theory that the "decadence" he observed in the paintings of Manet, the Impressionists, and the English Pre-Raphaelites; in the operas of Wagner; and in the works of Nietzsche, Tolstoi, and the Symbolists was the result of nervous disorders that had their roots in a degenerative downstroke of the evolutionary cycle. The creations of these men, he said, were informed by pathological egomania and antisocial impulses that produced an incoherent and hopelessly introverted aestheticism. Nordau discusses the "enervating and inhibitive" nature of violet as a hue, for example, and notes that "thus originate the violet pictures of Manet and his school, which spring from no actually observable aspect of nature, but from a subjective view due to the condition of the nerves."[45] The aetiology of the problem lay in addiction to narcotics, stimulants, and the ingestion of tainted foods; and those affected would beget "degenerate descendants who, if they remain exposed to the same influences, rapidly descend to the lowest degrees of degeneracy, to idiocy, to dwarfism."[46]

Nordau comes instantly to mind whenever one reads Sullivan's references to the "lesions significant of dementia" at the Chicago World's Fair or his attribution of "progressive cerebral meningitis" to architects from the East Coast. Whether or not Sullivan would have concurred with Nordau in his argument about decadence in modern painting and its causes is unimportant here. The significance of Nordau to Sullivan lies in his style and vocabulary, both of which seem to have been eagerly appropriated by Sullivan for use in his harangues against those who disagreed with him.

Nordau's *Degeneration* was, of course, another specimen of a flourishing breed: the nineteenth-century "process" book that tried to explain everything in terms of physical causes. Sullivan's familiarity with it raises interesting questions, however. His democratic millennialism had forced him to ignore a very real feature of evolutionary theory as it applied to his own situation, namely, that of organic degeneration. Both Darwin and Spencer had been aware of the importance of decay and death in the natural scheme, and Spencer in particular had observed them at work in societies as well as in individual organisms. Yet Sullivan does not admit that America herself might in fact have entered the degenerative stage of her own cycle of life, as some of his contemporaries feared.

In 1895 Brooks Adams presented "the first full length American critique of the conception of history as progress"; and as W. A. Williams shows, Adams was instrumental in persuading Theodore Roosevelt that the expansion of America's foreign markets, by force if necessary, was critical if America was to survive the downward slope of the "sine curve" of civilization/barbarism to which he believed every nation was subject.[47]

But for Sullivan American democracy was the goal of the *Ding an sich,* and it was therefore unthinkable that it should will itself into oblivion. It was inconceivable that America could be succeeded by other, more progressive statements of that will.

Again one witnesses Sullivan's highly selective incorporation of evolutionary theory. While the processes of evolution are endless, still they are teleological. With America as their goal, they would cease, finally, to be endless. The contradiction is startling: a perpetual process of modification that terminates in a state where further modification is undesirable or at least unimaginable!

Sullivan's real difficulty lies in his attempt to argue rationally with the data of empirical science for an inherently subjective, romantic, and unprovable position. His polemic is not logically consistent; but even beyond this, one must note that Sullivan does not ultimately bother to say whether he thinks the universal Will is the sole force of the cosmos or whether we inhabit a dualistic world where good and evil are truly at war. Indeed, Joan Didion might just as well have been referring to Louis Sullivan when she said of Doris Lessing: "What we are witnessing here is a writer undergoing a profound and continuing cultural trauma, a woman of determinedly utopian and distinctly teleological bent assaulted at every turn by fresh evidence that the world is not exactly improving as promised."[48]

3. Sullivan's Theory of History

Now the essential history of the people of the United States seems to me just this: at the Renaissance the old consciousness was becoming a little tight. Europe sloughed her last skin, and started a new, final phase.

But some Europeans recoiled from the last final phase. They wouldn't enter the *cul de sac* of post-Renaissance, "liberal" Europe. They came to America. . . .

The two processes go on, of course, simultaneously. The slow forming of the new skin underneath is the slow sloughing of the old skin. And sometimes this immortal serpent feels very happy, feeling a new golden glow of a strangely-patterned skin envelop him: and sometimes he feels very sick, as if his very entrails were being torn out of him, as he wrenches once more at his old skin, to get out of it. . . .

It needs a real desperate recklessness to burst your old skin at last. You simply don't care what happens to you, if you rip yourself in two, so long as you do get out.

D. H. Lawrence[1]

Evolution and Paradise Lost

It is well to bear in mind that Sullivan's vision of history was informed more by the idea of progressive evolution than by any other single concept. Every form that has existed and every event that has occurred has been the result of a sequential, lawful pattern operating throughout the universe; a pattern that has perpetual, ineluctable improvement as its underlying purpose. Without this obsession with organic as well as social evolution, many of Sullivan's ideas could not have come into being.

Like the other men of the later nineteenth century who followed in the wake of Darwin and Spencer, Sullivan was apparently convinced that mankind had descended from lower forms of life. It is a notion that he

himself did not emphasize, but as the following passage indicates, Sullivan thought of our beginnings as other than the product of "special creation": "From Nature's enveloping, a semblance of man once upon a time came forth as a little thing. A bit of soft stuff inspired by the Power of Powers. A little one, a mite, searching, seeking; patiently, sturdily; incessantly, ah, so clamorously aspiring."[2] This is as close as Sullivan comes to saying that the lower animals were our genetic ancestors. What is important for him is not the mechanism itself by which man came into existence, but that man had in him from the beginning that same spark of beneficent power and that same instinct to search and to be fulfilled that guide the plants and other animals in achieving their functions in nature. This is a crucial connection for Sullivan; for if man has no link to the "Power of Powers" (what Sullivan usually referred to as the Infinite), then he is without hope.

Hence, although Sullivan maintained that the authors of the Old Testament had bequeathed to us "a priceless heritage" in their "record of human sorrow, aspiration, triumph, and destruction,"[3] he seems to have been persuaded by the "evidence" that man had not come into the world as a result of the events described in Genesis. However, the physiological and anatomic particulars of man's evolutionary development, inasmuch as they remained then, as now, to be demonstrated fully, were not of great interest to Sullivan. He was content in "Natural Thinking," for example, to give a brief rehearsal of biological evolution in general terms without using a specific plant or animal as a model.[4] He then proceeded to apply the jargon of evolutionary thought (differentiation, movement from unorganized homogeneous to organized heterogeneous) to the development of man and of society as a whole.

Sullivan used the expression *protoman* to name the earliest, prehistoric stage of human development. Protomen were those for whom no truly deliberate relationship with time or events was possible. For these men, history took place subconsciously,[5] since they were incapable—Sullivan presumed—of grasping the connective tissue of causality that makes for a sense of historic continuity. For protomen self-preservation was uppermost, and this instinct was "tacitly assumed" by them to be the exclusive pursuit that could satisfy the exigencies of their precivilized condition.[6] Sullivan asserted that what early men did not recognize was that they were part of nature, not distinct from it. This was protoman's "inverted" way of looking at the world,[7] a perspective that placed him outside the forces of nature and made him the victim of fear and struggle. It also required that he appeal beyond himself—to fetishes and to gods—for help in explaining and accommodating the forces of nature.

Sullivan explained the emergence of this not altogether happy state by contending that we had taken leave of the aspiring tendency introduced

by Nature herself in times aboriginal. He called this natural gift Primordial Instinct and proposed that through some "stupendous biological crisis" man's intellect had begun to conflict with his inborn, beneficent, instinctual apparatus.[8] It is here that things started going wrong. While the details of life for protoman did not receive scrutiny by Sullivan, he was certain that the line separating simple self-preservation from a more malevolent feature of human character—domination and subjugation of the neighbor—was transgressed early on, and with relative frequency: "The inception of the law of the right of might lies within the beginnings of a law of self-preservation at first tacitly assumed, afterward consciously and constructively formulated, and which men have unanimously agreed to call 'Nature's first law.'"[9] The instinct for self-preservation itself was natural, but it was put to unnatural ends because of protoman's inability to see that he was part of nature and that men are basically alike, not different from one another.[10] Hence the "inversion" called *thought*, from Sullivan's somewhat Rousseau-like perspective, was the root of all misfortune in history.

Sullivan recognized that, in spite of Darwin's efforts to show just how much men have in common with the lower animals,[11] the development of intellect implied that men would "set forth upon an independent and unique career, among all the living things of the earth. It was his gain and his loss." In musing upon this estrangement from instinct, Sullivan found it useful to consider Scripture: "One might even fancy that his great crisis is hinted at in the fragmentary but beautiful allegory of the Garden of Eden, and that the ancient people among whom this myth-tale had its faraway origin, may have still preserved a racial memory thereof."[12]

Here Sullivan regards the story of Eden with "enlightened" modern eyes, using jargon from anthropology to explain it. Still, the sting of the "beautiful allegory" is stuck deeply within him. He cannot decide whether man sustained more gain or more loss because of his separation from instinct. The Genesis story is attractive precisely because of its articulation of the bittersweet aspects of mortality; and Sullivan, in savoring those aspects, is also admitting his involvement in them. He, too, lacks that full sense of instinct which must produce spiritual well-being. His rhapsodies on nature resound with the cries of one who yearns to live in a state of natural bliss but can do no more than describe its external appearances and sensations rather than what it is like to be in nature. To be *in* nature would be to sense no longer the need of appealing *to* nature.

It may be seen that the fall of Sullivan's Adam, or archetypal man, is very much rooted in the Judeo-Christian tradition. The sin of Adam and Eve, after all, had been to eat of the fruit of the tree of *knowledge*. But unlike Michelangelo's listless Adam of the Sistine Chapel, who finds it

impossible to arise from the ground that always seems to drag him down toward death and shapelessness, Sullivan's Adam will achieve salvation by embracing that very ground and by rejecting the airborne spirit of the higher mind, precisely because the latter is irresponsible and untrustworthy. Sullivan, it might be argued, belongs to that "Adamite" tradition which sees ultimate goodness in the life of instinct and primitive innocence.

The Church, the Aristocracy, and Feudalism

The departure from beneficent instinct, the perversion of the natural function of self-preservation, and the inversion called thought are the elements of Sullivan's version of the myth of paradise lost; they indicate not only the failings of individual men but also errors that became institutionalized early in recorded history. Sullivan liked to cite examples of such self-defeating human conduct. While, as a dutiful historian, he must have felt compelled to take note of the achievements of the Greeks (the development of reason and logic), the Romans (the beginnings of order and organized justice), and the ancient Hebrews (the advent of monotheism),[13] Sullivan was happier when he could enumerate the travesties of reason and liberty that took place during medieval times, beginning with Constantine or, more precisely, with the Roman Church as a great political power.

One of Sullivan's favorite terms, which he used to indicate the antithesis of democracy, was *feudalism*. He employed both upper- and lower-case spellings, using either to mean both the medieval socioeconomic system and what he took to be modern manifestations of that system in a broader sense. In any event, these feudal aspects of history fascinated Sullivan and also became obvious and useful foils to his notions of democracy. Feudalism also prompted some of his most spirited prose. Here he tenders a definition and explanation of his conception of the term:

> Feudalism signifies for the few. It means, in essence, denial; repression; segregation; class distinction; aristocracy; robbery of your fellow-men in every way, shape and manner. It means . . . irresponsibility, unaccountability. . . . It is the insanity of civilization because it breeds the diseases, the dishonesty, the crime, the cant, the hypocrisy of civilization. . . . Its power lies in the corrupted Dollar; this power means Death. The aspiration and goal of Feudalism is Absolutism.[14]

The main culprits in the evolution of feudalism were the aristocracy and the Roman Catholic priesthood, whose self-serving goals were pursued through mutual agreement and assistance, according to Sullivan. Each had its own peculiar inversion: in the case of the aristocracy, an

unnatural fear of the material world; and in the case of the clergy, fear of the "mysterious" world.[15] Both groups profited from the use of "brute physical force"[16] in setting themselves apart from the people in esoteric and elite groups. They conspired to keep the masses ignorant, to monopolize learning, and together they produced the "gloom of the early middle ages."[17] "The soul of man festers in the donjon of spiritual darkness and starvation," Sullivan said in reflecting upon what it must have been like to be one of the masses in those days.

> Hence arose the extraordinary gropings, and fantastic aberrations of the early middle ages; mortifications of the flesh, holy wars, practice of the black arts, plagues [as if planned and promoted intentionally?], degradation and filth; the rise of official feudalism; the rise of the robber barons, flowering in the child-like imbecilities of Chivalry.[18]

Sullivan's view of history as the unfolding of progressive evolution, an impersonal yet beneficent agency, did not prompt him to devote much attention to the particular actions of men prior to modern times. He only rarely mentions the specific encounters, debates, battles, generals, kings, priests, architects, scientists, and places that go to make up the raw stuff of history. For him all was prelude to the birth of democracy, so that past events were always interpreted in terms of their facilitation, foreshadowing, or hindrance of democratic man. While he noted that "many anti-democratic institutions had in them, in the beginning, a certain merit of expedience and adequacy, and a certain redeeming element of passing usefulness," he did not consider it necessary to ponder in detail the nature or the complexities of "those conflicting forces which have shaped the destiny of Man in his upward and onward growth."[19] For him "all recorded history . . . resolves itself into the story of the origin and growth of Democracy as a new species of thought";[20] and, as a result, the "Man of the Past" is treated as being of less importance in and unto himself than to us. Sullivan put it this way: "These men, our predecessors in hope, struggled ceaselessly, however unwittingly, that we may be free."[21]

Christ, to whom Sullivan usually refers as "the Nazarene" or "he who was crucified," embodied "the first aspiration toward Democracy."[22] His teachings of love and humility, however, "could not last. They came too soon. It was a local hour that was ripe, not a world-hour." The matter of Christ's divinity is avoided by Sullivan, and the significance of his mission is regarded as having been frustrated because it took place at the wrong time, i.e., not in Sullivan's era, when presumably it would not have been an anachronism! This is a good example of Sullivan's habit of viewing events as somehow being aimed at his own day and place and as lacking equal pertinence at the time the events themselves occurred.

Sullivan's attitude toward the actuality and significance of Jesus was

ambivalent in the extreme. He sometimes seems to doubt his historicity, as when commenting on the demise of the first Christian impulse: "And thus, if there were indeed a Christ, he sank softly and silently as the setting sun, beneath the horizon of the world of men."[23] Yet at other times, Sullivan quotes and comments upon Scripture as if speaking from the pulpit:

> It was the deepest, most gentle, most ecstatic of dreams, this dream of the myth-man of sorrows, acquainted with grief. Of Him who said "Behold the lilies"; of Him who said "Suffer little children to come unto me."
> Nothing could be so wholly and simply natural as the spread of such an aspiration, of such a belief, of such a faith.[24]

It is Christ the parable-maker and the man who taught by example that appealed to Sullivan, not the self-proclaimed Son of God, "a militant god of glory and power and dominion . . . a new sun-god."[25] Indeed, Sullivan remarked that "no conception has been so tragically obscuring and paralyzant as the notion of a Personal God."[26]

If Christ was the first democrat for Sullivan, it is clear that his understanding of the medieval Church necessarily made Christ's mission a kind of false dawning. Some of Sullivan's most spiteful prose is reserved for the institution of the Roman Church, an organ which, with its constituent and collusive groups (the aristocracy and the priesthood) opposed the spirit of Christ's teachings and thus fought against the unfolding of natural human impulses. The Church was responsible for the delay in the triumphs of science, and it systematically concealed from the people their own best interests (but apparently with their own cooperation).

The effects on early Christianity were disastrous. "That the church was founded in its temporal power in the fraud of substituting a Feudal Christ for a democratic Christ there can be not a doubt," Sullivan says.[27] "From the time of its Roman incorporation, the Church became distinctly and definitely a business institution. . . . It stands, in history, the paragon monopoly and trust, in comparison with which our modern American trusts seem amateurish and crude."[28] The rehearsal of medieval history continues with the conversion of the barbarians ("so sordid. They were so easily bribed"[29]), the rise of and confrontation with Islam, the appearance of baronial feudalism, chieftains, kingdoms, and the Crusades. "The Hierarchy had now definitely entered upon a career of crime, from which there was no withdrawal. It was too deep. It had tasted human blood. Its land-hunger, its money-hunger and its man-hunger were madly unsatisfied."[30] From here it was a short step to the quashing of scientific and philosophical investigation at the hands of the Inquisition, whose purpose "was to exterminate the danger of free thought and free inquiry—that is, publicity."[31]

Things looked hopeless for man. Yet Sullivan, always the optimist, could see a bright lining in this dark cloud. Eventually the church organization became "bulky, complicated, difficult to manage. Like one of our modern political machines it was filled with rings within rings, with complicated internal dissensions, bickerings, jealousies, intrigues, knifings; and the same quarrelings over the division of the spoils."[32] Furthermore, all the forces holding feudal society together "contained in themselves the germs of reaction; for no people can be permanently suppressed. The subconscious brain will at last find a way out. The law of decay is as inevitable in its action as the law of growth; and Nature, the all fertile, all resourceful is ever restoring her balances, against the folly of Man."[33] The "law of decay" brought about the necessary and inevitable demise of the Church as an earthly power and its dilapidation became evident in the familiar events of the later Middle Ages and the Renaissance: the creation of English law; the theological revolt of Martin Luther; the discoveries of the explorers, scientists, geometers, astronomers, biologists; and the flowering of the inductive method.[34] The story begins to have a happy ending, one that is insured as the significance of the American and French revolutions is revealed.

One of the peculiar aspects of Sullivan's exegesis of history may be seen in the way he generally depersonalizes it. He names relatively few men and women and chronicles even fewer actual events. He considers the broad outlines of history but tends not to document his generalizations. One becomes conscious, almost from the beginning, that one is being treated to a highly contrived and condensed telling of the history of the world: everything is rendered in highly contrasting passages of light and dark, so to speak, with hardly any gradations, complexities, or subtleties. History becomes a grandiose shell devoid of specific happenings, palpable things, or real personalities. Thus the Church is always regarded as an entity unto itself, not as a collection of men with ideas and varying points of view: "It studied human nature with infinite care and calculation, and knew men and their ways, especially their weaknesses and susceptibilities, far better than the men of its world knew themselves. Its clear, discerning eye was everywhere. Like a chameleon, its body reflected every mood of the people."[35]

Sullivan's analysis of the forces that shaped feudal society and the motivations that inspired it inevitably follows his impersonal and homogeneous theory of *how* history takes place generally. The modus operandi is one that is defined and generated, unconsciously for the most part, by the masses themselves. Sullivan blames the low state of man in the Middle Ages less on the Constantines, feudal barons, popes, and kings than on "the People," the great collectivity of anonymous men and women, who wittingly or not willed their own domination and subjugation.

A concept that appears again and again in Sullivan's writings and occurs in an amazing variety of contexts is that a people gets what it wills and what it thinks collectively, even if unconsciously. Like the Church, which Sullivan treats as an impersonal force, the masses, too, act as a single organism. If the people did not consent to feudalism, how could feudalism have come into being? The Church itself, far from being a force outside of human control and acting without the consent of the governed, was one of the creations of the masses: "If the Church flourished, it was because the multitudes wished it to flourish. It was their thought, their aspiration, their confidence, alone that delegated to it their own massive power."[36]

As I have mentioned already, this same explanation was used by Sullivan in his attempt to elucidate the forces that shape architecture. It is important to take note of the awesomely reductive nature of his understanding of history, which takes place, as he sees it, not as the result of an incomprehensibly vast mixture of vision, forethought, ignorance, irrationality, concerted action, and chance, but as the expression pure and simple of the will of the people. This will is a living force, whose existence Sullivan assumes but does not describe or truly demonstrate. It is here that his notion of history is least capable of explaining some of the more remarkable events of recent times.

While treating "the multitudes" as a more or less undifferentiated conglomerate, possessing few distinguishing traits of perception or understanding, Sullivan cannot deny the historic reality of truly exceptional individuals: men who doubtless changed the course of the world. Indeed, he would have regarded himself as just such a man. But the appearance of such individuals out of the multitudes is never explained. The Martin Luthers, the Michelangelos, the Wagners (men whose names are cited by Sullivan as exemplars of talent and vision) are figures whose arrival cannot be explained within Sullivan's system.

Had Sullivan been aware of the biological event we call "spontaneous mutation," he might have been tempted to justify the existence of such extraordinary men as the result of some human counterpart of that evolutionary concept. But he possessed no such idea, so the actual mechanism by which human "progress" is achieved, far from being elucidated in his writings, remains hidden behind such catch-all terms and phrases as *Nature, Primordial Instinct,* and *aspiration.*

Science and Democracy

Convincingly explained or not, the events of modern times are frequently cited by Sullivan as he endeavors to show that things are ever getting better, despite the remnants of what he saw as feudal "inversions" in contem-

porary society. The advance of science, seen as the natural companion to the demise of the Church, is the tendency, next to democracy itself, that Sullivan mentions most often in support of his evolutionary conception of history.

> Ours is a wonder-day of ocean-cables, land-lines, railways, machine tools, daily papers, printing press,—in short a day in which communication, production, distribution are reaching vibrant meanings they had not in the past. Meanings which confront us, to make the way plain.
>
> These new elements are of man's reality. They are modes of his free creative spirit. They are so new, they seem to have sprung full-born of his earth-grip. Yet they but herald a greater coming. The elemental dream of the ages shall achieve full voice in the advent of Democracy.[37]

Science, in fact, is more than the theoretical father of technology, which makes communication and transportation faster and easier. It is nothing less than the harbinger of the institution that is the goal of all natural impulses: democracy itself. Science is to democracy what the Baptist was to Jesus Christ; and for Sullivan it is the former pair that will realize the dream of the latter. While he recognizes that technology can be exploited for evil and selfish ends (the captain of industry "must be confronted by the peevish faces of children from his factories. For is not their blood exceeding fine of savor, and very welcome to the dainty palate of the god [of gold]?"[38]), his main concern is with its promise:

> This is what the power of Feeling has come to mean. It is the modern Clairvoyance—the seer-sight. It is the superfine listening and talking of the printing press, the land wire, the ocean cable. The talking of words grown new with meaning. The listening to new meanings. The charging and expanding of ancient words with modern purpose.
> What power is now ours—To Grasp!
> What power to choose!
> What power to cause Fate to vanish!
> What power to cause Destiny to withhold his hand.
> The power to put forth our WILL—in place of Destiny.
> This is the spiritual dawning power of Democracy.[39]

Sullivan's intense conviction that scientific progress was unmistakably the handmaiden of personal and political salvation required that he set down in several separate instances a kind of mythic telling of the history of science. It became for him a breathtaking manifestation of a beneficent inborn urge in man: that of inquiry, curiosity, and the search for the realities behind appearances.

In *Democracy: A Man-Search* Sullivan devotes a chapter called "The Span of Life" to a recitation of scientific progress, beginning with the refutation of the Ptolemaic model of the cosmos:

> Among other things he [this unnamed scientist], little lump of jelly, set the great sun right and the round earth right. Thus, in a manner, the enquirer got himself and his kind located in space. . . .
>
> From then on, "science" made wonderful strides in the pursuit of knowledge; extending even farther the boundaries, looking deeper and deeper into the content within these boundaries and marveling ever more and more as the unseen became tangible.[40]

Though science eventually became an institution itself with vested interests and a kind of entrenched dogma, and though reason became its "chief idol," still

> unlike the Church (and this is of profoundest moment to us all), Science relaxed its Ego, grasped the golden moment and renewed its youth. . . . For the "discovery" of radium and the unfolding of its far-reaching implications was, as a phenomenon, none other than the flowing of a new mode of life into the mode of life man calls his consciousness; creating thereby a vast extension of its span.[41]

Thus the spirit of scientific inquiry was capable of bringing about precisely what the Church had failed to achieve: it allowed man to transcend what had seemed the limitations of his own senses and thought. It extended and enriched his own relationship with himself and revealed hitherto unknown "living" forces (the radioactive elements, in this case).

Yet, with all of Sullivan's immoderate veneration of science, he still treated it as he treated all aspects of history—as an impersonal, conglomerate *it* and as the product of the people. Important as the "enquirer" was as liberator, he was also still "in a large way a reflex of the spirit of the time. For the multitudes were slowly changing—were distributed [*sic*] by the feudal thorn in their flesh. As the multitudes grew freer in their thought, the spirit of inquiry spread and grew freer. For it could go no faster than the multitudes would permit."[42] Everything for Sullivan, finally, must be seen as an emanation of the thought of the people. No matter how striking, how innovative, how unforeseen, things cannot happen in his universe except through the agency of an all-controlling, though unconscious, process of collective thought.

A crucial feature of that process, no matter what resistance is thrown in its way, is the urge toward freedom and the fulfillment of "natural" goals and "functions." The democratic state, not the feudal, is the natural condition of man as far as Sullivan is concerned, and to this fundamental concept I now turn in an effort to understand what Sullivan took to be the nature of a legitimate and just society.

The development of the organic, physical, and mathematical sciences in the Renaissance was a herald of the democratic condition because it implied the emergence of an irrepressible spirit of curiosity and inquiry,

the same spirit that would be necessary for the liberal philosophical speculations that underlay the democratic revolutions of the later eighteenth century. While this spirit had to overcome "feudal" notions and institutions that were venerable and entrenched, yet "the idea of freedom is *also* old; older, indeed, than the slave-idea. For it is of the nature of any organism that it wishes to be free to grow and expand."[43] The germ of democracy is present, in other words, in every organism and permeates every level of consciousness and understanding. The democratic urge is primordial, aboriginal, and genetic. It is the way things were *meant* to be, as the earth was infused with the beneficent powers of "the Infinite," for Sullivan the primary energizing force of the universe.

Although Sullivan nowhere offers what one might consider a comprehensive definition of *democracy* and although he rarely discusses it in a truly political sense, Sullivan gives an impression of his meaning in many long passages, usually by describing traits and aspects of democratic philosophy that are antithetical to those of feudalism, with which they are often juxtaposed so as to make the most of the contrasts. In "Natural Thinking," for example, after explaining the sense of *feudalism*, Sullivan epitomizes *democracy*. It

> signifies of, by, and for the people. It means equal rights, responsibility toward the neighbor and kindliness toward him. It means that we receive our individual divinity from Nature, as a gift at birth. It implies the brotherhood of Man, and universal love because of universal accountability. The rock of its foundation is Character. Its motive force is Natural thought. Its animating principle is Life. Its aspiration, its goal, the uplifting of man. Justice is its life blood."[44]

While "The Dishonest Man is Feudal" (unjust judges, crooked merchants, evasive workmen), "every Honest man is a Democrat" ("true" scientists are "manly men" and "real" philosophers).[45] The two, Sullivan says, are at war in the United States "to the death." "Democracy is ever a Revolution; superficially it is a reaction from Feudalism, but the deeper truth is that Democracy is an aspiration, a great instinctive reality pushing up through a heavy overlay of illusion, and seeking form for its superb and calm spirit."[46]

In short, democracy is everything good and worthy of pursuit: honesty, responsibility, work, and love. Sullivan uses the term in a broad, generic sense, not a governmental or institutional one; and where one might use adjectives such as *moral, loyal, sympathetic,* or *loving,* Sullivan takes *democracy* to encompass all these meanings. It is clear from the outset, in other words, that Sullivan's philosophy cannot be evaluated using traditional political analysis. The debates of the Federalists and the Jeffersoni-

ans would not have interested him. President Andrew Jackson's treatment of Nicholas Biddle and the Bank of the United States in the 1830s would not have entered his discussion. The Civil War itself barely received his notice, and the forge of debate at which the Constitution was shaped is never mentioned. It is not the process of discussion, compromise, and reconciliation through parliamentary methods that Sullivan means by *democracy*. He believes it to be a frame of mind, a conviction of virtually genetic origin. It is man behaving properly, in accord with *natural* law.

Yet the precise means by which the return of this instinct to its rightful place in man's affairs will take place is not explained by Sullivan. Evidently he wishes the reader to think of it as coming about through the natural process of decay that afflicted feudal society, decay that was made complete by the triumphs of science. (Sullivan somehow convinced himself that these triumphs were the result of beneficent instinct and not of intellect.)

Furthermore, Sullivan seems to attach great significance to the role played by members of certain racial strains in furthering democratic goals. Without becoming specific, he notes in *Democracy* that "the original individualistic spirit of the Teuton barbarian . . . had reemerged . . . and men had begun thinking somewhat of freedom."[47] Perhaps this is an oblique reference to developments such as the framing of the Magna Charta or the heretical rumblings of the likes of John Huss. But when more recent times are considered, one need not guess about identification of peoples or places: "Meanwhile constitutional government had assumed form. A new migration of the Aryan races, settling across the Atlantic, had reached the shores of a vast, sleeping continent seemingly destined by Nature to receive and develop organic Democracy on a new and grand scale."[48] Thus the democratic urge, though presumably inherent in every human being to some degree, is seen to emanate primarily from the ideas and actions of northern Europeans, i.e., Sullivan's own ancestors.

In this same passage Sullivan gives one of the clearest statements of his dual belief in modern democracy: that it is organic (a product of nature and therefore automatically good and desirable) and that the New World or, more particularly, the United States is destined to be the locus of its fulfillment.

Concerned chiefly with democracy as the carrier of ethical and spiritual values, not political or institutional ones, Sullivan rarely mentions actual features of government in America. He refers to the Constitution as an "organic document";[49] and since, through the appearance of *organic* in other contexts we know that it has a positive connotation for Sullivan, his characterization of the Constitution as such clearly indicates his approval. But Sullivan chooses not to define just what is organic about it;

neither does he give any clues as to how we might identify other written works with the same quality. For the most part, Sullivan's citations of specific events in American history are made for the purpose of demonstrating the baneful effects of lingering feudalism upon our shores. Thus, he complains of the two-party political system because it lacks the means "of individual or collective disapproval in the form of a blank ballot"; and in disapproving the collusion between big business and government, he asks, "Is not our House of Lords, the Senate, an obvious expression and instrument of Feudalism and Aristocracy?"[50]

By and large the frequency with which Sullivan discusses concrete matters in American life is closely related to the degree to which American conduct falls short of his definition of *organic democracy*. The Civil War, hardly ever mentioned, is seen to have "fattened and demoralized" the military contractor and the carpetbagger. Betrayal of ethical principles for monetary gain came into vogue during the war, Sullivan says, and is a worsening problem. While the "Democracy of the North wiped out the Feudalism of the South," it is also true that we have "secreted" the "poison" of "recrudescent feudalism" since 1865. "The folly of the South culminated in that false pride that goeth before a fall. The Puritan hypocrisy and cant of New England pretended it was actuated by humanitarian motives," but Sullivan claims that the preservation of the Union and the elimination of slavery are really mere side issues when the events since the war are properly evaluated.[51] Those events include "mad speculation," the confusion of laissez-faire capitalism with liberty, the rise of political bosses who make judges and legislators their puppets, and the appearance of both business and labor monopolies. It is these bosses who profit from economic catastrophes like the Panic of 1893,[52] a turn of fortune Sullivan himself had suffered acutely.

Sullivan likes to cite the gruesome and tawdry effects of this spirit of avaricious feudalism and mentions more than once the deaths of innocents at unprotected railway grade crossings.[53] But his bitterest complaints are about the adulteration of milk with drugs and the habituation to alcohol by exploited, hopeless laborers.[54]

> A drama of a wretched home:—Enter the man, drunk unto mania, surly, irritable. A surging word of reproach; an oath and a blow; a woman prostrate; huddled screaming children; a maudlin interval; and then a man, outstretched, snoring on the floor in the night stillness, in the sanctuary of one home . . . where we are told we cannot enter because there is no trail and all are safe in solitude.
>
> But there is a trail. It leads from the forlorn home direct to the workingman's saloon; and there it parts in two straight lines, running, one to the brewer, the other to the rectifier—both poisoners, both cowards—(they both struck the woman).[55]

But, of course, it is "the multitudes" who are responsible for the disease, poverty, and crime at every level of society.[56] They allow it to happen; they consent to it. But if the people are the heart of the problem, the solution then also resides within them. While noting that the "disease" itself is bad and that the conscious American mind is "mostly venal and corrupt," Sullivan observes that "the American people are at the core sound." Their subconscious is natural and good and will become conscious by and by.[57] It will at last occur to them that all these years they have been viewing things in an "inverted" way, and they will realize that what at first appeared to be democracy's peculiarities are in fact its uniquely natural aspects: democracy is the way things were meant to be. "Thus, when we awake, we will look on Democracy as a discovery; because it will seem first of all a huge inversion," just as the replacement of the Ptolemaic model of the cosmos by the Copernican had seemed at first also.[58] A consciousness of the feudal state of society, in other words, must first be attained. (Sullivan's denouncement of the great gulf separating rich and poor should not be taken as an endorsement of socialism, however. He was not an advocate of collectivism, which he called "a maudlin counter-doctrine founded upon the willing weakness of human nature. It ignores the glorious, the primal, the immediate power of the Infinite; it seeks merely the immediate dollar."[59] Sullivan was hardly an inveterate anticapitalist.)

Natural Thinking and the Infinite

Sullivan thought the righting of our inversions could come about only through a complete revision of the system of education in America. The consciousness of the people had to be revamped and opened to an awareness of the Infinite. Sullivan proposed such a revision in "Natural Thinking," whose very title suggests an alternative to what Sullivan believed was the habitual mode of thought in the western world. For him the occidental notion of truth was obsessively practical and logical and had concerned itself with verities that are "tangible, something that can be taken apart and put together." The western intellect is, in fact,

> mobile, restless, aggressive . . . loves force . . . loves matter, material objects . . . ambitious, proud, dominant, disdainful, imperious . . . loves obstacles and loves to overcome them . . . assertive, militant, extravagant . . . ever drifting toward the defiant and the grotesque . . . at home in turmoil . . . loves to build up, tear down, and build up again . . . loves change, novelty, progress . . . loves to destroy . . . lives on excitement, on feverishness . . . is always approaching exhaustion, and insanity . . . hates calm reflection . . . and the farther west, the more are these traits in evidence.[60]

Hence the education to be made available through natural thinking has set for itself an ambitious goal. Nothing less than the reworking of the

western intellect is required. (It is difficult to imagine Sullivan disowning all the traits he mentions, however. Though he paid lip service to certain transcendental eastern ideas, his admiration for "men who make things"—bridge builders and the rest—is unqualified and is certainly a part of the western mentality he describes.)

Sullivan's interest in the educational process is well known. The title *Kindergarten Chats* indicates his adoption of progressive theory regarding the rearing of young and the importance of early experience. Several titles in his library attest to this concern and to its corollary, the neurological and physiological development of man.[61] But Sullivan's fascination with the child was not an exclusively scientific or developmental one. In the long run it must be traced to the romantic notion of the child as a natural innocent and as the seat of unspoiled imagination and creative power. In the *Autobiography of an Idea,* it will be recalled, Sullivan regarded his own child-self in precisely this way.

Sullivan contended that the shortcomings of democracy in America could be remedied if a certain program of education were instituted across the country so that each child from birth would be watched and encouraged, his aptitudes observed, and his fullest potential developed. His educational theories are discussed most thoroughly in "Natural Thinking," and it is here that he states his belief in the primarily educational importance of a free and liberal press. "Secrecy is the germ" that is ever seeking to cripple democratic impulses, and "Publicity is the remedy."[62] Thus the battle between feudalism and democracy is waged through the "managing" of knowledge, and for Sullivan the advent of modern printing methods is a prime example of the way in which technological advancement is the natural companion to democracy.

The goal of the projected educational program is the flowering of real democracy: every man will be an honest man and will do his work conscientiously; the remnants of aristocracy and special interest will wither; and the populace will have access to news and knowledge via "publicity," as Sullivan calls it. Sullivan's young charge in *Kindergarten Chats* goes through something of a condensed version of the process mainly by opening himself to "organic" forces by becoming aware of, and therefore tapping, the flow of nature with all her moods and events. This is how the student begins to practice natural as opposed to artificial thinking. It is this very sensitizing of ourselves to the methods of such thought that Sullivan believes will undo all the "inverted" thinking that has plagued man since the birth of intellect. He asserts that natural thinking will allow man to realize the final stage toward which he has been moving all these centuries: the condition of democracy itself.

While Sullivan has a great deal to say in a romantic or sentimental vein about the child and the importance of attending to his experiences,

the particulars of the educational process are not defined or catalogued. While natural thinking is touted as a civilizing measure of great value, its elements are not really identified. We are left on the one hand—as is so often the case in Sullivan's general and largely hortatory argument—with no sense of what it is we should do or begin doing to receive the blessings of such a *modus cogitandi*. On the other hand, if Sullivan chooses not to characterize natural thinking in a systematic or exclusive way, we still can glimpse another inflection of his meaning by considering what one might call his cosmology, namely, his postulation of "the Infinite."

For Sullivan the universe is a macrocosmic organism whose processes and events are lawfully regulated, so that it must be understood in teleological terms. His emotional attachment to nature does not allow him to perceive its glorious moments, its evolutionary perfection, or its balancing of forces as occurring without motive or design. He would agree with the idea Emerson expressed in "Nature" that "Particular natural facts are symbols of particular spiritual facts."[63] Nature is not a collection of random, unintended happenings; rather, all things in the world are metaphors for and signifiers of a higher reality. Sullivan notes that, although external physical change seems to go on relentlessly about us, "Change is not erratic." It is "regular and ordered, and follows a law we call rhythm."[64]

Then again, Sullivan held the Judeo-Christian idea of God to be harmful. For him the concept of "a personal Feudal God has deprived us of a serenity of soul." With its kingly conception of God, that "traditional notion was and is deeply pessimistic."[65] He also rejected the hereafter as conceived in western theology, preferring rather to speculate on a reabsorption of the individual at death into the collective forces and consciousness of the cosmos. Natural law is "an essence so vast, so compelling, so completely integral, that death disappears; individual life vanishes; and there remains in our consciousness a sense, vague, grandiose, exalting, strangely attracting, deeply convincing—The sense of an Infinite that is complete."[66] Nowhere does Sullivan approach more closely the Neoplatonism he himself criticized in the Roman Church. The details of the Christian vision of a celestial Jerusalem are repugnant to him, suggesting as they do a feudal heaven. But Sullivan cannot bring himself to deny the concepts of an overriding, organizing essence in the universe and of man's connection with it even after death. Nature is too beneficent, finally, to leave us in the lurch. There may be no God, but it is unthinkable even in a rhetorical context to raise the question of whether or not life has meaning. If Sullivan is a prophet of modern architecture, he cannot claim an analogous role in the unfolding of existentialist philosophy.

Louis Sullivan posited a cosmic energy and consciousness that pervade the universe, an Infinite that is "partly intelligible to us, even though it is ultimately inscrutable."[67] "It is to this Infinite that the Natural Man

listens," he tells us, and it is in the Infinite that "he perceives a VAST RESERVOIR OF LIFE" that is of great use to him in daily life.[68] "It is this partial intelligibility that fills the soul with hope and it is this hope that is the animating function of that living form or expression of the Infinite that I am calling NATURAL THOUGHT."[69] Nature, in other words, is the Infinite made visible; and natural thinking is the process by which men make contact with the Infinite.

The Infinite is beneficent and all-infusing. Yet one can never completely know the Infinite, Sullivan cautions, for "in this sense, to know would be to vanish," to pass beyond the bounds of earth-life, and to experience the fulfillment of the prophecy of Paul, "but then shall I know even as also I am known."[70] Nonetheless the partial intelligibility makes possible man's hope, the spark of aspiration, that impetus of Primordial Instinct. Sullivan criticizes theologians for having merged the idea of the Infinite with that of a personal God. He sees it to be his duty to make the Infinite attractive once again, to divorce it from extraneous ecclesiastical trappings, and to show its practical applications. We are a part of the Infinite, he asserts, not separate from it. "This is the psychic foundation of Democracy—the living simple germ of Natural Thinking."[71] No less a destiny than the advent of democracy itself is the goal of natural law. No matter how complex its exterior manifestations, Sullivan cautions, we must not forget the perfection of its ultimate simplicity and irreducibility. Like a good fifteenth-century Neoplatonist, he proclaims the final reconciliation of all seeming opposites in a sentence that is unsurpassed in all his writing for lofty wordiness: "Therefore, while always acknowledging the inscrutability of the Infinite, we are always warranted, precisely because of the limitless complexity of Its manifestations, in assuming It to be an essence that signifies to our reason an ultimate pro-creative simplicity."[72] Interestingly enough, his use of uppercase pronouns demonstrates Sullivan's reluctance to shed every ecclesiastical convention.

Nature clearly plays a primary role in Sullivan's cosmology; and, indeed, one of the chief reasons for his celebration among both scholars and laity is the fusion in his work of a romantic, transcendental attachment to nature (a nature that is lovely and beneficent without qualification[73]) and hard-nosed American practicality as exemplified in American exploitation of technological innovation. Sullivan strove to design office buildings that are both utilitarian and aesthetically pleasing, they contend. Whether it is possible long to maintain simultaneously a romantic and an exploitative attitude toward nature as Sullivan has done will be dealt with later in this book;[74] but for the moment it should be recognized that Sullivan presumed a direct relation between nature and health, both mental and somatic, and between the unnatural and the unhygienic.

One who has read Sullivan even casually cannot have missed his frequent use of metaphors of disease and pathology. These are among his favorite devices and are ordinarily reserved for occasions when he wishes to signal his disgust with particularly inverted ideas or actions. One of the most famous instances is his observation on the "lesions significant of dementia" at the 1893 Chicago Fair already mentioned. But Sullivan also shows concern for the unnatural and unhealthful in concrete ways as well. He laments the misleading advertisements for a bowel purgative he has seen in a newspaper, denying the necessity for such astringents. In fact, he claims there is a connection between "physical and mental constipation . . . that thousands upon thousands of people are deficient in eliminative power . . . and therefore have been drugged and purged from infancy"[75] by artificial and, therefore, unhealthful means.

Sullivan's interest in such matters is of such urgency that he can on occasion break from a metaphoric structure he has been building to damn an institution that did not figure in the original image. Thus, his likening of social evolution to the proper fermentation of grapes (neither of which can be hurried) is mysteriously forgotten as he criticizes the liquor industry for alcohol-related abuses of wife and family. In this case the merely figurative use of the process of fermentation has triggered his prejudice against alcohol,[76] the entire non sequitur developing within less than half a page of "Natural Thinking." The garbled aspect of the passage is particularly ironic, since it appears in the discussion of an infirmity from which Sullivan himself suffered and that may, indeed, have been responsible for the lack of clarity in the first place. "Natural Thinking" was written in 1905, but Frank Lloyd Wright recalls in *Genius and the Mobocracy* that Sullivan's drinking problems were evident by the time of the completion of the Auditorium Building in 1889.

While granting that degeneration and death are natural to the human condition, Sullivan contends that "Disease of mind or body is a phantasm; and wholly unnecessary." He admits that we should pay attention to our physical symptoms, but he also professes that the Christian Science dictum "Disease and evil are errors of mortal mind" is "sound to the core."[77] Thus he takes illness to be a manifestation of one's being out of touch with nature and her beneficent forces.

Sullivan remarks upon his youthful athletic prowess in the *Autobiography*,[78] and it is clear from the entries in the Lotos Club Notebook that he was compulsive about recording year by year gains and losses in weight, bodily measurements, track timings, and swimming efforts. Health and hygiene seem to have preoccupied him; and in this he reminds one of other early twentieth-century architects. Toni Garnier and Adolf Loos, for example, both emphasized hygiene and sanitary physical condi-

tions in their buildings and theory. Loos's tirades against architectural decoration as representing sexual perversity are well-known.

Indeed, Sullivan seems to have ignored completely the opinion of one of his favorite philosophers in regard to this matter. In criticizing that "most contemptible" of creatures the "*last man*," Nietzsche includes a ringing indictment of the health obsession of such men. "One has one's little pleasure for the day and one's little pleasure for the night: but one has a regard for health. 'We have invented happiness,' say the last men, and they blink."[79] Nonetheless Sullivan blissfully recommends natural thinking as the best regimen:

> This . . . is the function of natural thought: to preserve in us health, through the free circulation in our bodies minds hearts and souls of the pure and undefiled stream of Infinite creative power that shapes in us reason, optimism and love. . . .[80] No brain, heart or soul can or will give birth to abnormal thought, if the individual professor of them, has from infancy received a normal vital education in natural living and natural thinking. . . .[81] Thus will the way be made clear for the body social . . . to so cleanse its own constitution, by natural thinking, that it may have no further sore upon its body, but a clean wholesome physique.[82]

No doubt Sullivan was aware of the essentially middle-class origin of his obsession with physical hygiene. Indeed, it was the bourgeoisie that for him was the most prominent locus of the workings of natural thought. He claims that the salient middle-class traits—honesty, the instinct for justice—must permeate all levels of society, and once they have done so the criminal "high or low" will be revealed and segregated and will be seen as "a social ulcer, a sore on the body politic." The proliferation of middle-class attitudes signified to Sullivan "the beginning, by nature, of a readjustment of social balances. It . . . is the inevitable automatic rebellion of the body social against an auto-intoxication which has reached the limit of endurance."[83] The rise of the American middle class may now be added to the list of harbingers of the organically democratic condition!

The Problem of Historicism

Sullivan's theory of history, advanced in support of his supposedly modern architecture, was thoroughly historicist in inspiration. Sullivan borrowed his suppositions from Hegel, Compte, Taine, Draper, and a host of others who believed that a science of society was, indeed, practicable and desirable. One of the most important of those suppositions is that, given a thorough knowledge of certain variables, the future of mankind is foreseeable with some accuracy. Sullivan as much as said so in his declamations

about America's being the place where man would at last know "the redemption of his soul." The variables of politics and technology implied this majestic purpose to him.

Karl Popper, among others, has criticized the major assumptions of the historicist viewpoint, particularly the one having to do with our ability to predict the results of our own actions (to take a pertinent example: that people will be happy and good if we build them good environments). Popper logically disproves this historicist axiom by showing that it is impossible for us to know how as yet unforeseen variables will affect history.[84] He thereby casts into doubt any assessments of our future prospects (optimistic or otherwise), including Sullivan's.

The flaw at the heart of Sullivan's positivism is his habit of viewing mankind merely from the distance. He treats the actions of men as being collective, as the unavoidable outcome of social forces or of a "spirit of the times." Individual actions are seen to have, not individual, but mainly societal meaning. His supposition, from a historicist's standpoint, of a teleological cosmos and a beneficent Infinite finally required that Sullivan posit a series of immutable laws of causality that did not admit of the unforeseen, the irrational, the uniquely individual, or the possibility of a change of method by nature. This, after all, is his greatest self-contradiction: that a force so flexible as nature was in fact incapable of teaching Louis Sullivan something he didn't already know.

4. Sullivan's Theory of Architecture

All practical demands of utility should be paramount as basis of planning and design; . . . no architectural dictum, or tradition, or superstition, or habit, should stand in the way.

—Louis Sullivan[1]

Architecture as the Thought of the People

I mentioned in the second chapter that Sullivan rarely addressed specific matters of architectural design or construction in his writings. He usually spoke of the architectural art in quite general terms, borrowing from Taine and others the idea that "the art of a people is a reflex or direct expression of the life of that people; . . . that one must become acquainted with that life in order to see into the art."[2] From this assumption he derived its architectural corollary:

> This flow of building we call Historical Architecture. At no time and in no instance has it been other than an index of the flow of the thought of the people—an emanation from the inmost life of the people. . . . For as a people thinks concerning Architecture, so it thinks concerning everything else; and as it thinks concerning any other thing, so it thinks concerning architecture; for the thought of a people, however complicated it may appear, is all of-a-piece, and represents the balance of heredity and environment at the time.[3]

By coupling this notion of architecture-as-thought to his belief that natural evolution brings about progressive modifications in human society, Sullivan propounded the idea that America, the modern product of social evolution, should possess an architecture that is the unique product of its own cultural thought. Because that thought centered on the concept of democ-

58

racy, it followed that American architecture ought by rights to be a democratic one. Much to his consternation, however, Sullivan was convinced that it was precisely a democratic architecture that America lacked, and he set about trying to rectify that grievous state of affairs.

He proposed to revitalize a tradition that he assumed to be moribund or at least dormant in American architecture, namely the creation of buildings that were in harmony with the processes of nature. Since evolution had dictated that all past cultures would produce architecture specially suited to their own time and place, so this culture was destined to manifest its own derivation from evolutionary forces in the production of fittingly American buildings. Sullivan was quite literal in his statement of the matter. When an architect designs a building properly, he is following the laws of nature:

> This is the problem; and we must seek the solution of it in a process analogous to its own evolution—indeed, a continuation of it—namely, by proceeding step by step from general to special aspects, from coarser to finer considerations.
>
> It is my belief that it is of the very essence of every problem that it contains and suggests its own solution. This I believe to be natural law.[4]

Since architectural design is somehow related to natural law, it follows that the problem of finding the right shape for a building is analogous to the problem nature faces when bringing new species of animal or plant life into existence: the external appearance and internal structure of these species are the direct results of adaptations to new or changing conditions. Likewise, the new cultural conditions of the United States necessitate the emergence of hitherto unknown forms of building.

Sullivan used adjectives such as *natural, organic,* and *romantic* interchangeably, sometimes including even *rational* in this group of words by which he intended to convey the sense of something's being a valid expression of the forces of the Infinite. The distinctions one ordinarily makes among these words apparently were not important to Sullivan; neither has his imprecise use of them deterred his partisans from assuming that they know what he meant by them. More important, the pithiness of his famous aphorism that *form follows function* has perhaps made it easy to overlook the questions of meaning that are raised by Sullivan's more effusive writings.

When explaining what he meant by his aphorism as it pertained to architecture, it is not surprising that Sullivan should resort to organic analogies: "The form, oak-tree, resembles and expresses the purpose or function: oak; . . . the form, horse, resembles and is the logical output of the function, horse."[5] Sullivan believed that the principle should also apply to

the creations of man and, therefore, that the appearances of a building should follow from its uses.

The phrase *form follows function*[6] has the ring of something both profound and authentic. It seems as if it should have universal validity. But its weakness lies in its tautological character. It is difficult to imagine (to use Sullivan's example) an organism that functions as a horse functions but does not look like a horse. Indeed, as Peter Collins has pointed out, Sullivan's statement may in fact be an inversion of the Darwinian concept of adaptation upon which it was based.[7] It can be argued that in nature function actually follows form, since the viability of any new organism is dependent upon its embodiment in an adequate physical form that is the product of random mutation. Forms that cannot adapt do not function, and they die out. Frank Lloyd Wright tried to clarify the proposition by stating that form and function ought to be considered the same thing; they could not be discussed independently of one another as if they were separate aspects of the same organism. For the younger architect, form did not follow function as in the deterministic relationship between cause and effect; instead form *was* function. In any event, the efficacy of the aphorism in an architectural context was limited, I believe, by Sullivan's incomplete understanding of the true complexity and richness of the varied functions of architecture.

While much of the architecture of America struck Sullivan as inorganic or feudal, still he was convinced that we would eventually generate a functional and therefore democratic movement in building. In "Characteristics and Tendencies in American Architecture," his first formal essay on the matter, Sullivan said that ours is a "tentative and provisional culture" and that in the architectural profession "the ability to develop elementary ideas organically is not conspicuous." Nonetheless he averred that "behind a somewhat uncertain vision resides a marvelous instinct. . . . National sensitiveness and pride, conjoined with fertility of resource, will aid as active stimuli in the development of this instinct toward a more rational and organic mode of expression, leading through many reactions to a higher sphere of artistic development."[8]

Certain difficulties arise out of Sullivan's cultural-natural argument. The most obvious difficulty is that the reality of American architecture is not consistent with Sullivan's own theory of unified cultural expression. Since most buildings in the United States did not strike Sullivan as being democratic, it should have followed that America was not truly a democracy. As has been suggested by others,[9] it is curious that Sullivan argued for the adoption of a style of building that was so at variance with most American architecture if at the same time he claimed that art was a reflex of the culture or of the times. According to the logic of that theory, he too

should have been designing neoclassical or Gothic revival structures and should not have concerned himself with strikingly new or different forms. What he was doing was in fact not included within the outlines of his own theory! Furthermore, inasmuch as natural evolution operates on the principle of successive and usually very small modifications stretched over many thousands of years, it stands to reason that any departures from the architecture of the past ought to be subtle or even negligible within the lifetime of a single architect, not obvious or revolutionary as Sullivan proposed. If one were to accept Sullivan's so-called organic argument, then one would perforce conclude that his architecture could be only a little more democratic than that of his predecessors and could not therefore be different from theirs in kind.

Another problem inherent in Sullivan's theory has to do with the matter of cultural homogeneity. Sullivan's assumption of a special destiny for the American people hinged on his belief that a recognizable unity underlies American thought or American character and personality. Despite all the evidence that suggests the variable and heterogeneous nature of the populace of this and every other country, Sullivan insisted upon speaking of the United States as if it were culturally monistic; as if it were a giant organism whose separate but coordinated bodily functions contribute to the life of the whole. Various nineteenth-century writers found it convenient to think of society in this way, believing that they had discovered a convincing metaphor to express what they took to be the lawful operation not only of nature but of human activity as well. Sullivan was no exception. If the evolutionary law of variability allowed plants and animals to adapt to their surroundings, then certainly that same law must apply to human society, which would find its appropriate artistic expression in any given time or place.

This way of looking at things placed Sullivan in an odd position. His belief in the unique, liberating destiny of America and his recognition that this destiny was yet to be realized made of Sullivan a prophet of better things, though not necessarily a realizer of them. Despite his contention that the present reality is the only pertinent one, he was actually forced into prophesying rather than fulfilling the promise of America. Yet the idea of destiny is somewhat foreign to the concept of evolution, a process that presumably does not cease. Thus Sullivan attempted to derive a teleological conception of America from a natural process that, so far as anyone can tell, is never-ending or destinyless.

Furthermore, since Sullivan's visions rely on evidence culled from the highly unpredictable actions of the social organism, actions that are the product of an almost limitless number of variables (many of them evidently unknown), his prophecies rest on uncertain grounds. This is per-

haps the most confusing part of Sullivan's argument: the modern, democratic spirit in America demands an architecture that is the reflection of that spirit. But since such an architecture is not in evidence, Sullivan is forced into the stance of a seer who, while admitting the absence of democratic building, predicts its *eventual* attainment. The problem with this theory of architecture as a cultural reflex is that it does not explain what Sullivan took to be the dysfunction of that reflex in his own day.

Because Sullivan often claimed that men had taken a wrong turn when they deserted instinct and embraced intellect, it is possible that he thought there were both true and false expressions of cultural thought. The illegitimate or inverted expression seemed in the ascendancy to Sullivan at the end of his life, but his theory fails to account for this false expression. His Infinite would hardly seem capable of introducing a negative impulse into nature alongside the beneficent one. Such a situation would be contradictory and self-defeating. But Sullivan's cosmology was monistic, and it really cannot locate or define the origin of the inverted aspect of culture.

Had Sullivan's interest in American architectural history been broader, he might have seen that the architectural productions in America, even within a single city in a single year, were so heterogeneous in purpose and appearance that they could not possibly reflect any such unity of underlying communal thought as he proposed. As I have shown, his conception of history compelled him to view events from the standpoint of a hypothetical aggregate and almost never from that of the private citizen. Even his concern with the specifics of designing a tall building left out important considerations of the individual worker and any aspirations he might have other than earning income. The offices are nothing more than cells within a hive, hardly working places that suggest the feature of democratic life Whitman defined as *personalism*. With the possible exception of the Wainwright Building, Sullivan's skyscrapers maintain a rather distant relation with the men and women who work within them. This deficiency is particularly ironic in light of Sullivan's own self-importance. His offices were at the top of the Auditorium tower, not in one of the cells of the hive. Thus we have the great social prophecies issuing from a quintessentially idiosyncratic man who finally refused to take his place in the social fabric whose importance, he asserts, is all-encompassing.

The Organic Argument

Sullivan's quest for a functional architecture by means of the organic analogy was not original with him. Several eighteenth-century architects and theorists in Europe preceded him in this endeavor, as Emil Kaufmann has

shown.[10] A rejection of baroque sensualism and theatricality in favor of a simple truth to functions and materials, for example, may be seen in the lectures of Carlo Lodoli, a mid-eighteenth-century Venetian. The first important proponent of such ideas in America was probably Horatio Greenough, a sculptor and aesthetician who wrote of an ideal architecture in his "American Architecture" (1843). It is not certain that Sullivan knew Greenough's writings, but there can be little doubt that he was familiar with the ideas propounded therein.

Sullivan's naturalistic argument is very much in the tradition of Greenough and Emerson, and it may prove helpful to summarize Greenough's conceptions as a way of demonstrating Sullivan's position within what we might call an antihistorical, modernistic tradition in architecture. In a frequently cited passage, Greenough disparages our reliance on the forms of Gothic and classical Greek architecture and recommends that we look to the structures of animals and machines for inspiration and education.

> If, as the first step in our search after the great principles of construction, we but observe the skeletons and skins of animals, through all the varieties of beast and bird, of fish and insect, are we not as forcibly struck by their variety as by their beauty? There is no arbitrary law of proportion, no unbending model of form. There is scarce a part of the animal organization which we do not find elongated or shortened, increased, diminished, or suppressed, as the wants of the genus or species dictate, as their exposure or work may require. . . . It is neither the presence nor the absence of this or that part or shape or color that wins our eye in natural objects; it is the consistency and harmony of the parts juxtaposed, and the subordination of details to masses, and of masses to the whole.
>
> The law of adaptation is the fundamental law of nature in all structures. . . . Observe a ship at sea! Mark the majestic form of her hull as she rushes through the water, observe the graceful bend of the body, the gentle transition from round to flat, the grasp of her keel, the leap of her bows, the symmetry and rich tracery of her spars and rigging, and those grand wind muscles, her sails! Behold an organization second only to that of an animal. . . . What Academy of Design, what research of connoisseurship, what imitation of the Greeks produced this marvel of construction? . . .
>
> Instead of forcing the functions of every sort of building into one general form, adopting an outward shape for the sake of the eye or of association, without reference to the inner distribution, let us begin from the heart as a nucleus and work outward. . . .[11]

In "The Cooper Monument," Greenough expresses a sentiment and develops a terminology for its statement that would seem to lead directly to the writings of Louis Sullivan: "If there be any principle of structure more plainly inculcated in the works of the Creator than all others, it is

the principle of unflinching adaptation of forms to functions."[12] Both the substance and the vocabulary of Sullivan's own writings suggest a familiarity with the mechanistic-determinist basis of Greenough's argument; and, owing to the many commissions that came to him early in his career, Sullivan was probably the first architect who had an opportunity to demonstrate on a grand scale the tenets of a romantic-structuralist ethic.

The support of Greenough and, therefore, of Sullivan for this theory was based on an assumption that may at first seem reasonable: since Nature is a marvelous designer, men in building architecture ought to use her methods as a point of departure. The functions of buildings ought to determine the appearance of those buildings in the same way that, say, the feeding habits of certain birds determine the length and shape of their necks and beaks. To design a bank that looks like the Parthenon would thus be a flagrant transgression of this canon, as eighteenth-century theorists like Lodoli had said. In the example above, Greenough asks that buildings possess as clear a relationship between structure and outward appearance as that demonstrated by a sailing vessel.

The efficacy of Greenough's argument may be questioned on two important counts, however. The first is that both he and Sullivan react in an aesthetic way to a natural phenomenon that does not have aesthetics as its primary goal. These architects admire plants and animals because their shapes are pleasing in certain respects to the human eye (and also happen to be products of natural adaptation to physical exigencies). That Sullivan's reaction to organic species was essentially aesthetic may be shown as soon as one remembers that the *structural* principles of the building art were quite satisfactorily developed long before he appeared on the scene and long before he offered his elaborate "organic" justification for his own buildings. That is to say, structure itself was not a problem in any real sense even at the beginning of the nineteenth century.

Buildings stood, and had been standing, for centuries without an organic apology for doing so. The organic argument is, in fact, an argument for a change in appearance and not in structure. In any event, it is difficult to see how, for example, the physiology of a bird can be or ever could have been much help in designing a state capitol. They are two entirely different *kinds* of problems, and it seems fair to say that the organic analogy presupposes a didactic intent on the part of Nature, one of which man is evidently expected to make use. In any event, Sullivan's own buildings are hardly paradigms of organic principles, even within his own definitions. He did not create a single building that could not have been executed in masonry rather than with the steel frame, the structural method that has for so long been touted as the "organic" solution to the tall building problem.

The second drawback of the organic argument is that, while it reasonably supposes that buildings of dissimilar purpose ought not to look alike, it fails to define very completely what the "functions" of buildings might actually be. Nowhere in Greenough's speculations is there a thoughtful consideration of the institutional purposes for which we build architecture in the first place: his discussion is restricted almost entirely to an ethic of structural determinism that lacks the clear "mechanism of determination" he observed in nature.

Greenough was unable to demonstrate that the relationship he believed to exist between form and physiological necessity among plants and animals also held good for architecture, mainly because he was unable to show how human institutions are like organic specimens. Like Spencer and Taine, he assumed that they were similar; but he chose not to define precisely those ways in which civic, economic, religious, and familial associations demanded concrete manifestation in the same way that the wind-catching exigencies of a sailing-ship demanded the various patterns of canvas. He left us with no clear notion of what architectural shape the determining mechanism of republicanism might dictate.

Perhaps there is a certain poetical attractiveness about Greenough's argument, but when it comes to the difficult and highly practical matter of giving visible or iconic form to the ideals of civilized man, it is worthless. This recognition is important in my effort to appraise Sullivan's efforts, because his architectural theory is based in large part on just these nebulous ideas about organic determinism.

I said in the first chapter that Sullivan's defenders do not see in his work a purely mechanistic or utilitarian principle. Morrison is adamant about this in his analysis of the Wainwright Building, and both Egbert and Sprague used the word *organismic* to describe the process by which Sullivan arrived at his solutions to the problem of a "functional" architecture.[13] Even the briefest glance at the buildings themselves indicates that, indeed, Sullivan had no such polemical utilitarianism in mind as was later in this century formulated by architects of the International Style.

But it is equally true that Sullivan's theory of architecture, whether it did or did not find expression in his buildings, was deterministic in that, as he said, "every problem contains and suggests its own solution."[14] The implication is that there is only one valid solution to every distinct problem, and the method for finding that solution is analogous to the process Nature exhibits in supplying the fauna and flora with adaptive modifications for special purposes. On one occasion Sullivan posed the matter this way: "The true work of the architect is to organize, integrate, and glorify UTILITY. Then and then only is he truly MASTER-WORKER."[15] And on another:

He could now, undisturbed, start on the course of practical experimentation he long had in mind, which was to make an architecture that fitted its functions—a realistic architecture based on well defined utilitarian needs—that all practical demands of utility should be paramount as basis of planning and design. . . . This meant in his courageous mind that he would put to the test a formula he had evolved, through long contemplation of living things, namely that *form* follows function, which would mean, in practice, that architecture might again become a living art, if this formula were but adhered to.[16]

Greenough's rhetoric of determinism—*utility, practical, function, formula*—pervades these proclamations.

But Sullivan's famous aphorism is in fact hardly a formula if we require it to account for the complex variables of any architecture other than commercial. Thanks to Greenough and Sullivan, *function* is today a loaded term and is burdened with a host of meanings (utilitarian, structural, and symbolic) one does not ordinarily associate with it in any context but an architectural one. Usually when we say someone or something functions in a certain capacity, we mean he or it acts according to some pattern in pursuit of a specific goal. Something that has a *function* has a *use*. But we usually select other words when we mean to communicate notions about cultural or institutional ideals or aspirations. It may be permissible to say that one of the functions of the Supreme Court is to make judgments on constitutional matters or that it is one of the functions of the family to provide infants with protection and food. But *function* seems an inadequate term to describe those profound intuitions and ethical convictions which bring judicial bodies and families into being in the first place.

In actuality Sullivan was rarely in a position to apply his formula to the solution of architectural problems other than mundane commercial ones. Had he been presented (by virtue of some curious anachronism) with the commission Cass Gilbert received in 1935, to design a new Supreme Court building in Washington, D.C., his formula would have undergone a test for which it was hardly prepared. Within certain limits the interior arrangement of offices and judicial chambers might be quite flexible: it is possible to imagine a variety of formal organizations that would permit the court to execute its duties, and Sullivan was probably right in this respect when he said that problems have a way of suggesting their own solutions. But, of course, this particular problem is neither very weighty, nor very difficult. It is conceivable that the justices themselves, having no architectural training at all, might arrive at an interior disposition of rooms that would allow them to pursue their duties quite satisfactorily.

Sullivan's formula is inadequate, however, in suggesting the solution

to a far more difficult problem, namely, in what ways and by what means can a Supreme Court building suggest and embody the cherished libertarian and egalitarian principles the justices are sworn to uphold? How can the building articulate in an appropriate symbolic way a function that has nothing whatever to do with physical structure or materials? It is in such a case that the aesthetic of organic determinism falters, since there are no precedents for the symbolic communication of ethical convictions in the plant and animal kingdoms. Nature may originate new forms because new functions require them, but painstaking judicial deliberations are not among the functions to be found in nature.

No doubt Sullivan's formulation of the matter was possible because his architectural practice was restricted almost entirely to the mercantile sphere; and, unlike Thomas Jefferson, he did not attach much significance to the architecture of the state or its component bodies. Given his quasi-Zarathustran interpretation of culture, it is small wonder that he never expressed any ideas on civic architecture. He evidently possessed none, for the criticisms he levels at the work of other architects (in *Kindergarten Chats*, for example) almost invariably come from the world of commerce: hotels, railroads, and banks. It is one of the unfortunate oddities of recent times, in fact, that a doctrine of architectural aesthetics conceived for a limited group of human activities (those of commercial intercourse) has come to receive acclaim as the doctrine that should govern the design of buildings housing *all* kinds of human activity, no matter how unrelated to things mercantile.

Perhaps one cannot fault Sullivan for exploiting the Chicago building boom after the Great Fire of 1871. Who could expect him to resist the temptation to design and champion the cause of huge structures he could so easily claim as prominent advertisements of his own genius? One may also be justified, on the other hand, in expressing dismay at the overwhelming of the city by the inert and unimaginative creations that are the descendants of the Chicago-School skyscrapers. It is ironic, indeed, that the commercial tall building should have received from the efforts of Louis Sullivan an emphasis that even the most avaricious nineteenth-century capitalists could not have achieved for it: the mystique of profoundly ethical, political, and social legitimacy.

"The Tall Office Building Artistically Considered"

The matter of organic determinism as it relates to Sullivan's architecture can be made clearer if we consider a case in point. His Buffalo Guaranty Building of 1895 (Plate 3) is particularly interesting because it is the Sullivan design that is most frequently cited as an example of the principles

he developed in an almost contemporaneous article, "The Tall Office Building Artistically Considered."[17] When Sullivan says, a little more than halfway through the article, that "the sixteen-story building must not consist of sixteen separate, distinct and unrelated buildings piled one upon the other,"[18] he makes it clear that, indeed, the sixteen-story Guaranty Building was on his mind as he wrote.

The general formula for the Buffalo Guaranty Building is the same as in many of Sullivan's earlier skyscrapers: a tripartite composition of two-storied base, repeated office floors linked by slender piers, and frieze with cornice. "The Tall Office Building" no doubt contains adequate descriptions of the external features of the building: its division into various parts, its emphasized ground-story entrances, its decoration. But Sullivan really means his argument to be a general and a theoretical one: "I am here seeking not for an individual or specific solution, but for a true normal type." (How reminiscent this phrase is of that ideal Sullivan says he learned from his mathematics instructor at the École des Beaux-Arts, Monsieur Clopet—to find laws "so broad as to admit of no exception.") As on other occasions, Sullivan here also dismisses the larger cultural questions pertaining to the skyscraper: "It is not my purpose to discuss the social conditions; I accept them as the fact" (i.e., he accepts them as the inevitable products of social evolution and does not question their efficacy). Instead he pursues mainly aesthetic matters. "How shall we proclaim from the dizzy height of this strange, weird, modern housetop the peaceful evangel of sentiment, of beauty, the cult of a higher life?"[19]

While at the beginning of the article Sullivan's aims seem commendable in certain ways—to make the skyscraper something more than a vulgar contraption by which the speculator, engineer, and contractor may reap their profits—it is with some surprise that one is greeted by other claims. In pondering the qualities an architect must possess to be capable of conceiving worthy skyscrapers (qualities he implicitly congratulates himself on possessing), Sullivan states that the architect

> must be no coward, no denier, no bookworm, no dilettante. He must live of his life and for his life in the fullest, most consummate sense. He must realize at once and with the grasp of inspiration that the problem of the tall office building is one of the most stupendous, one of the most magnificent opportunities that the Lord of Nature in His beneficence has ever offered to the proud spirit of man.
>
> That this has not been perceived—indeed, has been flatly denied—is an exhibition of human perversity that must give us pause.[20]

Indeed, far from questioning the *social* conditions that spawned the skyscraper, Sullivan actually ascribes the skyscraper's origin to *natural* causes. It is here that we witness one of the clearest instances of Sullivan's claim

that buildings are like plants and animals. They, too, are products of evolutionary "laws," though in this case man replaces nature as the overseer and executor of these laws.

Hence follows the apologia Sullivan offered for his own tall buildings: they are not merely mechanical constructions for the advancement of commerce; they are "organic," follow the "laws" of evolution, and therefore enjoy the same irreducible legitimacy in the cosmos that characterizes plants and animals. Sullivan talks of the interior parts of these buildings—the engines, ductwork, and electrical system—as a "circulatory system," and of other parts as being "physiological" in nature. He notices that any solution to the problem of the tall office building must follow evolutionary principles, "namely, by proceeding step by step from general to special aspects, from coarser to finer considerations" (enters the jargon of Herbert Spencer as a defense of a certain kind of commercial building). When Sullivan enumerates the various formal treatments given the tall building in his own day, he leaves little doubt, even in the tone of his voice, about which he prefers:

> Others, seeking their examples and justification in the vegetable kingdom, urge that such a design shall above all things be organic. They quote the suitable flower with its bunch of leaves at the earth, its long graceful stem, carrying the gorgeous single flower. They point to the pinetree, its massy roots, its lithe, uninterrupted trunk, its tuft of green high in the air.[21]

Once we have opened ourselves to the beneficent processes of nature by eschewing "all the narrow formalities, hard-and-fast rules, and strangling bonds of the schools . . . then it may be proclaimed that we are on the high-road to a *natural* and satisfying art, an architecture that will *live* because it will be of the people, for the people, and by the people."[22] Thus with a stirring paraphrase of Lincoln, Sullivan completes "The Tall Office Building" by insisting that good, democratic art is natural art and that any other kind of art is a violation of the "law" that "form ever follows function."

Sullivan's use of the organic metaphor has momentary appeal. After all, what normal human being can be opposed to nature? And if nature is the basis of the Buffalo Guaranty Building, how can one find fault with it? Yet, after a closer look at this literary device, one may begin to wonder about Sullivan's reputation as a master of the organic metaphor, for it is only at a vague and poetic level that the parallels between architecture and nature seem valid.

At the most concrete level, buildings are not very much like plants and animals. They are not conceived; and they do not mature, reproduce, and die, as the latter do, in accordance with impulses and rhythms at work

in the natural world. Buildings are artificial creations of human beings, whose efforts beyond the provision of shelter seem to be prompted by urges that are not found in other animals. The libraries, schools, factories, city halls, and capitols all seem to express a certain uneasiness and dissatisfaction with the way things are. They are manifestations of the desire to go beyond, to improve upon the natural condition; for if men were satisfied with the earth as it is, as the animals seem to be, there would be no need for the various institutions whose clear purpose is to regulate the patterns of life that are unique to mankind. Most buildings are evidence of man's patent rejection of the natural condition. With the exception of jerry-built structures whose "planned obsolescence" is purposeful, men tend to build with an eye toward permanence and durability: individual buildings do not die as individual animals do. Buildings do not move around, do not think, and are not capable of making decisions of any sort (other than those limited decisions men allow them to make, such as the regulation of heat by thermostats; but these are really dependent on human preferences anyway—one can hardly speak of a building as having a preference for anything). Buildings are wholly inanimate; and, although an architect like Sullivan might contend that he was inspired by things organic in creating his buildings (as the decoration suggests), still the Buffalo Guaranty Building is a factitious creation, and efforts to argue for its legitimacy that employ the organic metaphor seem inappropriate.

Sullivan's Heroism of the Present

What is it that led Sullivan to his peculiar understanding of the meaning of his skyscrapers? While most architects in history, from Imhotep to Thomas Jefferson, had a clear idea of the institutional purposes for which they designed their buildings, how is it that Louis Sullivan felt the need to justify his skyscrapers, not in terms of their roles in a capitalist economy, but rather in arguments that touch hardly at all on the companies for whom he worked? Why did he create his doctrine of "natural" buildings? What was his justification for thinking a building should be like a tree?

As has often been pointed out, Sullivan's philosophy of art depends very much on certain ideas propounded first by Emerson and then in more popular form by Walt Whitman. The call to open oneself to nature, to be a self-sufficient individual who is not swayed by the "tyranny of the majority," and the call for a native American art (the result of the former two) are hallmarks of this philosophy. For whatever good such attitudes may achieve in the formation of a sturdy individual, it may be also be seen that they tend to de-emphasize his relation to history and to cultural tradition.

One senses that while the Emerson-Whitmanite accepts the rightness of the Greek temple for fifth-century Athenians, he also believes the American of the nineteenth century to be a sufficiently different animal that he need take no particular notice of those temples insofar as his own life is concerned. At the same time that Sullivan's philosophy of art places little value on the current "uses" of history, it also therefore tends to ignore the relation between the individual and the institutions that inform his life, which are necessarily based on various historical precedents. While Sullivan held that sociology is the science of the future, still he always talked as someone outside of society, like a lone wolf "baying at the moon," as Wright put it.[23]

This particular facet of nineteenth-century American thought places an architect like Sullivan in a peculiar situation. While the traditional role of architects before him had always been to satisfy the requirements of some particular patron or institution, Sullivan remained the self-reliant Emersonian individualist whose creations were the product of his own highly subjective notions, not of some special insight into the relationship between architecture and culture. In certain ways he worked in a vacuum. Norris Smith believes that "the relation of architectural metaphor to the state and to the lesser institutions of which its fabric is made up" is something "Louis Sullivan never understood."[24] Such a conclusion does not seem farfetched in light of the fact that Sullivan makes no reference in his writings to the buildings of the early republic (Jefferson's Richmond capitol, for instance), whose forms are so clearly associated with the civil idealism of earlier governments. Sullivan neither designed any structure for a state institution nor was ever asked to do so; and the evidence suggests that he gave little thought to what such buildings should look like. His understanding of "democratic" architecture was restricted almost entirely to its commercial specimens.

This ignoring of the governmental buildings of the American republic may well be consistent with Sullivan's interpretation of history—i.e., that since their forms depend on historical antecedents selected from times and places less "advanced" along the evolutionary road than the United States, they are somehow inappropriate to *this* time and place. But this attitude indicates the narrowness of Sullivan's understanding of the truly conservative aspects of the libertarian revolution that led to the War of Independence. The convictions that prompted Sam Adams and his allies to action were much older than the feudal absolutisms of king and church that Sullivan had learned to despise through his reading of Walt Whitman and John Draper. They are convictions that even antedate Jesus Christ, Sullivan's "first democrat," and it is one of the most curious aspects of Sullivan's career that he simply could not grasp the significance of the efforts

of Jefferson, Bulfinch, Latrobe, Mills, and his other early American colleagues who, each with his own adaptation of the classical language, tried to represent the most optimistic side of American political idealism.

Sullivan's paeans to nature are, I believe, misleading in crucial respects. While his popular reputation is based to a great extent on his possession of a supposedly Emersonian attitude toward nature, I would argue that his understanding of the uses of nature is quite different from that of the Concord philosophers. Whereas Emerson's conception was a metaphysical, seemingly almost Platonic, one in which physical facts and external realities are the concrete manifestations of spiritual principles, Sullivan's conception was quite utilitarian, despite assertions to the contrary. The intellectual tradition to which Sullivan and Greenough belonged may seem high-minded in its rhetoric, but in fact its real interest in nature is an analytical and exploitative one. It seeks to answer the question What can we learn about the processes of nature that will facilitate our transformation of our surroundings? It cannot be denied that Sullivan revealed in his writings a heartfelt appreciation for the beauties of nature; but in seeking to legitimize his own architecture by claiming for it an organic basis, he suggests of what a mundane persuasion he really was.

Greenough and Sullivan were hardly unique or prophetic in this regard. Both belonged to an intellectual tradition that was well-established in America by the time of the Revolution. Daniel Boorstin, in his discussion of this tradition, has shown that the mechanistic, utilitarian frame of mind was a salient part of the philosophy of Thomas Jefferson and his circle.[25] Boorstin sees Jeffersonian ideas about the world as being concerned mainly with physical externals: the appearances and mechanisms of nature are the only things by which man can understand the world and his place in it. Like Sullivan, Jefferson and his followers had a "strong sense of separation from the past," and they were interested in history mainly insofar as it offered object lessons on the futility of metaphysical thought.

> The past seemed both uninteresting and unreal. Only the present seemed unique. Jeffersonian anthropology became the substitute for history. The animal qualities of the species, unalterably fixed by the Creator in the beginning, had determined human experience. Even the life of Jesus—because it had occurred after the Creation and within the realm of institutions—seemed less important than the simplest biological facts. What interest could there be in human vicissitudes when the full meaning of the universe appeared in the unvarying shape of nature?[26]

How similar this is to Sullivan's own excited statements on the surpassing significance of the present: "*Reality* is of, in, by and for the present, and

the present only. . . . It is in the present, only, that you *really live,* therefore it is in the present only that you can really think. . . . The present is the *organic moment,* the *living moment.* The past and the future do not exist: the one is dead, the other unborn." [27]

Sullivan shared with the Jeffersonians, not only a belief in the "sovereignty of the present generation" (i.e., its independence of past philosophies and institutions), but also the idea that it was in the ideal and perfect mechanism of nature that man would discover all he needed to know concerning his moral and social goals. "Jeffersonian political theory was dominated by this essentially practical notion: that the biological, the psychological, and the moral adjustment of man to his environment were all one. They were all equal and inseparable symptoms of harmony with the divine plan." [28] In answer to the question How can we know the right thing to do? Jefferson responded that "nature had constituted *utility* to man, the standard and test of virtue." Boorstin suggests that "the ethical corollary of this axiom was that the solution of moral problems was implicit in the successful life of action." [29]

Sullivan's own indebtedness to this point of view may be seen in his veneration of "men who make things": the engineers and bridge builders who, he believed, were the true artists and moralists in America. Technology, which has its roots in natural law, was far more trustworthy than any frail sense of moral rightness that men could determine on their own. Sullivan's basically apolitical conception of democracy also has its roots in just this set of assumptions. What Jefferson "asked of his political theory . . . was no blueprint for society, but a way of discovering the plan implicit in nature." [30] The problem inherent in this stance, however, is the idea that since, in democratic institutions, "everybody is entitled to a voice in political matters and since most people lack an articulate political philosophy, democratic peoples can think without major premises." [31] Sullivan himself seems to have lacked just this sense of an articulate political philosophy. In its place he substituted a sanguine belief in the efficacy of following natural law as a way of determining right behavior.

The organic defense of his architecture derives from the same assumptions. To say that form follows function is the same as to say that the utilitarian purposes which give rise to specific architectural forms are by themselves valid and not subject to criticism simply by virtue of their having been embodied successfully. The "intellectual humility" (as Boorstin calls it) that characterizes this position had become in the nineteenth century "a form of philosophical indifference, which dulled the motives to self-scrutiny and contemplation." [32] Indeed, it would be difficult to find a famous man less interested in the subjection of his ideas to analytic scru-

tiny and contemplation than Louis Sullivan. Like others before him, Sullivan found it unnecessary to question the proposition that nature tells us everything we need to know about society and about architecture. Finally, one also recognizes that Sullivan's nature worship leaves out from consideration some of the truly characteristic aspects of organic life. Aside from flowers, trees, and sweetly singing birds, Sullivan has few curiosities. He seems almost to forget that "nature's beasts defecate, copulate and produce disturbing noises and aromas, in utter disregard for the sensibilities of the bipeds on the other side of the fence," as one author has put it.[33]

5. The High-Building Question

Upwards it striveth to build itself with pillars and stairs, life itself: into far distances it longeth to gaze and outwards after blessed beauties—*therefore* it needeth height!

—Friedrich Nietzsche[1]

It was in the stockyards that Jonas' friend had gotten rich, and so to Chicago the party was bound. They knew that one word, Chicago—and that was all they needed to know, at least until they reached the city. Then, tumbled out of the cars without ceremony, they were no better off than before; they stood staring down the vista of Dearborn Street, with its big black buildings towering in the distance, unable to realize that they had arrived, and why, when they said "Chicago," people no longer pointed in some direction, but instead looked perplexed, or laughed, or went on without paying attention.

—Upton Sinclair[2]

I have contended that Louis Sullivan's theory of architecture failed to account for a very real aspect of the relation between buildings and culture: it neglected to say anything about the very forces that make buildings necessary, namely the organized bodies of society with their various interests, loyalties, convictions, and purposes. Instead of showing how architecture arises from the need institutions have to signify their convictions, Sullivan proposed that architectural design should be the result of something quite unrelated to the institutional character of society. He was convinced that buildings are the expression of an involuntary "reflex" or homogeneous societal "thought." He held that specific forms in architecture are created much in the same way that nature creates new species of life, i.e., that they are shaped by forces that lie beyond individual human volition.

75

Sullivan's narrow definition of architecture most likely crippled his efforts to design buildings relevant to the heterogeneous character of the city itself. He was hampered by his being a largely private man who had little comprehension of or interest in the institutional basis of culture or of its most complex manifestation, the highly developed urban settlement. Sullivan was in many ways an unattached, "natural" man who posed as an architect and a social critic, but whose skyscrapers actually fail to suggest much about their social significance. They issue from private and mainly aesthetic concerns, and it seems never to have occurred to Sullivan that he in fact possessed the opportunity to say something about the ideal relationship that might exist between the commercial institutions housed within his buildings and the other important bodies that composed his society. In this chapter I will discuss five tall buildings designed by Sullivan between 1886 and 1899 and will try to show that, though they suggest a development or refinement of his personal style, they do not reflect a growing understanding of architecture as the emblematic embodiment of ideal institutional character.

Given his conviction that America was possessed of a millennial destiny that would see the redemption of man's soul, it is not surprising that Sullivan envisioned an American architecture that was fittingly grand and awe inspiring. The skyscraper became for him a convenient expression of that national destiny. Sullivan almost always worked for prosperous capitalists; and since they required huge buildings to further their pursuit of financial empire, it is little wonder that he was able to convince himself that his skyscrapers were the ideal embodiment of the American spirit. But, as must have been clear even to Sullivan, the post–Civil War captains of industry had never made it their business to achieve for man the "redemption of his soul."[3] Hence Sullivan was forced to attach to his own creations a transcendent significance that was inconsistent with their actual purposes. On the one hand, it is not Sullivan's fault that the individuals or corporations who were his clients possessed little of the philosophical idealism we associate with the governmental or religious bodies that have traditionally inspired architects to their best efforts. On the other hand, Sullivan was naïve in projecting upon his buildings a meaning wholly incommensurate with the mundane interests that gave rise to the skyscraper in the first place.

It is a little surprising to realize that Sullivan designed skyscrapers only for a total of about ten years. His last, the Schlesinger-Mayer Store of 1899, was done when he was forty-three. During the last quarter-century of his life, he averaged fewer than one commission a year, none of them skyscrapers. This is a curious situation in light of the fact that his popular reputation rests primarily on his tall buildings and their ornament

and on his raising of the skyscraper as a form of democratic poetry. It would be idle to speculate about the appearance of his post-1900 skyscrapers, since none was ever built; but given his sympathies for Eliel Saarinen's entry in the Chicago Tribune competition (1923), one may easily see which side of the fence he was on (Plate 4).[4] One point is not moot, however: given the opportunity, he would certainly have continued to design large, imaginatively ornamented structures for ambitious clients. Nothing in his writings or in his buildings suggests that he entertained second thoughts about the validity of what had been initiated with his first skyscraper. Furthermore, in one way or another, all his skyscrapers must be seen in relation to one seminal plan of 1891.

The Fraternity Temple Project

The paradigmatic Adler and Sullivan skyscraper was the Fraternity Temple project, a thirty-nine-story giant to be erected in Chicago, which would have combined ordinary business offices with the ritualistic and administrative quarters of a fraternal organization, the Odd Fellows. The fact that plans to execute the project fell through has tended to obscure the real importance of this building in Sullivan's thinking. There is no question that all concerned parties were acting in good faith. A rental brochure had been prepared to entice potential tenants.[5]

Sullivan himself publicized the building in his article entitled "The High-Building Question." Donald Hoffmann has pointed out that this is an article absolutely crucial to our understanding of Sullivan's architectural thought.[6] It not only announces the Fraternity Temple (Plates 5 and 6), but it also contains a second rendering, which is intended to illustrate Sullivan's concept of the modern city as a whole and to demonstrate how a number of skyscrapers might be related to one another on a vast scale (Plate 7). The importance of the article and its two illustrations cannot be overestimated, for they reveal Sullivan's vision of the ideal modern city in what were for him remarkably unambiguous terms.

Willard Connelly believes the Fraternity Temple project to be so important that its abortion caused irreparable harm not only to Sullivan's career but also to the future of progressive architecture in America.[7] Even Montgomery Schuyler, whose appraisal was almost contemporaneous with the project itself, proclaimed its importance as a model for the developing American city.[8] Still, among Sullivan's works, the Fraternity Temple and its corollary, the setback skyscraper city, are relatively unknown. How can I therefore make the claim that the skyscraper phase of Sullivan's career should be interpreted largely in terms of this unexecuted plan?

It is because the Fraternity Temple alone among Adler and Sullivan's

tall buildings represents the *total* conception of what a skyscraper ought to be. It is very tall, has setbacks at carefully defined intervals, has exterior light courts, "functional" decoration, banks of elevators, and other modern features. Some of these elements were incorporated in the firm's tall buildings of the 1890s, but never all at the same time. In some ways the project is clearly dependent upon the Wainwright Building in St. Louis (Plate 17), a structure to be examined in detail presently, which comes from the preceding year. The treatment of the Fraternity Temple cornices and of the floors just below them, with their roundels and floriated patterns, is obviously derived from the earlier building, as is the general formulation of the piers and spandrels that form the severe rectangular gridwork of the elevation as a whole. The "reinforcement" by the thick corner piers also comes from this source.

But these are relatively superficial matters when seen in light of the truly new conception of the skyscraper that is proposed. The Fraternity Temple is first of all an enormous structure against which it would be difficult to gauge one's own size and importance, especially with such a bewildering number of windows. Much more than the Wainwright, it is the kind of building that promises to alter the feeling of the city in the direction of pure awesomeness and overwhelming mechanical power. The Wainwright, barely a ten-story structure, with a clearer differentiation of parts, is still classical in scale and form. But the Fraternity Temple introduces a definite change in magnitude and significance.

Furthermore, the Fraternity Temple is so large that it requires a new set of principles to regulate its overall shape. No simple cube, it must rely on a setback formula in which successive diminutions of the plan—retreats from the property line, so to speak—are introduced as the building rises, so as to allow enough "light and air" to reach street level. Concern for natural illumination within the offices themselves is also manifested in the light courts, those rectangular voids separating the individual office towers below the level of the first setback. The light court itself is not a new conception here, even for Sullivan. He had employed it in the Wainwright Building, although it had been concealed in the rear, away from the street. Here the light courts become part of the facade of the building and help to introduce contrasts between light and dark, space and mass, that are missing in the less "sculptural" Wainwright. Hence, rather than the unassuming cube of the earlier building we have the massing of blocks that suggests an office building ziggurat complete with pyramidal finial, a somewhat puzzling terminus for a specimen of democratic poetry.

"The High-Building Question," in addition to presenting the Fraternity Temple project, argues in a paternalistic tone for the adoption of the setback formula on purportedly humane grounds: while it clearly does not

utilize every bit of space above a given city plot, still it creates as much rentable area as is consistent with what Sullivan terms *public welfare*— the need of the individual for sufficient air to breathe and light to see. Curiously, however, the tone of the article is somewhat begrudging of those human requirements:

> It seems to me a subject not at all debatable that here in Chicago the freedom of thought and action of the individual should be not only maintained, but held sacred. By this I surely do not mean the license of the individual to trample on his neighbor and disregard the public welfare, but I do just as surely mean that our city has acquired and maintained its greatness by virtue of its brainy men, who have made it what it is and who guarantee its future. These men may be selfish enough to need regulation, but it is monstrous to suppose that they must be suppressed, for they have in themselves qualities as noble, daring, and inspired as ever quickened knights of old to deeds of chivalry.[9]

In light of what he had to say later concerning the "child-like imbecilities of chivalry," Sullivan here seems to deliver Chicago's businessmen a backhanded compliment, but it is clear that he set no very severe limits either on their ambition or on his ability to match it in architecture.

Hoffmann shows that Sullivan was not the inventor of the setback system.[10] Nonetheless the Fraternity Temple project seems to be the first instance of its promotion as a formula by a well-established architect. On the surface Sullivan seems to be proposing a reasonable compromise between business interests and public welfare; but one questions the possibility of any true compromise when it involves building at such a scale with the inevitable problems that ensue: crowding, disorientation, depersonalization through sheer numbers of people and offices. The difficulty is compounded when such a scheme is extended to form an entire urban center, as one can imagine by viewing the second rendering in "The High-Building Question."

The rendering (Plate 7) is not by Sullivan himself, but it is clearly intended to illustrate his ideas about the setback skyscraper as the most profitable and practical mode of commercial building. It even includes two structures with towers very much like that of Sullivan's Auditorium Building. The scale of the city Sullivan proposes is of a seemingly ungaugeable magnitude again: to see even half of what would be included in such a city, the draftsman has had to construct the perspective so that we ourselves are elevated to the height of a several-story building and are placed in an impossible position directly over a street, much as we are in the utopian cityscapes of later planners such as Le Corbusier (Plate 8). No one is seen to be walking about, and one senses none of the expected hustle and bustle of commercial intercourse. It seems to be a city that exists for

the buildings, not for men, women, and their activities. The forms seem timeless and immutable, and they also seem to possess a significance that is independent of any concern for human needs as we make our way in the world.

Indeed, it is the almost surrealistic suspension of time and of historic eventfulness that is the key to a criticism of Sullivan's urban ideal. It is an ideal that is not very inclusive. In fact it is monomaniacal, presenting commerce as the only legitimate pursuit of civilized man. No houses or schools are seen in this vista: no churches, no government buildings, no libraries, no plazas where people share their idle moments, no evidence whatsoever of those things we do besides make money. Here we have only the towering, implacable gray masses of setback office giants, presences that are felt so ominously throughout the novels of Frank Norris, Theodore Dreiser, and Upton Sinclair at the turn of the century.

One is left wondering what the end of the whole scheme can possiby be: what understanding of the nature of civilization allows Sullivan to conceive of urban life in such terms? It is an impoverished conception certainly when compared, say, to the renderings of the city in any number of fifteenth- or sixteenth-century paintings from Italy or the Low Countries, in which it is possible to find buildings that are representative of the richly varied interests and institutions of city life (Plate 9).

Such a vision as Sullivan's lends shaky support to his claims of Chicago's superiority over New York City. He makes one wonder if the incompleteness of his concept is intentional so that we ourselves fill out this city with our own knowledge of society's true heterogeneity or if Sullivan is someone who, in the brash epoch after the Great Chicago Fire, really thought of the setback skyscraper city as a sufficient index of the achievement of modern civilization. John Summerson is tolerant and somewhat optimistic in this regard. Despite the faults in Sullivan's *Autobiography of an Idea*, he finds it "a fascinating document in its way, gushing with the innocent self-love of the self-made America of the turn of the century, the rugged, generous, loose-limbed, eternally philosophizing America invented by Whitman and Emerson."[11]

One doubts that Emerson would have taken to the setback skyscraper city as a model of American excellence. It would have been foreign to his New Englander's notion of true self-reliance. Who can be one's own man in a city like this? Here is a paradox Sullivan was unable to philosophize away: that the kind of self-reliant, ambitious client he worked for made it more difficult for others to be equally self-reliant and self-sufficient. Commerce in America of the 1890s, prospering under what one might call a predatory laissez-fairism sanctioned by social Darwinism, was hardly a system in which Emersonian self-reliance was possible. In this omnibus

prosperity before the market crash of 1893, was Sullivan able to delude himself into thinking that this, after all, was civilization?

Others, like Leo Tolstoi, could see through the mask of prosperity and could glimpse a society that was already dangerously unbalanced:

> America has lost her youth. Her hair is growing gray, her teeth are falling out; she is becoming senile. Voltaire said that France was rotten before she was ripe, but what shall be said of a nation whose ideals have perished almost in one generation? Your Emersons, Garrisons and Whittiers are all gone. You produce nothing but rich men. In the years before and after the Civil War the soul-life of your people flowered and bore fruit. You are pitiful materialists now.[12]

Sullivan's ideal city makes one suspect that in 1891 he really could not see beyond the superficial successes that so troubled Tolstoi. Whether his later thinking allowed him to pass beyond this notion of what America was about will be considered in due time, but what one might ponder here are the larger problems implied by the skyscraper that Sullivan himself mentions briefly at the beginning of "The High-Building Question" but that are never the subject of an extended commentary by the architect during the heyday of his own practice:

> To elaborate in all its details and ramifications, its varied selfish and unselfish interests, its phases of public and individual equity, its bearings present and future, its larger and narrower values, to attempt indeed but a sketch of its general outline would carry the discussion of the high-building question far beyond the limits of space that a journal such as this could afford. I desire, therefore, to pass by untouched the broad sociological aspects of this very elaborate discussion, and to confine myself to a phase of it which, so far as I am aware, has not yet been touched upon, but which may prove a factor in the final solution.[13]

Here Sullivan takes the first ten lines of a 98-line essay—more than ten percent of it—to say in a roundabout way what he is not going to talk about. In 1891, at the height of his commercial success, he effectively dismissed the larger social questions concerning the tall building in an article entitled "The Higher-Building Question." He did not attempt to address the issue that seems to be at the very heart of the question, namely, Should tall buildings be raised *at all?*

It is not impossible, of course, that Sullivan was indeed concerned with the unchecked proliferation of the tall building. The fact that the negative side is not discussed extensively in his writings of the 1890s does not mean that he was unaware of it. But, as he was tempted to excuse some of the excesses of the medieval Church so long as they could be considered steps in progressive social evolution that would eventually lead

to democracy, he may also have been able to suspend his reservations about laissez-faire economics so long as he was convinced that some ultimate good would come of the excesses of the Chicago money knights. Walt Whitman himself was of just this opinion, and one is tempted to think that Sullivan was in sympathy with Whitman when he wrote in *Democratic Vistas*:

> For fear of mistake, I may as well distinctly specify, as cheerfully included in the model and standard of these Vistas, a practical, stirring, worldly, money-making, even materialistic, character. It is undeniable that our farms, stores, offices, dry goods, coal and groceries, enginery, cash accounts, trades, earnings, markets, etc., should be attended to in earnest, and actively pursued, just as if they had a real and permanent existence. I perceive clearly that the extreme business energy, and this almost maniacal appetite for wealth prevalent in the United States, are parts of amelioration and progress, indispensably needed to prepare the very results I demand.[14]

Whether or not Sullivan might have had this precise passage in mind as a way of justifying his own efforts in the 1890s we cannot know, but the evidence is persuasive that he was very much in sympathy with Whitman's view. With this understanding of Sullivan as a zealous businessman himself I turn to a consideration of his other major designs prior to 1900.

The Auditorium Building

The building that catapulted the names of Adler and Sullivan into national prominence was the Chicago Auditorium, designed in 1886, which was the first truly gigantic structure to come from their office. The commissions prior to the Auditorium tend to be undistinguished in appearance. Adler's engineering abilities insured their solidity in a structural way, and his reputation as a superior builder in itself was instrumental in capturing the Auditorium job. But Sullivan's facades before 1886—those of the Borden, Rothschild, Revell, Ryerson, and Troescher Buildings, for example—betray a highly eclectic and undigested vocabulary of ordinary commercial forms. Had the Auditorium and Wainwright buildings never been executed, it is doubtful that the banded polychromy, rusticated ground stories, bay windows, and pseudo cast-iron devices in these buildings would suggest anything out of the ordinary about their architects: it is only because of the later commissions that attention is paid to the earlier.

Two aspects of the earlier works are of interest, however, because they reveal from the beginning certain habits of design that stayed with Sullivan throughout his career: one is the tendency toward formal ambiguity, which can be seen in his intentional avoidance of a sense of hierarchy, central emphasis, or resolution; the other is the tendency toward a super-

fluity of ornament. The Rothschild (Plate 10) and Troescher buildings are notable in the former respect: they have even numbers of bays, and the two halves of each building are treated as mirror images of one another. No effort is made to interject an articulating phrase between these halves, and one misses this fulcrum as one misses punctuation in the expression of a thought. Otherwise, however, these early efforts present easily recognized and often redundant and awkward borrowings from Jenney, Frank Furness, and the neomedieval and Beaux-Arts traditions.[15]

It is the Auditorium, on the other hand, that suggests Sullivan's coming of age as an architect. He designed it in his thirtieth year; and although he had not abandoned all the picturesque devices that interested him in what might be called his Victorian phase, it has a grandness and simplicity (at least externally) that make one take notice (Plate 11). The mode of construction is not that of a skyscraper: the exterior walls are load-bearing and, indeed, appear so. Nonetheless the Auditorium did rise with a certain sense of engineering pyrotechnics—the "false loading" of the tower so that it would settle at the same rate as the building proper, and the experimentation with the footings.[16] These were Adler's achievements, as were the excellent acoustics of the opera theater itself. In large part the fame of the building is due to Adler, whose insight into physical problems was expert. Sullivan was responsible, as usual, for the decoration of both the exterior and interior surfaces of the building; and it is in his treatment of them that one witnesses his first real effort to attain the quality of majesty in a tall building.

It is achieved here, as in the Fraternity Temple project, by mounting a large tower on a lower rectangular prism. The preliminary designs, as often noted, not only contain several Victorian medievalisms (the high-pitched roof, the bay windows, and the conically topped oriels at the corners) but also a tower that is not exactly towering (Plate 12). The executed version is divested of what Sullivan must have considered the overly historicizing aspects of the earlier plans. Yet, in projecting the tower far above the cornice line of the main block, he created the kind of picturesque opposition that one admires in later medieval buildings, such as the Palazzo Vecchio in Florence. Furthermore, the progressive smoothing of the masonry as the building rises and the use of superimposed pilasters to bind the middle floors recall certain practices of design in the fifteenth and sixteenth centuries, also in Italy. Sullivan's investigation of noncommensurate rhythms—the grouping of three over two over one in the windows of the upper seven stories—betrays yet another "historical" trait, in this case Romanesque. Finally, unconventional as it is, the Michigan Avenue facade displays a portico that not only is quite classical, at least in the second story, but also achieves a sense of central emphasis lacking in the earlier works.

The Auditorium is as full of historical sources as any of Sullivan's prior work, but they are put together with a new clarity; and, as Sullivan himself admitted, that clarity was the direct result of an outside inspiration. H. H. Richardson, America's first renowned architect after the Civil War, had designed two of his late buildings in Chicago. One of them, the Marshall Field Wholesale Store, was rising as Sullivan thought out the Auditorium project; and there can be little doubt that his decisions to use a flat roof and to exclude the various other projections were the result of a conscious emulation of the Field building's radical economy of design (Plate 13). "Here is a *man* for you to look at," says the master to the pupil as they stand before the great warehouse in the sixth chapter of *Kindergarten Chats*. "A man that walks on two legs instead of four, has active muscles, heart, lungs and other viscera; a man that lives and breathes, that has red blood; a real man, a manly man; a virile force—broad and vigorous and with a whelm of energy—an entire male." [17]

This is Sullivan speaking in 1901, someone who in the fifteen years since his design of the Auditorium had come upon hard times and had had ample opportunity to formulate a theory of architecture, one that included a carping criticism of the buildings by those who enjoyed greater success than he. Its main criteria for judging buildings are derived from certain biological and hygienic concepts we have already encountered in his writings. The Richardson structure is a success because it is (a) a man, not an animal, and therefore stands at the top of the evolutionary ladder; (b) healthy, not moribund, degenerate, or pathological; and (c) male, not effeminate, frivolous, modish, or inconstant. It is these things in contrast to the Illinois Central Station in Chicago (discussed in the third chapter of *Kindergarten Chats*), whose "lucidity of thought is like unto the Stygian murk" and which is "neuter" and also a "canker on the tongue of natural speech." When instructing his pupil in the fine art of architectural criticism, the master neither teaches visual analysis nor speaks of the aims of the client. He usually expresses a hostile reaction in the form of invective and sarcasm. The master *reacts* to the building as a piece of abstract sculpture, not as the symbol of an institution.

Sullivan may have felt, even in 1886, that indeed here was a "man" that was presented in the Field Wholesale Store. But no matter how radical the metamorphosis it effected in his conception of the Auditorium, the latter remains uniquely Sullivan's creation. If the Auditorium, too, is a "man," surely it is one of a different family. It lacks Richardsonian understatement; and with its multiple textures, elaborate mouldings, and tower, it is also a highly picturesque structure. The same may be said of the interior. Its richness verges on the palatial and the opulent, and it may remind one in spirit of the "bourgeois palace" of the Paris Opera. But the

fragile character of these fanciful encrustations is mitigated by the thick and ponderous arches and columns. The interior of the Auditorium in fact presents us with one of the clearest examples of a never resolved conflict in Sullivan's work: the battle between structure and decoration.

Wright said that Sullivan had taught him "his practice '*of-the-thing-not-on-it*,' which I . . . saw most clearly realized in his singular sense of ornament."[18] Still, it is difficult to say how the decoration of the Auditorium interior is "*of-the-thing*." It is almost never in high relief and is usually organized into ribbons of foliated patterns, very much like repeated *rinceaux*. These ribbons, whether they tend more toward geometric abstractions or toward botanical representations, usually have the quality of applied decoration. One does not sense them as following inevitably from the architecture itself. Furthermore, there is inside, as outside, a certain overwrought heterogeneity in the ornament. The two colonnades of the bar (Plate 14), for example, are composed of columns utterly unrelated in shape, height, and decoration; and the lateral grillwork between the boxes and the proscenium of the opera house (Plate 15), which displays one of Sullivan's favorite Islamic motifs (the arch inscribed in a rectangle),[19] is unrelated to and is somewhat oppressed by the great concentric, elliptical arches of the vaulting. The structure and the ornament sometimes seem uncongenial, and Sullivan's first grand effort as a decorator seems fitful and thought out only in its parts, clearly exhibiting what one would term *Victorian additiveness*.

Thus far my comments on the Auditorium have been restricted to its "design." But the questions of engineering and decoration, interesting as they are,[20] concern one less than the matter of the building's cultural significance: its place in the setback skyscraper city. Of course, the Auditorium itself is neither a setback structure nor a skyscraper in the conventional sense; but Sullivan did not exclude such a building from his ideal city, as the illustration in "The High-Building Question" attests.

Chicago was a city that blossomed almost overnight after the Civil War. It rapidly overtook and passed St. Louis and Memphis in population and wealth as the railroads and stockyards made it the nexus of midwestern commerce, distribution, and finance. The pace of its growth was achieved, as one might expect, through rampant speculation and the exploitation of immigrant laborers. Everyone came to Chicago—capitalists and workers—because they sought salvation in quick money. Thus the populace was characterized by extremes: ambitious nouveaux riches, whose machinations and social climbing are examined in novels like Henry B. Fuller's *Cliffdwellers* (1893); and downtrodden blue-collar families from eastern Europe, ripe for the gospel of socialism, whose lives are explored in Upton Sinclair's *The Jungle* (1906). Chicago was a city with-

out a tradition other than commerce; it lacked a solid middle ground between the extremes of wealth and poverty; and it was without a civilizing, tempering ability to sublimate its ambition. It was without "culture."

Recognizing Chicago's deficiencies, some of its citizens were anxious to fill out the mercantile skeleton with cultural flesh and color. Ferdinand Peck, for instance, had sponsored an operatic festival at the Chicago Exposition of 1885 and had been so inspired by its success that he was able to convince the Mercantile Club that such productions needed a permanent home in Chicago.[21] Adler and Sullivan had done the temporary structure of 1885, and it was to them that Peck looked for a suitable building the following year. The Auditorium gave the firm a chance to provide Chicago with an instrument by which it might realize its desire to be ranked with the cities of the East in cultural achievement. The citizens of Chicago were not just money-grubbers; they could also produce an institution capable of attracting great audiences and performers. The opening of the Auditorium seemed to demonstrate just that. It was attended by President Harrison and Vice-President Morton, and the performances included choral works composed expressly for the occasion. America's opera idol, Adelina Patti, sang "Home Sweet Home."[22]

In scale and decorative pretension, the Auditorium was a pure Chicago-style success. It was big. No building in town had greater height than the tower of the Auditorium, and none enclosed more volume. Moreover, it would pay its own way, because it was also a hotel and an office building. It stood for culture and profit at the same time, an almost impossible dream come true. The theater was emblazoned with the names of great composers—evidently of Sullivan's choosing; and a set of allegorical frescoes, annotated with Sullivan's poetry, proclaimed the role of the artist and his relation to nature. These, combined with Adler's ingenious solutions to the problems of acoustics, mobile stage properties, ventilation, and diminution in the size of the theater for chamber and solo recitals, seemed to prove Sullivan right: technology was, indeed, the handmaiden of democracy in the making of an architectural *Gesamtkunstwerk*.

A real shortcoming, however, is the Auditorium's failure to distinguish itself from Chicago's other office buildings. Nothing about it allows one to identify its mainly "cultural" character, at least from the outside. Its appearance in the rendering of the setback skyscraper city would not be such as to make one suspect its real function in the life of the city. It would stand, as indeed it does today, as one more specimen of a battery of tall commercial structures on Michigan Avenue that, though varying in details, clearly belong to the same family.

If one considers the clear differentiation among buildings in the Athenian agora of the fifth century and later, of those around the green of a

New England town in the eighteenth century, or of those around the court-house in the county seat of a midwestern town, it becomes clear that the Auditorium does not articulate its purpose as a theater as, say, the Athenian odeon did. To use Sullivan's own way of putting it, this is a case where the function *auditorium* did not generate the form *auditorium*. The form is *office building*. From the outside there is no way one can know that it means to proclaim the relevance of the arts to the city of Chicago. It is, at last, an undigested restatement of the Richardsonian model. It lacks an appropriate iconography or a convincing metaphoric reference to its purpose. In *Kindergarten Chats* Sullivan chides the architects of the Marshall Field Wholesale Store (not to be confused with Richardson's warehouse) for giving Chicago a copy of New York's Imperial Hotel, i.e., for having borrowed a form devised for a hotel for a department store.[23] But his own failure to distinguish the Auditorium from the Marshall Field Wholesale Store does not occur to him.

In one sense at least, in the Auditorium Sullivan faced a problem much more difficult than those Adler solved. Adler's problems were, after all, mechanical; and their solutions were purely physical. On the other hand, Sullivan, who heretofore had done almost nothing but design faces for mercantile buildings, was placed in the position of saying something in his architecture about the significance of the arts. He says nothing about them at all on the outside of the Auditorium, and his statements inside are ambiguous. Called upon to create a fit setting for events that were, after all, steeped in tradition—opera, orchestral concerts, recitals, drama (all of them sponsored and made possible in days past by the "feudal" aristocracy)—Sullivan's response was to produce a radically *un*traditional panoply of decorations, columns, and arches. Beautiful as the polychromy, botanical and geometric borders, and railings are in detail, and imposing as the theater is in overall effect, the building cannot take an appropriate place among the richly conceived but also integrated and complete works to which the Auditorium played host—Beethoven symphonies, Shakespeare plays, and Wagner operas. Its eccentricities and sometimes forced originality are not sympathetic with the translations of human experience into universal terms that one experiences in the latter works.

Even the Sullivan inscriptions in the theater seem too personal and inarticulately "sublime" to be of much help in tying the program of the Auditorium together. Over the proscenium a passage in gilded letters reads, "The utterance of life is a song—the symphony of nature." It is taken from Sullivan's own prose poem, "Inspiration," which was read before a group of his colleagues in 1886 and which comprised the first section of the cycle *Nature and the Poet* mentioned earlier.[24] The seasonal murals on the north and south walls of the theater are also captioned: "O

soft melodious springtime, first-born of life and love"; and "A great life has passed into the tomb and there awaits the requiem of winter's snows." These lines no doubt possess something of poetry, and one can imagine them urging upon Chicago businessmen and their wives a frame of mind somewhat removed from the workaday world of State and Dearborn streets and of stockyards and brokerage houses. But they finally strike one as inspired non sequiturs in the context of a building that may be an engineering marvel but that has the appearance of an ordinary office structure. The murals and their mottoes are in effect quaint reminders of that natural order of things over which the capitalists of Chicago had ridden roughshod in their drive toward economic bigness. Sullivan's poetic sense and his devotion to nature have been touted as indications of his having been an inspired and prophetic man. But the effect that the Auditorium's supposed paeans to nature may have had in the life of Chicago's capitalists eludes easy detection. Nature and the world of business remain unreconciled here.

For Irving K. Pond, who wrote a review of the *Autobiography of an Idea* shortly after Sullivan's death, the failures of the Auditorium were symptomatic of the architect's inherent sadness and pessimism. In addition to criticizing the arcuated system of the Auditorium, "in which the dominating arch is made mere ornament and its structural character is denied," Pond sees in Sullivan's ordering of his epigrams ("soft, melodious Springtime" is followed by "the requiem of Winter's snows" in the *Autobiography*, p. 303) a revelation of Sullivan's character:

> Not . . . the resurgence of a life protected by the soft mantle of Winter, but a budding and blossoming of flowers to cover the grave dug by Winter. Louis Sullivan's self accepted Orientalism speaks in these lines as in his design—a semblance of joy . . . covering and concealing his innate pessimism and sadness. Louis Sullivan's intense egotism . . . has long seemed to me to have been worn as a garment to cloak that pessimism, that deep sadness, which he did not care to expose.[25]

Perhaps the additive, unsynthesized quality of the Auditorium decoration was a sign of confusion on Sullivan's part. Like his poetry of the same period, which is redundant and sappy in its effusiveness, the ornament is simply too much of a good thing. Sullivan apparently possessed no clear idea of what was necessary and sufficient in either poetry or ornament, as may be seen in these lines from the opening section of the "Spring Song," composed while he was designing the Auditorium:

> When birds are caroling, and breezes swiftly fly, when large abundant nature greets the eye, clothed in fresh filigree of tender green, when all is animation and endeavor, when days are lengthening, and storm clouds smil-

ing weep, when fresh from every nook springs forth new life,—then does the heart awake in springtime gladness, breezy and melodious as the air, to join the swelling anthem of rejuvenated life, to mate with birds and flowers and breezes, spontaneous and jubilant as the glow of dawn to pulsate ardently with hope, rich in desire so tremulously keen,—when wondrous joy simply to live,—and question not, to walk into the ample air, to open wide the portals of the winter-bounded soul and eagerly to hail the new-born world with voice like mountain torrent quick-melted from the heart's accumulated snows,—even so eagerly and so voluminously does the song gush forth and wildly leap, tumultuous as nature's self,—to fall in gentle spray upon the misty valley far below, and there, to live,—bound up within the very life it sung.[26]

Pond's claim that such effusions are actually compensations for a deep-seated pessimism is supported by Wright, who says that the triumph of the Auditorium seemed to "sober" its architect more than excite him.

It might be argued that Sullivan's understanding of the role of the arts in society kept him from giving a shape to the Auditorium that might proclaim the richness of its aesthetic and didactic purposes. The Paris Opera of Charles Garnier (Plate 16), constructed 1861–74, offers an instructive contrast. Because the French had important operatic composers in the nineteenth century (Berlioz, Bizet, Gounod), and because their musical academies were producing great singers and instrumentalists, it seems appropriate that the resplendent Neo-Baroque palace of the Opera should take its prominent place in the overall image of Paris, namely at the end of a broad avenue that connects it with the Louvre. Sullivan would undoubtedly have berated the Opera for what he would have seen as lavishness and prodigality inspired by monarchical absolutism. But, in fact, it was not built as a private entertainment for Napoleon III and his empress. Rather, it was meant as an apotheosis of French national culture, and in this regard it was very much a public palace. It employs the classical language in a particularly lush way, to be sure; but that language is used grammatically and consistently, as befits a public edifice. The Auditorium, with its bizarre and solecistic effects, is a different creature entirely.

It is true that the cultural ambience in Chicago was different from that in Paris during the Second Empire. But Chicago's industrial barons did not entirely lack a desire for cultural activity or for an appropriately sumptuous setting for it; wherefore it seems peculiar that Sullivan should have covered the exterior of his theater with garb that is much akin to that of ordinary business buildings. No doubt Daniel Burnham's plan for Chicago (1909) would have provided an auspicious shape and place for an opera house, as Hausmann's had for Paris; but this was just the sort of planning Sullivan would have rejected for its "feudal" character. Anything

that seemed unmodern to him, whether useful or not, was suspect; and it appears that Ferdinand Peck, for whom Adler had engineered excellent acoustics, was given by Sullivan a building whose physiognomy was far less satisfying than that of Garnier's Opera or of any number of public buildings in the United States at the same moment (Charles McKim's Boston Public Library comes to mind as a prominent example). It is ironic that Sullivan's original project for the Auditorium was probably truer to the spirit of the commission than was the executed version.

Two interesting questions arise out of the glaring contrast between the internal richness and the external plainness of the Auditorium: How did the contrast come about? and What does it imply about Sullivan as an architect? Writing three years after the dedication of the Auditorium, Adler chided the board of directors for having required an inappropriately severe facade for their building:

> It is to be regretted that the severe simplicity of treatment rendered necessary by the financial policy of the earlier days of the enterprise, the deep impression made by Richardson's Marshall Field Building upon the Directors of the Auditorium Association, and a reaction from a course of indulgence in the creation of highly decorative effects on the part of its architects, should have happened to coincide as to time and object, and thereby deprive the exterior of the building of those graces of plastic surface decoration which are so characteristic of its internal treatment.[27]

Here Adler suggests that the decision was partially a measure of economy; but such an interpretation is unlikely, because the corporation had already consented to the expense of the interior decoration and also because the original specifications and requirements of the project had been expanded more than once as the board members became more ambitious in their goals. The directors were not really operating under any severe financial limitations. Adler says it was they who required the firm of Adler and Sullivan to alter the original designs, but there is reason for doubt.

If construction of the Auditorium was hampered by the financial policies of the board in its earlier days, as Adler said, it seems likely that Sullivan would not have proposed the more highly decorated exterior that we see in his first project. Such a design would have been out of keeping with the limits placed on the commission. It would have been more likely for Sullivan to have proposed the severe Richardsonian facade at the beginning, since he knew what the Marshall Field Wholesale Store looked like even as he set to work on the Auditorium. But Sullivan himself never mentioned the directors or any pressure they had brought to bear on him or Adler to alter the facade design (indeed, it would have been like him to complain of such interference), so it was probably Sullivan himself who convinced the board that the Field building format should be adopted.

Given the fact that a remarkable shift from external richness to plainness took place at the same time the project for the Auditorium was being expanded internally, I would argue that it occurred to Sullivan after the preparation of the first designs that they were stylistically backward by comparison with the clean contours of the Richardson Wholesale store. Recognizing that he and Adler were working on the most important building in the city, Sullivan must have conceived the Auditorium as a kind of architectural manifesto: it was the first building in which he tried consciously to be "modern," and it was designed at exactly the same time when he published his first writings on architecture. It would have been inexcusable for the Auditorium to have appeared archaic or historicizing next to Richardson's building.

Evidently Sullivan was able to convince the members of the board that the plain facade was the preferable one, and it is tempting to conclude that the probable disagreement between Adler and him on this matter contributed to their eventual estrangement. The finished product shows the intensity of Sullivan's desire to appear modern. His decision to pattern the Auditorium after the Field building reveals that his need to keep abreast of new stylistic developments in commercial architecture, regardless of their applicability to the building of an opera house, took precedence over other considerations.

Sullivan's use of lines from his own nature poetry to decorate the opera theater must be seen as a reflection of his own approval of the Auditorium as a concept. On the one hand, he defends the building as a monument that is in harmony with the forces he is celebrating. On the other hand, the quotations lend a particularly ironic and bitter flavor to his subsequent evaluations of his adopted city. Chapter 8 of the *Autobiography*, entitled "The Garden City," begins with a long and rhapsodic description of the physical setting of Chicago. The lake, the prairie, the rivers and woods are described lovingly; and one assumes that Sullivan intends for Chicago to bask in the glow of these descriptions and to gain legitimacy through the beauty of the natural tableau. Even the ambitions of its citizens are sanctioned by nature. After the fire of 1871, "Another story now began—the story of a proud people and their power to create— a people whose motto was 'I will'—whose dream was commercial empire. They undertook to do what they will and what they dreamed."[28] After recording the post-fire aspect of the city as it appeared to him as a young man, Sullivan in 1922 ascribed to his earlier self the thoughts: "*This* is the Place for me! This remnant scene of ruin is a prophecy!"[29]

The notion that Chicago was superior to New York City for the same reason that democracy is superior to feudalism runs throughout Sullivan's writings. Its people are more honest somehow, and they are also closer to

nature. The aboriginal beauties of Manhattan receive no such poetic treatment as is accorded to those of Chicago. Still Sullivan, after the beginning of his own professional decline, became more sensitive to the failings of Chicago. After berating the architecture of New York (its various types "swell and sway and swirl into a huge monotone of desolation, of heartlessness, and of an incredibly arid banality that roars above a muffled murmur of incompetence and strangulation"[30]), he turned his wrath upon the very town that had taken him in:

> Chicago is indeed a *sui generis*. Seventy years ago it was a mudhole—today it is a human swamp.
> It is the *City of Indifference*. Nobody cares. Its nominal shibboleth, "I will"—its actuality, "I won't"; with the subscription: "Not how good but how cheap!" Impoverishment of heart and mind are here conjoined. They seem to glory in conjunction.[31]

Sullivan was clearly not insensitive to the tawdry and inhumane aspects of Chicago. His, Wright's, and others' residence and work there have tended to lend it the aura of an architectural Jerusalem, but it would be a mistake to think that Sullivan's appraisal was unqualified.

The real problem concerns Sullivan's attitude toward his own buildings in Chicago in light of the twentieth-century jeremiads he himself penned in criticizing the selfishness of its citizens. (Here again one encounters his questionable treatment of a social body—in this case the city—as if it were an autonomous organism. It is the *city* that says "I won't," not any *individuals* whom Sullivan cares to mention. The occasions are refreshing when he goes beyond his personifications of the aggregate to name names.) If Chicago is a nay-sayer in crucial ways as Sullivan says, then what of his own role in the nay-saying? He admits to none, but one wonders if his own worsening career did not provide opportunity for deeper reflection on the matter of city life than was possible in his heyday. He must have begun to wonder what it was he could have done to prevent Chicago from becoming a "human swamp." My appraisal of the Auditorium and its place in the setback skyscraper city of 1891 suggests that Sullivan's own conception of the city was a strangely incomplete one.

The Wainwright Building

While the Auditorium would not be out of place in the rendering of the setback skyscraper city, it is in the Wainwright Building in St. Louis (see Plate 17) that one first glimpses, albeit on a modest scale, the sort of building with which Sullivan intended to shape his city. It was designed in 1890 and was the first skyscraper erected by the firm of Adler and Sullivan.

Taking as evidence its recent rescue from demolition, thanks to the efforts extended by an international coterie of preservationists, it is not an overstatement to say that the Wainwright is among the most famous of all modern buildings. Sullivan himself claimed that the "steel-frame form of construction . . . was first given authentic recognition and expression in the exterior of the Wainwright Building."[32] Wright, who had been startled by what seemed the revelatory nature of Sullivan's conception, said that it was a "splendid performance." "Although the frontal divisions were still artificial, they were at least, and at last, effective." Wright contended that in the Wainright, Sullivan turned away from the "simpering superimposition of several or many low buildings to arrive at height."[33] Morrison echoes both Sullivan and Wright in his own appraisal: "The Wainwright Building was the first successful solution of the architectural problem of the high building."[34]

But Morrison uses the expression *architectural problem* in a special sense. Several skyscrapers had been erected prior to the Wainwright Building, and since they all seem to have been reasonably useful structures, it would not seem inappropriate to say that they had also been successful. What Morrison, Sullivan, and Wright mean is that the external treatment of the Wainwright Building—the articulation of its wall surfaces—was somehow more fitting than had been the case in the earlier skyscrapers. It is this aspect of the Wainwright and no other (since it is quite ordinary inside and in no important ways innovative) that is the basis of the claim that it deserves a superior position in the history of modern architecture. When one compares it to William Le Baron Jenney's Home Insurance Building of 1884 (the first true skyscraper), with its purposely "lithic" handling of the wall, the contrast is easily seen (Plate 18).

But here one encounters the problem of forming a judgment relative to the superiority of one building over another on what seem at first to be purely aesthetic grounds. The aesthetics of the Wainwright, however, is for these men and for countless others since a matter of virtually ethical or moral significance. In the Wainwright, Sullivan seems to have avoided the more obvious lithic allusions of earlier skyscrapers and to have sought in the facades a reflection of the internal steel frame. This has led critics to the contention that it is a more "honest" building than its predecessors and therefore ought to stand as a didactic model. Buildings that use internal steel construction but cloak that construction in traditionally trabeated or arcuated forms are "dishonest" and ought to be relegated to less distinguished positions in the history of architecture. By such standards Stanford White's New York Life Insurance Building in Kansas City (1888) (Plate 19) is dishonest, whereas Mies van der Rohe's Federal Courts Building in Chicago (Plate 20) is honest. Readers with a knowledge of nine-

teenth-century critical prejudices will immediately recognize the influence of the polemics of John Ruskin, Viollet-le-Duc, and William Morris in this apology for the Wainwright Building. It succeeds where earlier skyscrapers fail because it possesses "truth to structure" and "truth to materials," "truths" that were vital to mid-Victorian theorists and have their social corollaries in the code of upright behavior glorified by the family of the "bourgeois monarchy" itself.[35]

Beyond this, however, discussion of the Wainwright Building rarely proceeds. For example, though Morrison extolls its virtues and its influences for more than ten pages, he fails to mention anything about the circumstances of the commission or about the client, Ellis Wainwright, for whom Sullivan actually designed at least three buildings. Unconcerned with matters of patronage, politics, or institutional significance, Morrison restricts his criticism expressly to the area of design, i.e., to what the building looks like. Although he claims for the Wainwright the distinction of expressing in an eloquent manner "the physical and spiritual facts of its existence,"[36] the precise nature of the "spiritual" facts is not disclosed, and one is left in doubt as to how they *can* be expressed through the medium of commercial building. Despite its moral overtones, Morrison's argument is essentially concerned with aesthetics, and he leaves one puzzling over the question of how a mercantile structure, the least sacred and most mundane of all architectural creations, can be accorded spiritual attributes.

The corner into which some critics paint themselves is a particularly tight one. On the one hand, they say that the Wainwright is more honest in its external treatment than other skyscrapers both before and after it and that it celebrates one of the most obvious qualities of the tall building, namely, its tallness. But the Wainwright is not particularly tall, even by the standards of its own day. Furthermore, as its enthusiasts invariably confess, the Wainwright fails on several counts to fulfill a "functional" definition: it has two pilasters for every internal steel column; the second story is treated differently in elevation from those above it, even though its plan is no different from theirs; the floor just beneath the cornice—site of the toilets, ventilation equipment, and elevator motors—is actually the floor that receives the richest decoration on the outside.

The effort to obviate these seeming paradoxes, which place the Wainwright squarely into a category of building from which its apologists try to rescue it, usually takes the form of a compensatory argument on behalf of the Wainwright's "wholeness" or the success of its overall design. Morrison says, for example, that

> The answers to these questions are inherent in Sullivan's whole conception of architectural design as the symbolic expression of an emotion aroused by practical conditions. Such a theory rests on no purely mechanical basis.

The judgment of the success of a work of architecture, according to Sullivan, should be made subjectively and synthetically rather than objectively and analytically. The interpretation of the specific features of a design need not depend on the intimacy of their correlation with specific constructive or functional facts, but on the intimacy of their correlation with the expressional quality of the whole.[37]

But we are left with no precise notion of what sort of emotion might be aroused by practical conditions or what sort of symbol might express the emotion; and from the criteria devised by Morrison to exalt the Wainwright—the celebration of its height, volume, and internal structure—it is not clear how it might be considered superior to White's New York Life Building, which also has a tripartite elevation, is also red, tall, and not particularly intimate in correlating interior and exterior "facts."

Morrison seems to be saying that while the Wainwright is not a mechanistically determined building in every way, still it is quite handsome. This is an aesthetic verdict that, as far as I know, has not seriously been questioned. What is debatable is whether *any* commercial building possesses the order of significance that is usually attributed to civic, domestic, or religious architecture. An exposition of the problem of what can and ought to be symbolized in an office skyscraper may help to reestablish the Wainwright in its larger social context.

It would be naïve to underestimate the role of capitalist economics in American life. From its beginnings in seventeenth-century New England to the present, this economic system has been responsible for establishing patterns of human endeavor perhaps more than any other single force. The shape taken by large American cities after the Civil War, for example, would have been unthinkable were it not for the way in which financial practices were coupled with modern technological methods for tapping natural resources. Laissez-faire economics, which reached maturity in the twenty or so years after 1865 and which was the subject of extensive literary and philosophical speculation at the end of the century, is tied inextricably to buildings like the Wainwright and to the rise of Chicago architectural firms such as Adler and Sullivan's. The aesthetic triumphs of their buildings would have been impossible were it not for the immensely shrewd and wealthy men who, as someone once pointed out, were proud of the fact that they had "never read a book."

Ellis Wainwright was rather typical of the American breed of capitalists who thrived after the Civil War. His uncle, after whom he was named, had migrated from Pittsburgh to St. Louis in the late 1830s, and his father Samuel joined him there later. Upon the death of the elder Ellis in 1849, the *Missouri Republican* noted that he had been a city councilman and volunteer fireman as well as a successful business executive. His Fulton

Brewery in St. Louis had brought him substantial returns, and he "always governed by a strict sense of justice and right. Gentlemanly and courteous in his bearing to everyone—active and industrious in the pursuit of his business. His prosperity may be justly referred to as an instance of the values of their qualities."[38] Here is a statement at mid-century of the old Protestant notion that economic prosperity is evidence of God's approval of one's conduct in life. The younger Ellis, who inherited the family fortunes, continued the brewing ways of his uncle and father; but he seems to have been governed somewhat less "by a strict sense of justice" than were his forebears.

Sullivan met Wainwright in St. Louis late in the 1880s, when various professional meetings brought him to that prosperous river town. Connelly describes Wainwright as a "'progressive' young brewer . . . an amiable, good-looking citizen whose eye combined humor and calculation." He "not only collected paintings of the Barbizon school . . . but he perceived the worth of architecture. Temperamentally he was the ideal client for Sullivan; both loved art."[39] A flattering portrait of the Wainwright position in St. Louis society was painted in a notice of the sudden and premature death of Charlotte Wainwright, Ellis's young wife, in 1891:

> As her husband is very rich, he enhanced her loveliness by exquisite French costumes and jewels of every description. She was rather tall, with a queenly carriage and somewhat haughty manners. A small nose, straight and perfectly chiseled; complexion a delicate pink and white; deeply fringed hazel eyes shining beneath finely marked eyebrows, and hair almost matching the color of her eyes—she was strikingly handsome. She and her husband formed part of a gay coterie of young married people, who were seen at all the most modish entertainments. Last spring Mr. and Mrs. Wainwright took possession of their new and elegant house on Delmar Avenue in one of the most fashionable parts of the city. The house is built in the early English style of architecture, of rough-hewn brown stone granite. Here the couple entertained friends in a regal style, amid rich surroundings, the home being adorned with fine paintings and rare and costly decorations.[40]

Such a description has much in common with scenes portraying the style of life of various nouveau riche characters in the novels of Norris and Sinclair.

The untimely death of Charlotte Wainwright seems, however, to have initiated a long succession of reversals for the young capitalist. His fortunes suffered during and after the market collapse of 1893, as did everyone's; and by 1902 his efforts to provide for the style of living he had enjoyed earlier had become so dubious as to implicate him in one of his city's most famous boodle cases. As a director of the Suburban Railway Company, he was indicted for bribing city legislators to ratify a plan by

which the company would come into possession of valuable franchises.[41] Wainwright was not convicted, for he fled St. Louis and placed himself in a nine-year exile in Paris, where he evidently pursued further misadventures. The St. Louis *Republican* of February 5, 1909, reported: "Wainwright on Paris Boulevard Whips Marquis. Former St. Louisan Thrashes a Spaniard Who Owed Him $2,800." The marquis, who was named Amodio and was supposedly married to a Wainwright relation, was punished by Wainwright after having called him "an American Barbarian." Wainwright returned to St. Louis in 1911, safe from prosecution, since the witness and important documents had scattered. But he was also contrite. A newspaper reported his words: "I have no intention of engaging actively in any business enterprise."[42] Ironically Wainwright died in the same year as Sullivan (1924), but his passing was not marked by the flattering eulogies that had accompanied his uncle's.

The inclusion of this sketch of Wainwright is meant to show how ordinary a capitalist he was: shrewd, ambitious, socially ostentatious, with propensities toward the unethical. Connelly's account of Wainwright stops with the "'progressive' young brewer" and collector of Barbizon paintings. Morrison does not mention him, as if his connection with the building that bears his name is of no importance, perhaps the best policy if one fears that a modern icon will tarnish if touched by the reputation of its patron. The question raised by this state of affairs admits of no easy answer, but I pose it anyway: To what extent should an evaluation of the Wainwright Building be influenced by an understanding of the forces that brought it into existence?

If we take Sullivan's own social philosophy at face value, the Wainwright must be considered a failure, because it embodied antisocial impulses. It was built by a man who, not only was dishonest but whose fortunes had been made from the sale of the very narcotic Sullivan berated in *Democracy* and elsewhere. What do the form and decoration of the Wainwright have to do with the inevitable filth and turmoil that issue from concentrated urban industry? Are the classical form and botanical details non sequiturs in the industrial context as they had been in the Auditorium? Or should one treat the Wainwright as the proposal of some ideal—an optimistic statement of transcendent "values" amid the grim urban vista?

The Wainwright Building is, and was at the time of its erection, a building of no particular distinction in plan (Plate 21). While it appears to be solid and cubelike from the street, its plan is actually U-shaped because of the large light court at the center; it is like a quadrangle that is missing one side. The light court was intended to provide the interior with natural illumination; although, since it faces north, these rooms actually require supplementary light from artificial sources. In elevation the light court is

extremely plain, exhibiting none of the rich decoration featured on the street facades and somewhat resembling the factory exteriors by Adler and Sullivan from the 1880s. A more successful handling of this problem may be seen in another St. Louis structure by Sullivan—the Union Trust Building of 1893 (Plate 22), in which the light court not only faces south but, because of the building's position on the city block, also faces the street. The U-shape opens to public view in this case; and the facade, since it is made up of five surfaces instead of one, is therefore more complex and "sculptural" than is the Wainwright's.[43] (It might be mentioned in passing that, although the problem of light and air was of some interest to Adler and Sullivan—both of them having written articles in trade journals on the subject[44]—they were hardly alone in this. Neither were they the first. White's New York Life Building (Plate 19) illustrates this fact, as do even earlier buildings by George B. Post—his Post Building in New York (1880–81), for example.[45])

The acclaim given the Wainwright, therefore, stems from the treatment of the two major facades on Chestnut and Seventh streets. In certain ways these walls are quite traditional and even classical. There are three major divisions: a solid, quite "lithic" but austere base in the first two stories that is terminated by a modestly projecting cornice; a seven-story "shaft" of similar stories depressed behind the plane of the base, in which the windows are formed by a reticulated grid of spandrels and piers, whose attenuated forms are decorated at their bases and capitals; and an ornately decorated frieze with a heavy, projecting cornice. Thus the Wainwright Building adheres to the centuries-old practice of articulating an entire facade so that it corresponds to the base-shaft-capital syntax of an individual column.

It is the "honesty" with which Sullivan attempted to adjust this formula to a steel-skeletoned structure that has impressed historians of modern architecture, especially when they contemplate the vast number of buildings, particularly after the First World War, that seem to reflect the influence of the Wainwright in this regard. Thus it is seen as heading a long line of buildings that do not mask the structure with thick, bearing-wall exteriors, which indeed make a religion of not doing so. Actually, contrary to what critics like Hugh Duncan propose,[46] the Wainwright does not eschew the lithic allusion. While one experiences the glass "skin" of Mies van der Rohe's Federal Courts Building as something quite fragile and membranous, the Wainwright strikes one as deliberately thick, sturdy, and wall-like. The corner piers reinforce this impression. Furthermore, while recent skyscrapers have tended not to differentiate their individual floors, but instead to make a virtue of undifferentiated repetition, Sullivan has carefully introduced variation within his scheme. It is one of the most

interesting aspects of his design: the spandrels are richly decorated with geometric and botanical motifs that are different for each floor (Plate 23). One is tempted to say that the similarities in geometric plainness between the Wainwright and later structures are superficial and that the subtle but rich vocabulary of mouldings, ornaments, and depressed and projecting planes helps to create a building that is far richer in design than those more recent ones that claim to be its descendents.

Without doubt the Wainwright facades are organized with great formal skill. The problems of decoration—how much should there be, where should it be placed, and how might it be integrated into the building as a whole?—are solved with a sureness not evident in the Auditorium. But to acknowledge the satisfying aesthetic result merely admits to Sullivan's artistic maturity. What one wants to know is, what does it *mean?* Behind the facades and in between the celebrated structural members are offices for businessmen of every sort—investment agents, attorneys, opticians, and the like. How does the building come to terms with the professions that are pursued and the lives that are led within? Admitting, along with Hugh Morrison (and Philip Johnson, who said that "Sullivan's interest was not in structure but in design"[47]) that the Wainwright is not a "functionalist" building in any pure sense, one might try to find reasons other than an "expression of structure" for celebrating those facades or for preferring them to those of Stanford White's buildings.

Sullivan argued in "The Tall Office Building Artistically Considered" that American architecture ought to reflect the spiritual destiny of this country, and I think that it is not unfair to judge the Wainwright Building by the standards of the high claim Sullivan himself made for it. On the one hand, it cannot be interpreted as a paean to the investor-owner whose name it bears. He was not an admirable man and, in any event, one would hesitate to base an apologia for such a building on the appreciation of an economic order that both makes possible the erection of such a structure and at the same time throws so many antisocial temptations in the way of its practitioners. On the other hand, it is hardly Sullivan's fault that Ellis Wainwright failed to achieve an ideal of civic virtue that Sullivan may have intended to signify in the design of his building. Perhaps the Wainwright Building is therefore the symbol of an imperfect economic system more than anything. It cannot stand as the icon of an idealistic or transcentental institution.

But it is just in this connection that the difficulty of appraising the significance of the Wainwright Building lies, because Sullivan himself was convinced that the modern skyscraper was capable of embodying and expressing the emotional and philosophical sense of America's millennial destiny. He thought that buildings such as the Wainwright should elicit

mythic associations as profound as those stirred in the Athenians by the Parthenon (a peculiar sentiment, since one would be more likely to see a kinship between the commercial skyscraper and the stoas of the Athenian agora). But if one accepts Sullivan's argument, one is led to what is probably the most optimistic interpretation of the Wainwright Building.

If one considers the old classical notion that a column is like a man (Vitruvius was fond of this idea) in that its base, shaft, and capital are the architectural analogues of the human feet, body, and head, it requires no great leap of interpretive power to see "men acting together" as being symbolized in groups of columns or colonnades. The Greeks must have been aware of the analogy, for they seem to have paid particular attention to the problem of raising the "right number" of columns in their temples, i.e., that number which simultaneously suggests cooperative effort *and* the importance of the individual column. The individual and the cooperative group are mutually dependent. It is in cultures where the individual does not count for much that this balance between the one and the group is not sought, as evidenced in many buildings of the later Roman Empire in which the columns are either so numerous as to lose their individual significance or, as l'Orange points out, disappear altogether to be replaced by a severe architecture of plain walls (the basilica at Trier).[48] It is tempting to see parallels in the architecture spawned by social conditions under other absolutist and/or imperial regimes: Versailles, the new St. Peter's, and perhaps even the buildings of America's blatantly imperial epoch after the Civil War, for example, A. B. Mullett's State, Navy, and War Departments Building in Washington (1871) (Plate 24).

The Wainwright Building occupies an interesting position in the history of this idea that relates columns and people. It is a structure in which a balance of interest between the individual components and the composition of the whole is sought, and an analysis of the Chestnut and Seventh Street facades should recognize the effective way in which Sullivan has articulated this balance. The pilasters, rising to support a common entablature, bind the compositional elements into an intelligible whole. But interspersed among them are the spandrels with their decorations that are different story by story. These seem to proclaim the rightness of what it is that makes for differences among individuals. The Wainwright facade synthesizes these differing but related elements to a degree rarely achieved by Sullivan in his other buildings. The undisciplined talent that decorated the Auditorium is brought under control and seems to say something at last: it takes cognizance of the cooperation among individuals within a community which, ideally, takes place *behind* the facades.

Though Sullivan nowhere states the matter succinctly, it is possible that he, like other social philosophers, felt that one of the principal bases

of community is to be found in men's willingness to share with one an-
other the fruits of their different kinds of labor. Given his pragmatic point
of view, Sullivan would have considered the economic foundation of
American society to have been the primary one, wherefore his celebration
of it in the mercantile skyscraper would have been quite appropriate. The
difficulty arises when one notices that the Wainwright Building attempts
to communicate its ideas in extremely general ways.

It is difficult to say what the spandrel decorations mean, for example.
They are composed of undoubtedly lovely forms: intricate geometric and
botanical abstractions. But if one were to compare them to the more artic-
ulate sculptural *programs* of other buildings (the Parthenon, for example),
one would see that they stop short of expounding specific events and their
mythic significance. Even if we admit that the Wainwright decorations
may intend to say something about the process of biological evolution
itself (and perhaps they do in some tenuous way), we are left with a series
of forms whose relation to capitalist economics in St. Louis is not clear.
Perhaps the forms that seem reminiscent of primordial fauna and flora
were meant as arguments against the ostensible primacy of a kind of
mechanistic interpretation of the social and economic orders. If that is the
case, Sullivan may well have been holding forth for the efficacy of organic
vitalism and growth in American business. Still, the goal of this poetic
vehicle is uncertain. The ambiguity may be seen at the merely formal level:
the flowing, intertwining passages are in a sense lorded over by the severe
gridwork of the facade; and the freedom and spontaneity that one sees in
various details seem contradicted by the inorganic rectangles that border
and contain (and even restrain) them. Here one could almost infer a meta-
phor for the crassly mechanical subduing of nature in modern times. The
Wainwright facades are attractive as pieces of abstract sculpture; but if
they say something about a particular view of the world, they do not say
it directly.

I said before that the Fraternity Temple project was dependent in sev-
eral ways on the Wainwright Building. But I also said that the former
seemed to initiate a change in kind more than in degree: it was to be four
times as high as any previous effort by the firm. Still, certain features that
are fully developed in the Fraternity Temple may be seen inchoate in the
Wainwright; and it is these, in addition to the other considerations men-
tioned above, that make it difficult to interpret the latter as Sullivan's final
statement on the tall building. He must have considered it something of a
modest preparation for the more definitive Odd Fellows plan. Indeed, his
main concern seems to have been with the development of his own aes-
thetic rather than with the institutional occasions with which great archi-
tecture is usually associated. Sullivan's interests were perhaps only pseudo-

ethical, and in the end it is uncertain that he cared very much about whom the Wainwright was built for or who was going to work in it or how the workers might feel about it. The modifications of the Wainwright formula that Sullivan effected in his later skyscrapers constitute evidence which supports this conclusion.

Toward Homogeneity: The Later Skyscrapers

Sullivan designed two more tall buildings after the Fraternity Temple that are of special interest. The first, which also happens to be his last joint effort with Adler, is the Buffalo Guaranty Building of 1895 (Plate 3), which is considered by many to be the firm's best skycraper. The other, the Schlesinger-Mayer Store in Chicago (Plate 25), was designed in 1899 by Sullivan alone and was his last tall building. Both works depart significantly from the Wainwright in certain ways and incorporate instead those features of the Fraternity Temple that tend toward unrelieved repetitiousness. The Buffalo Guaranty Building is particularly interesting for two reasons: first, although its superficial resemblance to the Wainwright is obvious, it exhibits modifications of the earlier plan that give it quite a different character and, I believe, meaning; second, it is the Sullivan design that is most frequently cited as an example of the principles he developed in his contemporaneous article, "The Tall Office Building Artistically Considered," which was discussed in the previous chapter.

Despite its resemblance to the Wainwright Building, the Buffalo Guaranty is more elegant, attenuated, and "fragile." The recesses are not as deep, and neither are the vertical forms (including the corner piers) as wide, as those of the Wainwright; and since it has six more stories than the St. Louis building, it is clear that it is more the "proud and soaring thing" than the cubical Wainwright. The cornice is thinner, and instead of meeting the walls abruptly at right angles, it emerges as a graceful, continuous, curviplanar swelling of the walls themselves. The overall effect is one of stretching and attenuation: the wall is membranous and not lithic. This tendency to "abstract" and "dematerialize" the St. Louis format has prompted architectural historians to treat the Guaranty as a building of greater historical significance: it seems much closer in spirit to recent modern buildings than does the Wainwright.

But while the Guaranty may anticipate certain features of twentieth-century architecture more clearly than the earlier building, it also tends to lose sight of the problem of the building as institutional metaphor. Here the balance of interest between the individuals and the group to which they belong is precarious, and the sheer number of compositional elements makes it difficult to attend to them individually. That the Buffalo Guaranty

relies less than the Wainwright does on a physiognomy derived from the classical tradition is made even more obvious by the decision to do away with a differentiation of spandrel decorations between floors. Here they are all the same, and although George Grant Elmslie seems to have been responsible for much of the surface ornament,[49] it must have been Sullivan's own choice to ignore the solution to this problem as it appeared in the Wainwright Building. In the Buffalo Guaranty Building an utter homogeneity typifies the facades, and it is this quality that tempts one to see another anticipatory aspect of the building: whereas the Wainwright recognizes heterogeneity and diversity as ideals useful to economic and "democratic" bodies, the Guaranty seems to embrace sameness; it is the architecture of the "organization man." One is left wondering if Sullivan really grasped the implication of his own design in St. Louis.

The Schlesinger-Mayer Store finally does away with the columnar formulation altogether; its repeated "Chicago windows" merely float in their walls, unlinked and unsynthesized by vertical members. It has been remarked that this decision not to emphasize vertical articulation was "truer" to the structural premise: that the steel skeleton of the tall building is a cagelike affair wherein neither the upright nor horizontal components dominate. The result is a homogeneity even more glaring than that found in the Buffalo Guaranty Building. It is true that the lower two stories receive elaborate decoration and that they are thus set apart from those above. But it would be difficult to find a better example of Sullivan's uncertain struggle to achieve a sense *"of-the-thing-not-on-it."* The ornament here is really skin-deep, and the decision to terminate it abruptly at the third story seems arbitrary.

It is here, too, that Donald Egbert's claim[50] of Sullivan's "organismic" (as opposed to "mechanistic") approach to functionalism is contradicted. The decision to decorate the street-level floors with flamboyant, eye-catching swirls (Plate 26) and to leave the other stories plain seems now to be the result of the most straightforward and calculated cause-and-effect determinism (the sort that Morrison denies in Sullivan's oeuvre). Wright had said that Sullivan really meant by *form follows function* that form and function should be the same thing; that the "seams" shouldn't show. But in the Schlesinger-Mayer Store they manifestly do show. The marriage of mass and decoration is suddenly ruptured and so, it seems, is the chance for a statement about the ideal cohesiveness and interdependence of people in a democratic condition. The windows are so many isolated elements spaced without true rhythm or complexity along a vast, flat surface. If one searches for the beginnings of the dehumanized, trackless expanse of modern corporate giantism in architecture, the Schlesinger-Mayer Store might be a good place to begin.

The relation between the Wainwright Building and the later skyscrapers admits of no easy statement. While the Odd Fellows Temple and the Buffalo Guaranty Building clearly derive some features from the St. Louis building, they are really structures that throw into doubt my earlier claim that the Wainwright takes cognizance of the basic concern of democratic society: the discovery of the proper adjustment between individual and societal rights. Since Sullivan's understanding of democracy was almost completely apolitical, it could not come to terms with the most crucial and difficult questions, i.e., those that had been the subject of public debate throughout the history of the country. His conception of democracy was such that it could not be of much help in designing his skyscrapers.

The tendency toward multiplication of redundant forms in ever larger individual buildings leads one to suspect that the Wainwright was a fluke of stylistic refinement and that Sullivan himself failed to see the implications of his own design insofar as metaphor was concerned. The design of 1890 appears more crucial as the skyscrapers both before and after it are considered. Its fine adjustment of mass and decoration seems to materialize, alas, only once, with the replication, flattening, and abstraction of columnar forms quickly superseding it in later buildings. Stylistically speaking, Sullivan developed from the obvious anthropomorphism of the Auditorium Building (its model, Richardson's Field Wholesale Store, had been called "a manly man" by Sullivan) to the pristine, hygienic whiteness of the Schlesinger-Mayer Store, a building the young Le Corbusier might have been proud to have designed.

Sullivan, the Tall Building, and Nature

One of the more ironic implications of Sullivan's organic approach to design is that man has come to replace nature as the chief determinant of the process of evolution. While Sullivan did not say this in so many words, it is apparent from his own writings (and from those of his favorite authors[51]) that, at the pinnacle of the evolutionary pyramid, man himself had taken over the job of shaping the world. With the advent of democracy, history is no longer "natural" or automatic, but is the result of modern man's totally conscious effort. Viewed from this standpoint, Sullivan's latent antinaturalistic prejudices become apparent.

While frequently relating good practices in architecture to organic archetypes, Sullivan's numerous references to an overcoming and a defeating of nature seem to contradict his supposedly naturalistic sympathies. His youthful adulation of "men who make things," described in the early sections of the *Autobiography of an Idea*, never left him; and when he identified the seminal works of engineering from the middle of the nine-

teenth century that inspired his belief that men could do truly great things, he did so in a spirit that seems to applaud man's final triumphs over a nature that had denied him for so long. Two huge and dramatic bridges— the Eades at St. Louis and one built by the Cincinnati Southern Railroad over the Kentucky River chasm—had sparked Sullivan's imagination:

> Here was Romance, here again was man, the great adventurer, daring to think, daring to have faith, daring to do. Here again was to be set forth to view man in his power to create beneficently. . . . The chief engineers became his heroes; they loomed above other men. The positive quality of their minds agreed with the aggressive quality of his own.[52]

Indeed, this exaltation of human faculties knows no bounds in Sullivan's mind:

> The result of inquiry we call knowledge; its high objective we call science. The objective of science is more knowledge, more power; more inquiry, more power.
>
> Now, if to the power to do we added the power to inquire, Man, the worker, grows visibly more compact in power, more potent to change situations and to make new situations for himself. The situation may be a deep gorge in the wilderness; the new situation shows a bridge spanning the chasm in one great leap. Thus it is that man himself, as it were, leaps the chasm.[53]

Nothing is said here about the desirability of living in harmony with nature; in fact, those efforts which do not afford obvious references to human *triumph* over natural obstacles strike Sullivan as inappropriate and paltry. Witness his reaction to the bridge that used to span the Hudson at Albany:

> It [the Hudson] seemed to lack what Louis had come to believe the character of a river. The bridge crossing it, with its numberless short spans and lack of bigness, beauty and romance he gazed upon in instant disdain. It appeared to creep, cringing and apologetic, across the wide waters which felt the humiliations of its presence. . . . And Louis mused about the bridge; why was it so mean, so ugly, so servile, so low-lived? Why could not a bridge perform its task with pride? . . . And even more keenly he felt, as his eyesight cleared, that this venomous bridge was a betrayal of all that was best in himself, a denial of all that was best in mankind."[54]

That proud achievement of man, the railroad winding through the Berkshires from Boston, had been insulted by the puny bridge at Albany. Furthermore, Sullivan did not hestitate to criticize Nature herself for not having provided a river commensurate with his own expectations of a sublime waterway!

Thus Sullivan places himself in the curious position of saying, on the one hand, that buildings should be like plants or animals and that one

should follow an organic method in designing them; but, on the other hand, that these creations of man ought to be used to obviate the very processes that inspired them in the first place. It is one of the supreme contradictions of Sullivan's life that he never recognized this schism between his aesthetic appreciation of nature (its seasons, moods, and aspects that are commended to the pupil in *Kindergarten Chats;* his raising of rose bushes in Mississippi) and his call for its subjugation through technology. Such ambivalence inevitably throws into doubt every adulatory thing he has to say about nature. When applied to the tall office building, the organic metapor is really used to proclaim man's entrance as the *rival* of the natural order.

The setback skyscraper city offers an instructive example. While Sullivan sings of the prairie and of the site of Chicago by a great lake, the city itself ignores that natural situation and effectively removes men from the realm of nature altogether. The titanic office buildings in no way take cognizance of the original landscape; in fact, they contest with it. The horizontal grid of streets and the vertical one of skyscrapers throw up inorganic challenges to nature and ask us to believe that men can finally live outside the natural order, that one can simply redefine the entire sense of what it means to be alive in the world.

These contradictory attitudes reveal themselves quite prominently in the events of Sullivan's private life. The architect was out of sorts for a time in 1889–90 and left business affairs to Adler while he traveled first in the West and then in the deep South, where he purchased some land and built a house at Ocean Springs, Mississippi. His cultivation of several varieties of roses there and his "close communion with nature"[55] are often seen as evidences of his Thoreau-like character and are treated as justifications for the belief that his "organic" theories of architecture must rest on firsthand experience. The house at Ocean Springs was, in fact, for Sullivan a refuge from the hectic life of Chicago that so often seemed to drain him of energy. It was a place where there was "'no enterprise,' no 'progress,' no booming for a 'Greater Ocean Springs,' no factories, no anxious faces, no glare of the dollar hunter, no land agents, no hustlers, no drummers, no white-staked lonely subdivisions."[56]

Surely it is no failure of character to wish to escape the restlessness of urban life, but it must not be forgotten that even Louis Sullivan, who helped to create a new "world order of architecture,"[57] found that order tiresome and insufficient. In effect Sullivan helped to establish an urban pattern from which he often found it necessary to flee. One cannot help wondering if the immense pride Sullivan felt as leader of the Chicago architectural boom must not always have been at odds with his strong inner drive to find salvation at a private level through transcendent experience

in nature. His buildings themselves often bespeak this paradox: their inert, stolid masses and bureaucratic compartmentalization would hardly seem to be the creations of a man steeped in the rhythm and ritual of nature.

Whatever internal conflicts Sullivan may have endured in this matter, his contributions of an architectural nature should be judged pragmatically—i.e., they should be seen in their primary role: as the manifestations of big money. Hugh Duncan, author of what can only be termed a syco-phantic monograph on Sullivan (it is dedicated "To all Chicagoans who struggle to keep alive the soul of a city guarded by the spirit of Louis Henri Sullivan"), believes the architect to have offered a truly noble alternative to the ordinary commercial buildings that had been going up around the country. He opines that Sullivan's alternative somehow elevated Chicago's obsession with money above the crassness it showed in the "feudal" structures put up by George H. Pullman and his ilk. The drift of Duncan's argument may be apprehended in his discussion of "The Glamorization of Money in Art." While claiming that "the mystery of money, which was so well exploited by Chicago businessmen, was also completely debunked in Chicago,"[58] he concedes that the architects of the Chicago School finally had to face the proposition that the glorification of money was what their buildings were about:

> Radical Westerners in architecture as in literature did not deny the tran-scendence of money. The architects Root, Sullivan, and Wright sought to dignify capitalistic earnings and spending. The office building, the factory, even the "grocer's warehouse" should be beautiful. This was not the beauty of austerity, but of wealth. The "simple" Monadnock building of Root, the great Auditorium of Adler and Sullivan, like the simple homes of Wright, were very costly. In place of crenelated towers they offer us clean, soaring planes in space filled with interlocking cubes of glass and steel. But these "simple" cubes, where, as Mies van der Rohe tells us, "less becomes more," are very expensive. And thus even art proper, like religion, becomes subordi-nate to money as a symbol of life. We spend our way to beauty as we do to God. . . . Behind the ignoble capitalist consumer stands the noble technolog-ical worker and engineer. These were Veblen's heroes, and, as we shall see, the heroes of the Chicago school of architecture.[59]

Viewed from this position, Sullivan's organic methods seem completely irrelevant. No matter what the source of the aesthetic appeal of his build-ings, they are creations that serve institutionalized cupidity.

Duncan's absorption of the Sullivan legend is complete, however, and his own economic interpretation of the buildings is ultimately obscured by the nature-democracy myth. He makes much of Sullivan's love of nature and pictures him high above the city, in his office in the Auditorium tower, from which he could "see the city, the lake, and the prairies"[60] like some

deity contemplating the rightness of his creations. Henry B. Fuller, on the other hand, suggests how unlikely such an ideal overview was even in the Chicago of 1893. The inhabitants of the Clifton, a fictional eighteen-story skyscraper, are daily treated to the following vista, as described in *The Cliffdwellers*. It is a vista quite in contrast to the one Sullivan wants us to believe he knows:

> The explorer who has climbed to the shoulder of one of these great captains and has found one of the thinnest folds in the veil may readily make out the nature of the surrounding country. The rugged and erratic plateau of the Bad Lands lies before him in all its hideousness and impracticability. It is a wild tract full of sudden falls, unexpected rises, precipitous dislocations. The high and the low are met together. The big and the little alternate in a rapid and illogical succession. Its perilous trails are followed successfully by but few—by a lineman perhaps, who is balanced on a cornice, by a roofer astride some dizzy gable, by a youth here and there whose early apprehension of the main chance and the multiplication table has stood him in good stead. This country is a treeless country—if we overlook the "forest of chimneys" comprised in a bird's-eye view of any great city, and if we are unable to detect any botanical analogies in the lofty articulated iron funnels whose ramifying cables reach out wherever they can, to fasten wherever they may. It is a shrubless country—if we give no heed to the gnarled carpentry of the awkward frameworks which carry the telegraph, and which are set askew on such dizzy corners as the course of the wires may compel. It is an arid country—if we overlook the numberless tanks that squat on the high angles of alley walls, or if we fail to see the little pools of tar and gravel that ooze and shimmer in the summer sun on the roofs of old-fashioned buildings of the humbler sort. It is an airless country—if by air we mean the mere combination of oxygen and nitrogen which is commonly indicated by that name. For here the medium of sight, sound, light, and life becomes largely carbonaceous, and the remoter peaks of this mighty yet unprepossessing landscape loom up grandly, but vaguely, through swarthing mists of coal smoke.[61]

The question is whether Sullivan's buildings, in spite of the romantic rhetoric that purports to justify them, and no matter what they look like, can possibly make any difference in the scene painted by Fuller. The situation seems out of control from the beginning.

Today it is easy to identify the failings of this sort of building,[62] but it would be a mistake to think the prospects for it were any better in the 1890s. Fuller's description of Chicago makes that painfully clear; and even Sullivan himself realized, at least at the end of his life, that the tall office building "presents . . . aspects of social menace and danger."[63] What he might be faulted for is a certain naïveté about what men will do and will not do under conditions of unprecedented economic growth. Many will pursue that prosperity vigorously and will tend not to discipline the means

by which they do so, even though deleterious effects may easily be antici-pated. Sullivan's post-1900 writings are filled with invective against selfish and irresponsible men—the likes of Ellis Wainwright. But he never enter-tained the notion that the skyscraper itself might place an irresistible temp-tation in the way of such men. It is not the potentially beneficent creations of technology that are at fault, Sullivan contended, but men's use of them.

What Sullivan failed to recognize was that technology never really offers neutral or untainted inventions to a society that then has the choice of using or abusing them. The efforts of technology are themselves the products of that very same society and are brought into being in anything but an "antiseptic" or "value-free" way. Economic desire was the mother of invention here; and whereas Sullivan posited a dichotomy between a morally blameless scientific and technological community and a morally vulnerable societal one, little evidence supports such a dichotomy. Sullivan would no doubt have been perplexed by later twentieth-century develop-ments in this connection. It is precisely the "centers of industry based on high technology" that have witnessed a "remarkable growth in the mem-bership of fundamentalist churches" (in Texas and southern California, for example);[64] and it would seem that more and more people have found the fruits of a scientific method to be inadequate in helping them to dis-cover the sense of their lives.

John Draper's telling of the intellectual development of Europe must have created for Sullivan a spotless hero in science.[65] It is clear in the pages of *Kindergarten Chats, Democracy,* and the *Autobiography of an Idea* that Sullivan stood in awe of the technological achievements of his day. They indicate to him nothing less than the imminence of true democracy, pos-sibly because science had fought and won a difficult battle with the forces of feudalism. This may explain Sullivan's "sublime" reaction to the sky-scraper. He responded to it as a piece of heroic sculpture, "Dionysian in beauty,"[66] an indisputable sign of the triumph of progressive evolution. The connection with economic institutions was lost, and thus Sullivan's feelings about the tall buildings are largely personal and subjective. He responded mainly to the aesthetic thrill.

Norris Smith, in the final chapter of his book on Frank Lloyd Wright, tries to show the degree to which Wright recognized the significance of the polarity between urban life, with its patterns of activity, mutual depen-dence, and community, and the life of the "natural" man, who like St. Francis believed that ultimate goodness resides outside the highly ordered structures of the city. Wright's own life seems, in fact, to have been a struggle to find a proper balance between being "free" and being a respon-sible member of the group.

Sullivan, on the other hand, despite his erection of buildings for com-

mercial intercourse, seems to have viewed things mainly as a private, un-
attached, "free" man. He was without political commitment; he contrib-
uted in no practical way to the workings of the regulatory offices of the
community; he belonged to no religious community, even though he built
for some; his short marriage was an unhappy one, and it had no issue; he
wrote and lectured only under circumstances that would allow his own
highly personal views to be expressed; and he was happiest when secluded
in his rose garden a thousand miles from the bustle of Chicago, of which
town it cannot truly be said he was a citizen.

Thus, Louis Sullivan was a private and largely idiosyncratic man who
viewed the city from outside the city, as it were. He was a "natural" man
who nonetheless undertook to shape the city as if it were part of nature.
The dichotomy that he should have recognized seems to have eluded him.
Instead he concentrated on one that was largely illusory (that between
science and man's use of science). The question of whether tall office build-
ings should be built at all evidently never occurred to him.

In his sad later years, Sullivan often railed against the feudal struc-
tures then being raised in American cities—those buildings, commercial
and otherwise, that employed various motifs from historical sources. In so
doing, he applied to these efforts the vocabulary of physical pathology that
he had learned in the pages of Max Nordau's *Degeneration,* as if these
modern buildings were signs of mental and spiritual deterioration in the
American people. Sullivan seems not to have seen that the city is a place
inextricably bound up with man's historical being. Much more than the
natural man, the city man participates in the life of a community whose
vitality depends upon his understanding of patterns, arrangements, and
laws determined throughout the course of a historical development to
which he owes his very consciousness of the world. But Sullivan thought
it inappropriate that cities, the creations of history, should contain refer-
ences to that history; and now his disciples, like Hugh Duncan, claim to
see the vindication of this ahistorical vision of the city in the repetitious
curtain-wall buildings by the epigones of Mies van der Rohe.

Sullivan was destined for disappointment, given his particular view
of the city. As long as it remained the timeless, ahistoric vision of a natural,
noncommunal man, it could never be realized. Some intimation of this
may be glimpsed in Henry Hope Reed's criticism of Sullivan's ornament.[67]
He notes that it was too personal ever to be widely incorporated into the
decorative vocabulary of urban architecture. Reed, because of his own
prejudices, criticizes Sullivan's ornament because it was not derived from
classical sources, which may be too parochial a reason for rejecting it. But
the ultimate basis of the criticism is just, for it recognizes the ornament's
inability to communicate anything about the character of life in the city.

Sullivan's ornament and his particular way of articulating the inert mass of the skyscraper were not widely imitated, mainly because they were irrelevant to the nature of the city—they existed outside the realm for which they were created. While it would be difficult not to be attracted by the abstract beauty of these buildings in some of their parts, just as it would seem perverse to deny the beauty of the "Chi-Rho" page of the "Book of Kells" (the work of Sullivan's fellow-Celt, a medieval monk) (Plate 27), it is also true that these decorative passages are as effective and pertinent on the page as they are on the buildings (Plate 28). They lose none of their attractiveness when viewed out of context. The same could not possibly be said of the sculptural *program* of the Parthenon, whose various parts are integral to the entire meaning of the building. Sullivan's skyscrapers do not present statements of an equally profound cultural significance: they remain the creations of a private, self-absorbed genius-draftsman.

In berating the cities of his day for their commercial and architectural feudalism, Sullivan denied his own true self: the man who preferred the private life afforded by the natural order, to which he kept returning at Ocean Springs. His frustrations and their expression through all the unwieldy, disconsolate prose were the result of his failure to know himself. Indeed, there is reason to believe that Sullivan, no matter how much his writings bear the tone of Nietzsche, neglected one of the passages in *Thus Spoke Zarathustra* that should have struck closest to home. In "On Passing By," the Persian sage meets the "fool whom the people called 'Zarathustra's ape'; for he had gathered something of his phrasing and cadences and also liked to borrow from the treasures of his wisdom." The fool then catalogs for Zarathustra the features that make the city so despicable:

> "O Zarathustra, here is the great city; here you could find nothing and lose everything. Why do you want to wade through this mire? Have pity on your foot! Rather spit on the city gate and turn back. Here is hell for a hermit's thoughts: here great thoughts are boiled alive and cooked until they are small. Here all great feelings decay: only the smallest rattle-boned feelings may rattle here. Don't you smell the slaughterhouses and ovens of the spirit even now? Does not this town steam with the fumes of slaughtered spirit?
>
> "Don't you see the soul hanging like a limp, dirty rag? And they still make newspapers of these rags! . . .
>
> ". . . . Spit on the city of compressed souls and narrow chests, of popeyes and sticky fingers—on the city of the obtrusive, the impudent, the scribble-and-scream-throats, the overheated ambitious-conceited—where everything infirm, infamous, dusky, overmusty, pussy, and plotting putrefies together: spit on the great city and turn back!"

Here, however, Zarathustra interrupted the foaming fool and put his hand over the fool's mouth. "Stop at last!" cried Zarathustra; "your speech and your manner have long nauseated me. Why did you live near the swamps

so long, until you yourself have become a frog and a toad? Does not putrid, spumy swamp-blood flow through your own veins now that you have learned to croak and revile thus? Why have you not gone into the woods? Or to plow the soil? Does not the sea abound in green islands? I despise your despising; and if you warned me, why did you not warn yourself?

".... This doctrine, however, I give you, fool, as a parting present: where one can no longer love, there one should *pass by*."[68]

Sullivan could not, in fact, pass by; and in not doing so, he refused to recognize what one can see as his own strongly antiurban character: his inability to love the city.

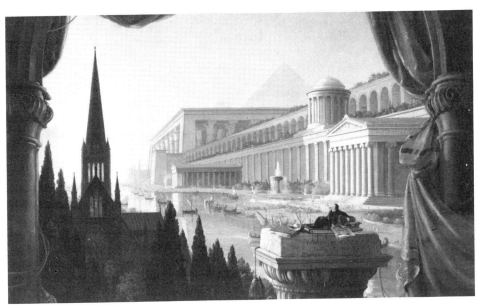

Plate 1. Thomas Cole, *The Architect's Dream*, 1840. Oil on canvas, 53 × 84⅙ in. Courtesy of Toledo Museum of Art, Toledo, Ohio. Gift of Florence Scott Libbey.

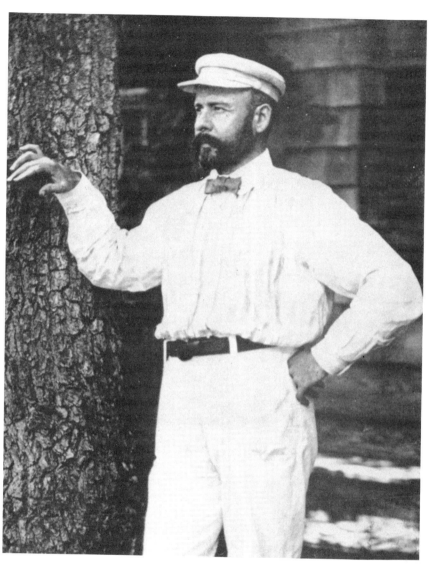

Plate 2. Louis Sullivan, photograph c. 1890. Source: John Szarkowski, *The Idea of Louis Sullivan* (Minneapolis, 1956).

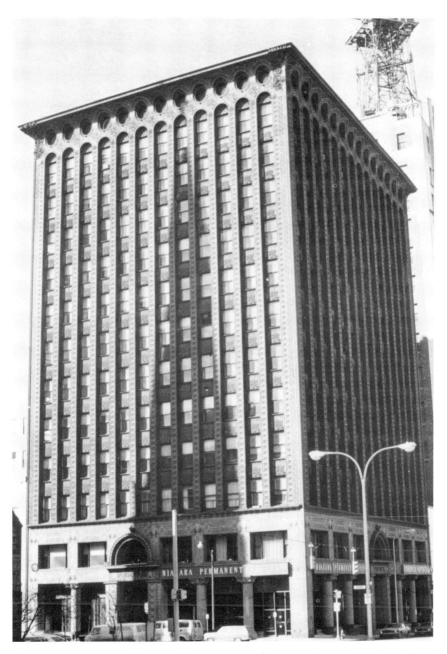

Plate 3. Guaranty Building, Buffalo, New York, 1895. Photograph by David S. Andrew.

Plate 4. Eliel Saarinen, Proposed Chicago Tribune Building,
Chicago, Illinois, 1922. Source: *Architectural Record*, February
1923.

Plate 5. Fraternity Temple, 1891. Source: *The Graphic*, 1891.

Plate 6. Fraternity Temple, plan. Source: *Engineering Magazine*, 1892.

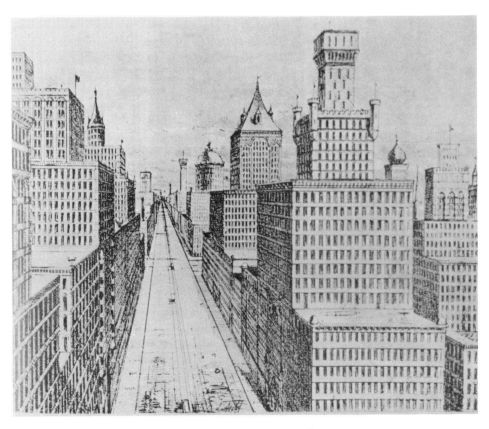

Plate 7. *Ideal City of Setback Skyscrapers*, 1891. *The Graphic*, 1891.

Plate 8. Le Corbusier, *Ideal City*. Source: Le Corbusier, *Oeuvre Completes* (1910–29).

Plate 9. Anonymous Italian Artist, *View of an Ideal City*, c. 1465 (Ducal Palace, Urbino). Source: Edizioni d'Arte Nova Lux, Florence.

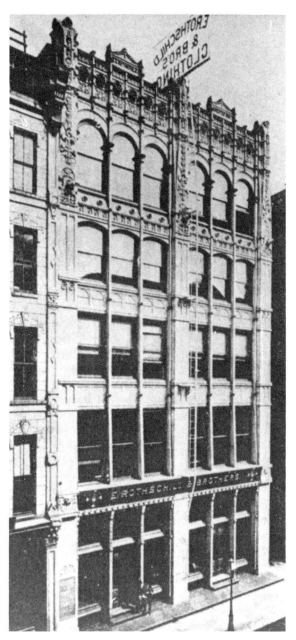

Plate 10. Rothschild Store, Chicago, Illinois, 1880.
Source: Hugh Morrison, *Louis Sullivan: Prophet of Modern Architecture* (New York, 1935).

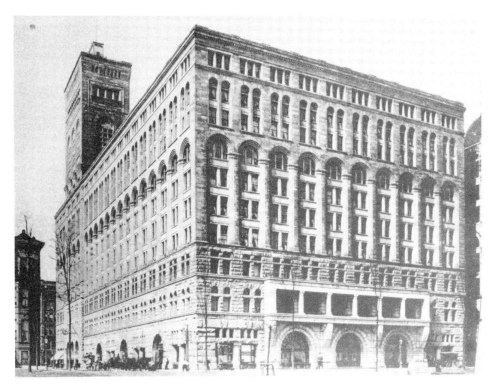

Plate 11. Auditorium Building, Chicago, Illinois, as erected, 1886–89. Source: Albert Bush-Brown, *Louis Sullivan* (New York, 1960).

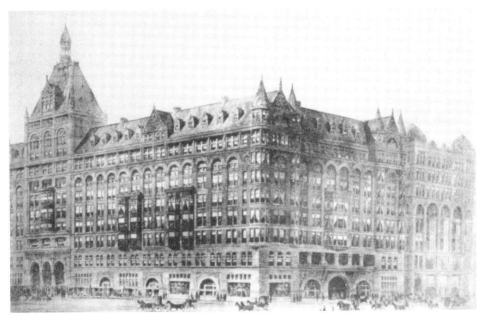

Plate 12. Auditorium Building, preliminary drawing, 1886. Source: Bush-Brown, *Louis Sullivan*.

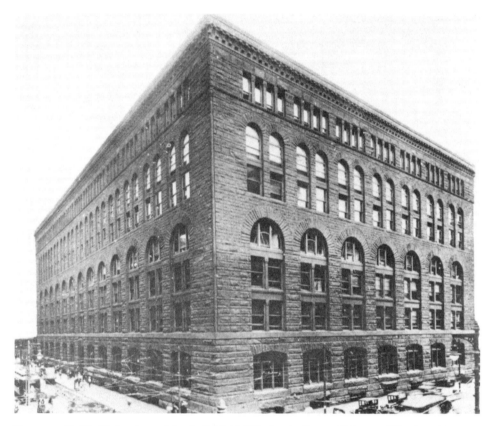

Plate 13. H. H. Richardson, Marshall Field Wholesale Store, Chicago, Illinois, 1885–86. Source: William H. Jordy, *American Buildings and Their Architects* (New York, 1972).

Plate 14. Auditorium Building, bar. Source: Bush-Brown, *Louis Sullivan*.

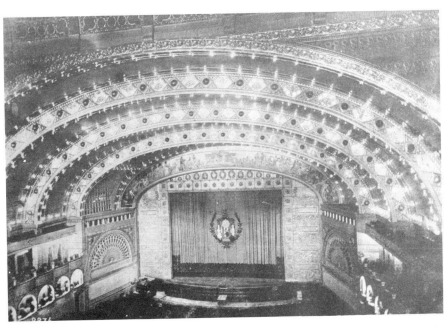

Plate 15. Auditorium Building, view of opera theater facing proscenium. Source: Bush-Brown, *Louis Sullivan*.

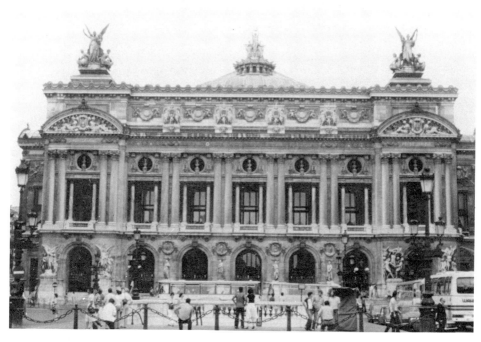

Plate 16. Charles Garnier, Paris Opera, 1862. Photograph by David S. Andrew.

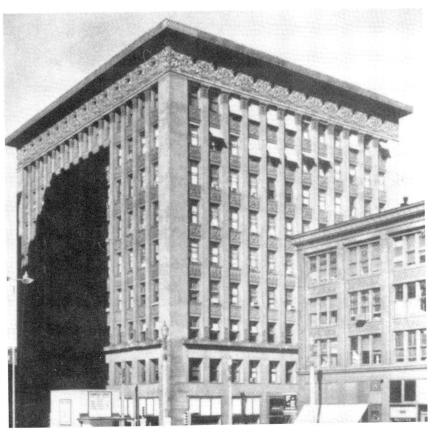

Plate 17. Wainwright Building, St. Louis, Missouri, 1890. Source: Szarkowski, *The Idea of Louis Sullivan.*

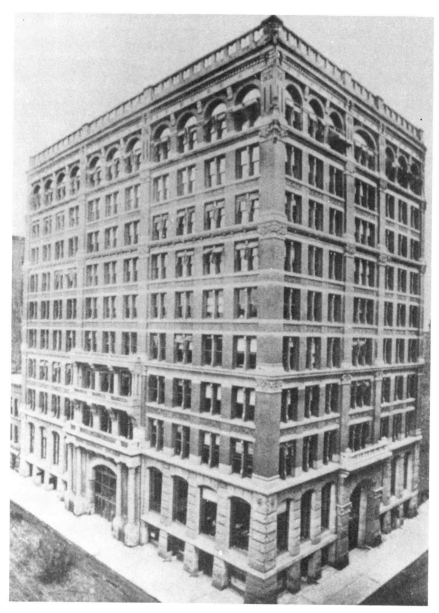

Plate 18. William Le Baron Jenney, Home Insurance Company Building, Chicago, Illinois, 1884. Source: Bush-Brown, *Louis Sullivan*.

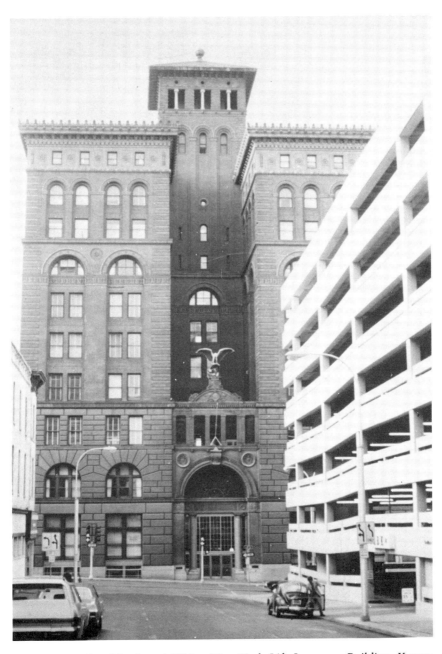

Plate 19. McKim, Mead, and White, New York Life Insurance Building, Kansas City, Missouri, 1888. Photograph by David S. Andrew.

Plate 20. Mies van der Rohe, Federal Center, Chicago, Illinois, 1967. Photograph by David S. Andrew.

SIXTH FLOOR PLAN

Plate 21. Wainwright Building, plan. Source: Morrison, *Louis Sullivan*.

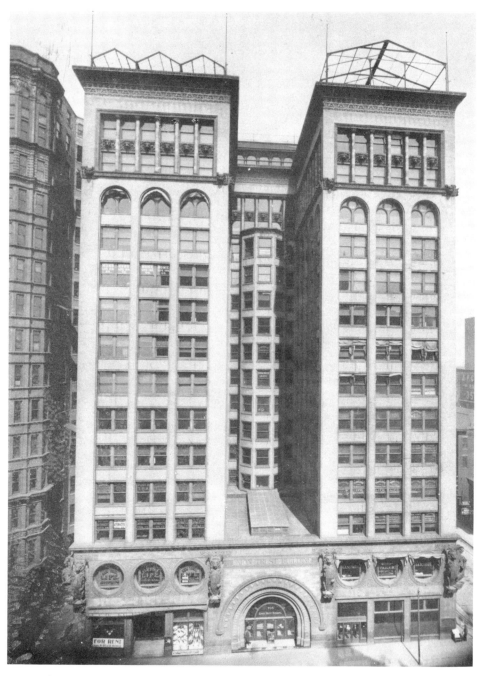

Plate 22. Union Trust Building, St. Louis, Missouri, 1892. Source: Missouri Historical Society, St. Louis, Missouri.

Plate 23. Wainwright Building, facade detail. Photograph by David S. Andrew.

Plate 24. Alfred B. Mullett, State, Navy, and War Departments Building, Washington, D.C., 1871. Photograph by David S. Andrew.

Plate 25. Schlesinger-Mayer Department Store, Chicago, Illinois, 1899. Photograph by David S. Andrew.

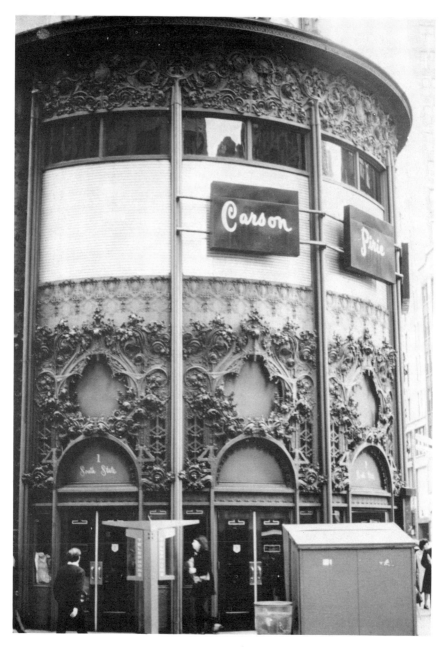

Plate 26. Schlesinger-Mayer Department Store, entrance detail. Photograph by David S. Andrew.

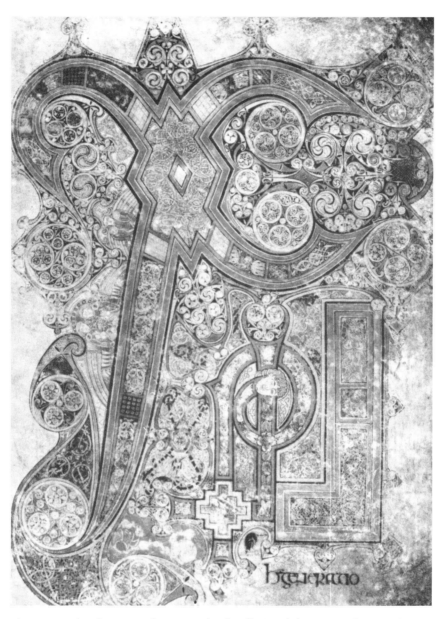

Plate 27. "Chi-Rho" page from "Book of Kells," eighth century. Source: George Zarnecki, *Art of the Medieval World* (Englewood Cliffs, N.J., 1975).

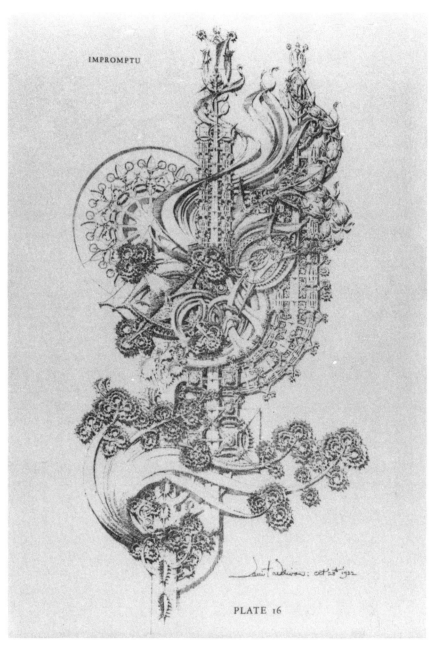

IMPROMPTU

PLATE 16

Plate 28. "Impromptu," ornamental drawing by Louis Sullivan, 1922. Source: Louis Sullivan, *A System of Architectural Ornament according with a Philosophy of Man's Powers* (New York, 1924).

6. Buildings Other Than Tall

I don't know now whether he knew God in the depths of his heart or not.[1]

Principle is all and single the reality my master Louis Sullivan ever loved.[2]

—Frank Lloyd Wright

In the *Autobiography of an Idea* Sullivan tells his story with a certain narrow emphasis that hardly does justice to the actual complexity of his career. He would have us believe that, from the cradle, his evolution as an intellectual force was destined, as its most important "function," to culminate in the creation of the skyscraper. In fact, Sullivan undertook on several occasions to design buildings quite unlike the Buffalo Guaranty Building both in purpose and in form; and in some respects it is unfortunate and unfair that his contribution, steeped as it is in a great romantic tradition, should be judged solely on the merit of structures whose uses were inevitably so mundane. Montgomery Schuyler was perfectly aware of this fact when he said that Sullivan could not be blamed for encrusting his office buildings with exotic ornament "in the absence of temples and palaces upon which he could discharge the fantasies of his teeming brain."[3]

Schuyler recognized that there was something fundamentally opposed to the very character of the skyscraper in Sullivan's highly subjective, irrational decorations, a state of affairs that, I have argued, suggests Sullivan's difficulty in "locating" himself relative to the city-country dichotomy. On the one hand, he evidently accepted the skyscraper as a necessary result of industrial capitalism, an institution whose ultimate validity he seems not to have doubted. On the other hand, his decorations for those

office buildings are much more the outpourings of a mind that was at home in the private rose gardens at Ocean Springs than in the tower of the Auditorium. Such a contradiction was present in his other commissions as well.

Had it been possible, Sullivan might have preferred to design office buildings exclusively. The fact that Frank Lloyd Wright was given most of Adler and Sullivan's commissions for residential architecture seems to support this assumption. But the depression that began in 1893 and the dissolution of the partnership kept Sullivan from continuing the career he had known before the crash of the stock market. As a result, Sullivan's work not only was smaller in scale after 1893, it was also different in kind: he designed houses, churches, and small-town banks that probably would not have interested him earlier. It is these smaller commissions that give clues valuable to an unravelling of the Sullivan story, clues that are not hinted at in the *Autobiography*.

The Houses

Stylistically, Sullivan's residential architecture passes through the same stages of metamorphosis that may be seen in his commercial work. The townhouses that were designed early in the partnership exhibit a plainness and regularity that are typical of late Victorian taste. Sometimes, as in the Halsted Residences (Chicago, 1884) (Plate 29), the medieval, round-arch vocabulary is enlivened by curious ornaments and rhythmical irregularities that are the remnants in Sullivan of the powerful personality of Frank Furness. The central, two-storied feature of the West Chicago Club (1886) (Plate 30), for example, seems a somewhat chaste paraphrase of the analogous form in Furness's Pennsylvania Academy in Philadelphia (1871–76) (Plate 31).

By the time Wright joined him, Sullivan was thoroughly absorbed by the Richardsonian way of doing things, so the three townhouses for Victor Falkenau (Chicago, 1890) (Plate 32) that Wright executed for the firm clearly indicate that the domestic commissions, like the commercial, had come to bear the unmistakable mark of the architect of the Field Wholesale Store. However, Sullivan's interest in residential architecture was slight during the years of the great commercial triumphs, so he really had little to contribute to two of the houses that are most often discussed in connection with his name—the Charnley Residence and the townhouse for Sullivan's brother Albert (both Chicago, 1892) (Plate 33). In fact, these two buildings are so unlike the earlier designs that it comes as no surprise to learn that they were actually the creations of Frank Lloyd Wright. The Charnley Residence in particular, with its severe geometry and formal symmetry, shows that Wright was not long content with the Richardson-

ian formula; and, as a result, Sullivan's conception of residential design was altered almost beyond recognition by his pupil.

Sullivan's relative lack of enthusiasm for designing houses may in part be due to the fact that he seems, prior to his contact with Wright, not to have possessed a sense of what is appropriate in residential architecture. The pilaster decorations of the Halsted Residences (Plate 29), for example, come from the vocabulary of mercantile motifs that he had applied to the facades of various stores and warehouses. The Bloomenfeld Residence (Chicago, 1883) (Plate 34) demonstrates this peculiarity even more clearly. The main part of the composition of this three-story townhouse—i.e., the two-story unit to the left of the entrance—is articulated in precisely the same way Sullivan handled his skyscrapers: with continuous piers and mullions that run past spandrels decorated with abstract ornament. This unit, which seems so incongruous in the composition as a whole, could not be less in harmony with the spirit of domestic building. It is like a miniature, impacted skyscraper; and any symbolic analysis of the facade would likely be confusing indeed.

Morrison says that the Bloomenfeld Residence "is clearly an adaptation of the scheme of the Rothschild Store to a smaller building, and its success makes one wonder why Sullivan never attempted it in another residence. The calculated asymmetry of the facade is worthy of note."[4] Morrison neither explains the criteria by which he judges the house to be successful nor says why the asymmetry is noteworthy. If he were charitable, he might contend that Sullivan was attempting to suggest here the complexity of modern city life or perhaps even the domination of that life by mercantile institutions. But the family hardly depends for its validity or its meaning on its relationship to commercial interests, so the commercial reference in a dwelling seems eccentric.

Sullivan's insensitivity to the real exigencies of domestic architecture may be seen when he is contrasted to his pupil. Norris Smith has shown that Wright's concern with the architecture of the home was the result of circumstances far more profound than his position as the residential architect in the firm of Adler and Sullivan.[5] Wright had been raised in a large, extended family, where communal ties (especially on the maternal side) were strong, owing to a fundamentally religious interpretation of the family itself. Wright's preoccupation with the family as the most important binding unit was also the result of a personal misfortune: the desertion of his mother, his siblings, and himself by his father, a Universalist minister. The conflicting forces at work in the family—the simultaneous urge toward order, regularity, responsibility, and security on the one hand and toward freedom, privacy, and subjectivity on the other—were thus witnessed by Wright as a child in the most dramatic way.

Wright's concern with the architecture of houses may thus be seen as

an effort in his professional life to provide the family with a harmonious setting for the cultivation of its relations both communal and individual. As Smith has shown, it is the communal aspects of family life that engaged his imagination in the early years—the binding of members of the group. But Wright's later decision to abandon his own wife and children, as his father had done, suggests that he had come to feel overwhelmed and limited by those binding aspects and to believe his private, free, "loosed" self had been neglected for too long. Whatever conflicts Wright experienced as a family man and as a private individual, his overriding professional concern with the home seems never to have diminished. By far, the largest portion of his commissions was for private residences; and while considerable thought must have been expended on his commercial work—the Larkin Building and the Johnson Wax complex—it is clear that his primary contribution was in upholding a "cause conservative in the best sense of the word":[6] the preservation and enhancement of family life.

Sullivan's life, however, offered no such exposure to the contrasting modes of binding and loosing. His own familial experience was mainly of an unordered, perhaps even disorderly, variety. He says very little that is complimentary about his Irish father, the sometime musician and dance instructor. The hints dropped in the *Autobiography of an Idea* indicate that Patrick Sullivan was mercurial and distant, at least from Louis's point of view. It is toward his mother that he felt warmth and from her that he received sympathy. Unlike Wright's large and localized Wisconsin family, Sullivan's was neither extended nor particularly close. Relatives lived at some distance from one another, and Sullivan himself was raised as much by his grandparents as by his own mother and father, who owing to the economic necessity of their musical partnership were unable to be fulltime parents. Huge sections of the *Autobiography* are devoted to Sullivan's reconstruction of his early life, but very little of it has to do with his relationships with his brother or his parents. He recorded instead his solitary, fantasy-laden wanderings over the terrain of his grandparents' farm outside Boston.

The course of Sullivan's private life in adulthood is therefore not surprising. He married late (at age 43), fathered no children, and separated from his cheerful but evidently unintelligent wife after seven years. Indeed, Sullivan's marital experiences seem remarkably consistent with the spirit of a curious aphorism that appears in the notebook he kept during the early years in Chicago: "That holy state in which they will have a legal right to hate each other as much as they please: Matrimony."[7] Sullivan did not form personal attachments with his employees or colleagues (Wright is the only real exception), and it may be fairly said that he had several acquaintances but hardly any enduring friendships. He was simply not a man whose character had been formed in relation to others.

Sullivan possessed a scant sense of the practical matters of human community; and though he professed an interest in the education of children, it seems his abiding concern with childhood was restricted to his own. The *Autobiography* communicates the obsessive nature of that concern and shows the extremes to which Sullivan could go in interpreting his life after an organic model. As Connelly points out, Sullivan's self-concern excluded the possibility of seeing himself in a social context of any sort:

> His Autobiography . . . turned out to be a semi-biography, for it broke off with the World's Fair. Up to that point it presented a certain record without which Sullivan, as a man and a character, though not as an architect, would have been almost lost to history, even as Shakespeare. The author mentioned neither his brother, his sister-in-law, nor his wife. He said not a word of any woman friends except the girl with whom he had once rambled in childhood, Minnie Whittlesey. Those whom he knew in maturity, like Charlotte Wainwright . . . he omitted altogether. Nor did he yield any information even about men, other than the architects he knew in his youth and his prime. He had associated in Chicago with a number of convivial characters outside his profession; of them he related nothing. In this sense his story was not a very "personal" life, not a rounded chronicle even to mid-career.[8]

Even the tone of the *Autobiography,* for all its inflated prose, is impersonal and detached, as if written by someone viewing his own life from a distance. Its third-person narration has a curious quality that suggests a man erecting a formal monument to himself in his own lifetime: the sort of honor usually accorded by others. Fearing, perhaps, that no such commemoration would be forthcoming from those others, Sullivan decided to fabricate it himself.

This is not to say that the *Autobiography,* as an index of Sullivan's capacity for affection, is totally lacking in feeling for others. But the feelings are usually frustrated or unrequited. One of the truly revealing and touching episodes is the Minnie Whittlesey affair mentioned by Connelly. Sullivan tells of his intimacies with Minnie while on a visit to some relatives in upstate New York[9] (after 128 pages of autobiography have finally brought us to his fourteenth year). Vulnerable to the coquetries of an eighteen-year-old temptress, as any adolescent would be, Sullivan found in her an "irresistible pervading charm" that was prompted, among other things, by her pale face and "nostrils trembling." But to the young Sullivan, all the ritual of courtship seemed to be without rationale. "It all seemed to lack order and singleness of purpose." Indeed, to a mind trained on rules "so broad as to admit of no exception," the purposeful purposelessness of trysting would not make sense. But at some intuitive level it must have made sense, for Sullivan says at the end of the chapter, with "his fairie queen" gone forever, that "it seems as though half a century had stood still." The half a century was the interval between the recording

of the memories and the events that prompted them; and it is in his long recounting of these bittersweet recollections that Sullivan finally reveals a capacity for expressing warmth, vulnerability, and tragic melancholy. Fifty years had not dulled the intensity of the memories, but neither had they seen him prepare himself to effect relations that would be other than melancholic. It is little wonder that domestic architecture did not hold his interest. The impersonality of the skyscraper was safer.

The four houses Sullivan designed after the removal of Wright from the firm are interesting in this regard. In appearance they bear the undisguised influence of his pupil. The two that were built—the Babson Residence in Riverside, Illinois (1907), and the Bradley House in Madison, Wisconsin (1909) (Plate 35)—not only are stripped of the Richardsonian references, but also spurn the commercial decorations that had typified the earlier domestic efforts. The houses are horizontal, have considerable overhangs, and possess the cantilevered projections and "Roman masonry" that are so prominent in the prairie house. The same may be said of the unexecuted residences for Ellis Wainwright and Mrs. N. F. McCormick, whose plans were published in 1902.[10]

But that these houses were an expression of Sullivan's own views on the nature of ideal family life, as their counterparts had been for Wright, is doubtful. For one thing, the designs are not entirely Sullivan's. As was the case in happier days, he relegated the development of important aspects of residential commissions to assistants, in this case to Elmslie, who, according to Morrison, was responsible for much of the work in both the Babson and the Bradley houses.[11] Even in the adverse conditions of his later career, Sullivan seems to have preferred passing on work to his underlings, even when there would have been more than enough time to work out every aspect of every commission by himself. All of the major written works, with the exception of the *Autobiography*, had been completed by this time (1909); and the single most important architectural commission after the turn of the century, the bank at Owatonna, was also finished. That Elmslie seems to have done most of the Bradley house suggests that Sullivan's energies were no longer focused on his architectural practice. These were grim times for him, a fact dramatized by the unfortunate necessity to sell most of his belongings at public auction.

The crises of his life had evidently overwhelmed Sullivan, for he was not able to conduct his professional duties efficiently. The Babson and Bradley commissions are indicative of this state of affairs: they are only partly his creatures, and they are basically stylistic mimicries—pastiches of Wrightian forms that are unpremised by the thematic concerns which generated the forms originally. Compositionally the houses are additive. Their features do not grow from and into one another as is the case in

Wright's houses, where the forms interlock and make continuous group-ings that suggest the family life led within. As is the case with the skyscrap-ers, the shapes tend to be independent, stolid, and inert; and while there are effective passages (the dramatically cantilevered sleeping porch and balcony of the Bradley Residence, for example) (Plate 36), they are often cancelled or nullified by incongruous features nearby (in this case the senseless projection of an unimaginative, blocky section of the ground story beneath the balcony). While Sullivan and Elmslie borrowed some-thing of the look of the prairie house from Wright, their borrowings did not necessarily enable them to capture its meanings.[12]

Religious Architecture

Before moving to a discussion of Sullivan's real successes in the design of smaller buildings—the tombs and later banks—I should say something about his religious commissions. These are baffling and contradictory works; and they imply, as do the skyscrapers, that Sullivan's grasp of the institutional basis of architecture was unsure.

Sullivan's connection with sacred architecture began early in his ca-reer. John Edelmann, his youthful mentor, had given him the job of deco-rating the interiors of both the Sinai Temple and the "Moody Tabernacle" while the two were in the office of William LeBaron Jenney. The highly abstracted botanic forms of the latter building seem to have enraged the congregation, since they betrayed no hint of traditional religious subject or style; although, as Connelly reports, Sullivan's nineteen-year-old ego must have received a considerable boost from the favorable reviews of his work in the Chicago press.[13] It is clear from the long descriptions of these no longer extant frescoes that Sullivan's flair for fanciful polychromy was already well developed in 1876.

What is more noteworthy, however, is its reception by the brothers and sisters of the Tabernacle's evangelical congregation. They were dis-turbed by its unreligiousness, its ignorance of an appropriately sacred ico-nography. It lacked symbols and personifications that might link the mem-bers to any tradition of religious practice. Where they required emblems of Christian devotion, Sullivan gave them schematic renderings of the new religion of Darwinian evolution. The Reverend Mr. Moody himself seems to have been untroubled by the conflict: art was evidently irrelevant in his scheme of things.

But one wonders if the true nature of the confrontation between ar-chitect and group occurred to Sullivan. The incident reveals an instructive example of a modern phenomenon—the architect ignores the wishes of the client and gives him what he believes the client needs or would want if

he were enlightened. Presented with a traditional problem at the beginning of his career, Sullivan was unable or unwilling to render a solution that satisfied his patrons. Perhaps it would have been more ethical for him to decline the commission, given his atheism.

It may seem small to criticize an ambitious architectural neophyte for not having turned down a piece of work whose very meaning was alien to his own convictions. (Sullivan had written in the Lotos Club Notebook that "Christians are those who place a magnified image of themselves on the throne of the universe, and make its doings a mere colossal imitation of their own." [14]) But Sullivan's headstrong dismissal of the wishes of his patrons reveals a curious attitude, namely that the architectural art is the exclusive domain of the architect and does not or should not be a response to the intentions or wishes of an instituted body for which a building is erected. Furthermore, it is an attitude that belies Sullivan's avowed belief that "as a people thinks, so does it build." Here is an unmistakable case of Sullivan's effort to make a people think something it isn't thinking at all.

Sullivan was responsible for the entire designs of three other religious buildings: the Anshe Ma'ariv Synagogue (Chicago, 1890), the Holy Trinity Russian Orthodox Church (Chicago, 1903), and the exceedingly curious St. Paul's Church (Cedar Rapids, Iowa, 1913). Each was constructed for a congregation with doctrinal traditions quite unlike the other two. It is interesting to see how Sullivan articulated these differences, despite his own disavowal of the creeds themselves.

It is doubtful that the commission for the synagogue would have come to Sullivan had it not been for his partnership with Adler. The congregation had been established before the Civil War by Adler's father-in-law, and his father had been its first rabbi.[15] Thus it was natural that his firm should have been selected to design the ambitious new edifice and that the nonengineering aspects should have been developed by Sullivan. But since Sullivan's own metaphysical "system" lay far outside the tradition of orthodox Judaism,[16] it is hardly conceivable that he would have received the commission by himself, despite his commercial works for several Jewish businessmen in Chicago (these, just as surely, came to the firm because of Adler's heritage). It is intriguing to see Sullivan's willing participation in this "double bind," designing an edifice for a people whose beliefs he did not share but, at the same time, with a Jewish partner whom Sullivan held in high esteem intellectually (Adler was one of those possessed of a vision of men's powers to build things).

Information regarding the physical requirements of the Jewish rites— the hall with galleries, the pulpit for the reading of the Law, an appropriate setting for the keeping of the scrolls—would have been supplied by Adler, but the specifics of their architectural articulation were Sullivan's. It is not

surprising, therefore, that Sullivan once again relied heavily on Richardson. The exterior (Plate 37), originally to have been constructed of irregular courses of ashlar masonry with openings in the Romanesque tradition, is a streamlined version of Richardson's Trinity Church in Boston (Plate 38): a low block is surmounted by a squat tower with high-pitched roof. The synagogue thus stands in relation to its prototype as Sullivan's Walker Warehouse does to Richardson's Field Wholesale Store—a severely abstracted version of the antecedent.

The interior (Plate 39) is likewise Richardsonian, with its dark-stained wooden vaults and gilded decoration; and it shares with Trinity Church the imitation in timber of lithic forms, thus rendering somewhat timidly what would otherwise have been massive and enduring. The vaults, as in Boston, seem like membranes stretched over a delicate armature. Evidently it did not occur to either Sullivan or Adler that some fundamental contradiction might be implied in allowing the transverse ribs to rest on puny brackets or in having all-too-slender metal columns in the galleries answer to the broad, Michelangeloesque pilasters flanking the chancel.

As in the Auditorium, there is awkwardness in the way materials relate to forms. Sullivan might respond by saying that academic correctness was of no concern to him; but it would seem that he revered no more highly the matter of forthright appropriateness and consistency. The columnar elements, the clerestory windows, the vaulting and wall surfaces simply do not merge into a piece. They are disjointed elements that fail to suggest that a clearly identified problem had sought and reached its own evolutionary solution (to paraphrase Sullivan).

The reason for this may lie in Sullivan's position as a man who chose to stand wholly apart from any religious tradition he might be called upon to elucidate. His services having been engaged by a religious community that was without a consistent stylistic tradition, Sullivan seems to have adopted the point of view of late nineteenth-century eclectics, who thought of the Romanesque as indeed owing something to the architecture of the Holy Land: the round-arch vocabulary had at least partially been derived from Near Eastern forms brought back to Europe at the time of the Crusades. Thus did Sullivan, on this and on at least one other occasion, adopt the historicizing principles of the revivalist architects he presumed to hold in disdain. But it must be admitted that Sullivan faced a particularly difficult problem when he tried to supply the synagogue with a truly Hebraic character. Unlike the ancient Jews, for whom Solomon's temple was the central symbol of a theocratic monarchy, the Jewish businessmen of Chicago were citizens of a democratic republic and owed allegiance to the political thesis of the United States far more than to that of

ancient Israel. Hence it would have been difficult for Sullivan to give the synagogue an expressly Jewish character, since the Jewish capitalist of industrial Chicago found himself in circumstances quite different from those of his ancient forbears.

Sullivan might have pondered the solution to the problem that was tendered by Peter Harrison in the Touro Synagogue in Newport (1762). Harrison would have provided Sullivan with a valuable model, not because he employed the language of English Palladianism, but because he clearly emphasized the character of Jewish ritual: he provided an intimate setting for communal worship that is basically nontheatrical. The interior of the Touro Synagogue (Plate 40) is compact, its seating is close by the central pulpit from which the Law is read, and it contains and intensifies the simultaneously introspective and communal aspect of the Hebrew rite. The Anshe Ma'ariv Synagogue, on the other hand, presents an open auditorium not unlike the opera theater of the Auditorium Building itself: it is expansive and shell-like and does not seek to intensify religious affections. Again we see Sullivan at work on a commission in which he had none but a professional interest. However that may be, he deferred to a model of Boston Episcopalianism in his effort to characterize the Jewish community of Chicago in the 1890s.

The church Sullivan built for the Russian Orthodox community of Chicago in 1903[17] is without question his best religious work, mainly because it sets aside, as seems proper, Sullivan's factitious theories about form and function. From a traditional point of view (in this case the only view that is relevant), it is one of Sullivan's finest buildings. It shows that, even though he might have felt himself compromised in undertaking the commission, he was actually capable of giving adequate form to a building outside the commercial realm.

Unlike the synagogue, the Orthodox Church required not only specific physical accommodations but also specific stylistic features that would clearly indicate its cultural and theological position. Sullivan's library contained books on Byzantine architecture and decoration;[18] and judging from his use of the octagonal dome, the plain wall surfaces in stucco, and a generally vertical disposition of parts, it would seem that Sullivan was conversant with the Greek and Russian traditions of sacred building. The church is of basically centralized plan (Plate 41); and though there seems to be no precise Old World source for the multistory tower of the entrance vestibule, the inclusion of the (imported) iconastasis and other ritual paraphernalia (Plate 42) and the tendency of the cornices to echo the upper contours of the openings below them indicate that a set of well defined specifications had been handed to Sullivan and that he followed them to the letter.

While Sullivan's own taste in ornament may be detected in the carving over the entrance, still he displayed none of the self-assertion that had characterized his work for the Moody Tabernacle. It comes as no surprise that the Orthodox Church received scant attention in the critical literature. It is not mentioned by Morrison, Connelly, or Bush-Brown, presumably because it cannot be fitted into the structuralist's dialectic that these authors want to see operating in the skyscrapers. For them it must have been an embarrassing hiccough in Sullivan's career that was best left unheard.

But the Russian Orthodox Church is a complete success in the way that matters most: it fulfilled the requirements of the congregation and continues to do so today. It is in fine repair and functions as it must have when built—in a modest residential neighborhood on Chicago's near-west side, cared for by the descendents of the eastern Europeans who embarked in the late nineteenth century on the greatest adventure of their lives, immigration to the Promised Land. Sullivan must have sympathized with these people, who like his own parents had uprooted themselves and had taken a great chance. It was such people who composed "the masses" for him, and it was through them that he expected the democratic dream to be realized.

But it is precisely in this regard that the Orthodox Church must also have stood in opposition to what Sullivan claimed to have cherished the most—the possibility of personal freedom. This religious institution, after all, was feudal by his definition and propounded a notion that was anathema to the architect: that ultimate goodness resides in the next world, not in this. It stands for a kind of communal binding based on doctrinal orthodoxy that relegates personal activity outside the religious community to an inferior position in the cosmic scheme, and on this point Sullivan's acquiescence to the requirements of the commission is unusual. How, we may wonder, did he rationalize this building in light of his own antifeudal convictions? It is not possible to know, of course. Sullivan mentioned neither it nor any other sacred building with which he was associated, so one is left to one's own devices in attempting to fathom the meaning it must have had for him.

Probably the least convincing of Sullivan's religious commissions is St. Paul's Church, Cedar Rapids, Iowa (Plate 43), which was planned in 1910 and completed, though not entirely according to Sullivan's specifications, in 1914. The church's board of governors selected Sullivan's plans from among those submitted by several firms and then decided that the congregation could not afford to erect the building as planned. After Sullivan's resignation they hired another architect to redraw the plans to less costly specifications. Although the building lacks what would undoubt-

edly have been handsome examples of Sullivan's characteristic work in glass and ornament, St. Paul's, as it stands, is basically his concept.

The decidedly nonsacred appearance of St. Paul's Church is the result of special requirements of this particular Methodist group, and it must be admitted that in this case the pursuit of a form-follows-function method (as the "Visitor's Guide" to the church proudly announces) produced singularly infelicitous results. Methodism, with its jettisoning of traditional Christian ritual and its replacement of ritual with social programs (athletics, Sunday School, square dancing, and pot-luck dinners), seemed to require an edifice completely unlike any Sullivan could have used as a model. In this the commission probably appealed to him, as the Holy Trinity Russian Orthodox Church may not have, since it presented problems that were purely organizational rather than ritualistic.

In St. Paul's Sullivan was not called upon to represent transcendental ideals, and he was thus able to apply the same organizational system he used in manipulating the various parts of a commercial skyscraper. The semicylindrical auditorium (it is decidedly not a sanctuary) with a seating capacity for a large congregation, together with the gymnasium, the Sunday School classrooms, and the rectangular office block that adjoins the auditorium were all functional parts of the edifice that Sullivan arranged in a purely utilitarian and somewhat bland fashion.

The only feature that distinguishes this building from a high school theater is the campanile at the rear, which is an early medieval affair with Wrightian cornice that completes an uninspired architectural composition.[19] If any of Sullivan's religious works deserves to be forgotten, it is this one, since it is the issue of a highly unpromising marriage between a somewhat characterless Protestant congregation and an architectural ethic that did not recognize the validity of religious building in the modern world.

Sullivan's ecclesiastical work is a motley collection of half-hearted efforts. The one exception is baldly historical, and the recognition of that fact leads to a conclusion that is unflattering to the architect's theoretical assumptions: that democratic architecture must be fundamentally ahistorical. Indeed, Sullivan's homogeneous interpretation of democratic culture is given the lie in the Orthodox church. Was it not the very purpose of the Constitution to affirm the cultural richness and diversity to which the Orthodox church makes a significant contribution?

It may be seen, in fact, that Sullivan's own democratic ideas were, in important ways, contrary to those of a large segment of "the people." Their understanding of the role of American government was that it was to provide a civic structure under which the practice of religious beliefs was held literally sacred. The America that was the culmination of all

history and in which the "fullness of times" was to be realized, was not the culturally homogeneous civilization Sullivan vaguely envisioned. He consistently underestimated the degree to which men are unlike one another and, as a result, tended to ignore the fact of cultural heterogeneity.

Had Sullivan pursued the matter, he might have seen that the partially different and partially similar beliefs of the various religious sects could have been both differentiated and united by a judicious use of the architectural traditions available to him. It is difficult to say whether or not any architect of the 1890s could have achieved such a synthesis. But Sullivan's creation of essentially unrelated religious buildings indicates that he did not really care about the problem.

The Tombs

Sullivan's mainly uninspired efforts as an architect of houses and churches force one to conclude that the appreciation due him as a builder must be founded upon his commercial works; and, in my opinion, the smaller of these are the finest, both in design and in their ability to suggest something of the exemplary aspects of American culture.

It may seem curious to consider Sullivan's tombs within a basically mercantile context, but in fact his three mausolea were designed for prosperous capitalists, and it is fitting that any discussion of them take that circumstance into account as a central determinant of meaning. Almost every artist and architect in history has had to deal with the matter of earthly wealth of men and women whom they have memorialized in painting, sculpture, or architecture. Jan van Eyck's Arnolfini portrait (Plate 44), for example, clearly states the attribute of material well-being that is at the heart of the bourgeois sense of life. Indeed, this material wealth acts as a vehicle by which other ideas—the worthiness of marriage and its sanction in both the civic and mythic orders, for example—are expressed. Thus van Eyck communicates notions about the ideality of marriage through objects that are possessed by the Arnolfini couple: the modest but beautiful collection of personal belongings that simultaneously proclaims certain convictions about their social position and also the hope that their family will be blessed by the spirit of Christ. Sullivan, the architect, was in much the same position as van Eyck, the painter, when he was requested to create funerary monuments for Martin Ryerson, Carrie Getty, and Charlotte Wainwright. (The Arnolfini portrait is not funerary, of course. I mean that Sullivan, like van Eyck, was faced in these commissions with the task of making a profound statement for wealthy and prominent patrons about the matters of living and dying.) All three of these commissions came to Sullivan within a three-year span that coincides with the

acme of his career. It is enlightening to discover how he dealt with these highly personal challenges to his architectural insight.

Each of the mausolea possesses a unique character. One may assume that this in some way reflects Sullivan's reactions to the personalities of human beings who were, indeed, quite different. Morrison notes the relative femininity of the designs for the two women, for example, and contrasts them to the somewhat plainer and more muscular features of the Ryerson tomb. He notes the various Richardsonian and oriental qualities of all three, and concludes that they "celebrate, not the permanence of death, but the permanence of life; they express in terms of lyric beauty that a man or a woman has *lived,* not merely that he or she has died. They are individual in form and they speak unmistakably of a personality, a personality that is immortal if only because it is enshrined in a living architecture."[20] This last observation points out an unusual irony of the tombs, for hardly anyone would deny that their fame rests more on Sullivan's authorship than on the persons they commemorate. One thus faces a dilemma: are they effective monuments because Sullivan made them stylistically interesting or are they effective monuments because the lives and ideals they commemorate are somehow exemplary and therefore deserving of special treatment? Before this dilemma can be solved, one must pose yet another question, namely, what are the principal functions of tomb architecture in the first place?

The principal functions of tomb architecture would seem to be threefold: (1) In the case of a person who is still living, the projection of a burial monument might express a kind of self-salutation that in the best instances would be appropriately respectful but not arrogant. Such a man would thus avail himself of the satisfaction that comes from having taken himself seriously and from recognizing the worth of at least some of his efforts. (2) The second purpose might be fittingly to perpetuate the memory of a deceased on behalf of living family members, for whom a mausoleum might be an ennobling exciter of recollections and affections that lend a sense of continuity to life. Familial pride and cohesiveness might well be served by such a concrete gesture. (3) Finally, in the case of persons noteworthy in the public sphere, the monument might act as a reminder of exemplary deeds and aspirations and as a challenge to like action on the part of the living. This is not to say that examples of pretentious, trite, or lugubrious funerary monuments are nonexistent, but rather that, in the best instances, memorial architecture may possess a high purpose.

Sullivan's tombs might well be discussed in terms of the first two criteria, and in these cases the families might be expected to feel especial pride by virtue of the formal uniqueness of their mausolea. But it is largely incidental that the Ryerson, Getty, and Wainwright tombs are known pub-

licly. None of the persons memorialized was a public hero or heroine, and it is doubtful that anyone but next of kin would have a significant interest in any of the tombs were it not for their appearance in texts on the history of modern architecture. They possess a certain renown that is in no way related to the lives they celebrate. The Wainwright tomb is the most obvious example. Commissioned by Ellis Wainwright to enshrine the memory of his wife Charlotte, who died as a young woman in 1891, this mausoleum undoubtedly served an important private function for the unhappy husband. Perhaps, too, it struck other citizens of St. Louis as a just reference to the beautiful woman they had toasted on many social occasions. Indeed, Sullivan seems here to have combined the best aspects of funerary architecture: an enduring monumentality and a fragility of decoration (Plate 45) that bespeak both the permanence of collective memory and the bittersweet fact of morality. In this it expresses the lovely poetic quality Wright attributed to the Getty tomb,[21] and it presents one of the occasions on which Sullivan's exotic ornament seems truly fitting. While similar decorative patterns are ambiguous at best when they occur in the office building that bears the family name, here they strike one as absolutely central to the business of giving adequate expression to the simultaneously grand and frail nature of human life. Ellis Wainwright could scarcely have hoped for a more gratifying statement of homage to his wife.

Wainwright also knew this was to be his own place of interment, and at this most private level he must have experienced some degree of satisfaction. Bellefontaine Cemetery is filled with unexceptional mausolea of every description, some of them dedicated to rival brewers, so it is easy to imagine that a businessman whose life could in no important particulars be distinguished from others among the nouveaux riches of St. Louis might well take pride in the knowledge that his name would nonetheless be kept before the public because of the striking appearance of his memorial. In fact, it may be seen that Sullivan's design achieved for Wainwright a distinction to which he was not fully entitled. His tarnished public career would hardly seem to justify the memorial he received. In this light the preference for extravagant funerary monuments exhibited by late nineteenth-century industrialists is readily understandable. In a land where millionaires were a dime a dozen, so to speak, one of the few means by which such a man could lend distinction to his memory was in his mausoleum. Many such men were *merely* rich and had no other attributes. Wainwright was one of them, and he also happens to have been one whose effort to perpetuate his memory was successful because of an architect named Sullivan. It has been pointed out to me[22] that the Wainwright tomb is unique in Bellefontaine Cemetery in that it does not bear a family name. Since Sullivan did not comment upon this or any other aspect of his funer-

ary designs, we cannot know with certainty what he meant by such a departure from tradition. But, given his belief that at death we are reabsorbed by the forces of the Infinite, it seems possible that the decision not to nominate the tomb was an expression of his conviction that we are no longer role-playing individuals after we die, but are merged with the larger order of nature where the particulars of name and place are unimportant.

Today the Wainwright tomb is really Sullivan's own memorial. The brewer himself is an inconsequential figure in American history excepting insofar as his capital prompted the raising of what have come to be considered two major monuments in the development of modern architecture. I have argued that the Wainwright skyscraper, noteworthy as it is in the stylistic progress of the tall building, may not entirely deserve the veneration it receives. Henry B. Fuller would argue that for all his good intentions, Sullivan's enthusiasm for the commercial skyscraper was misguided and that it could hardly matter less what a tall building looks like given its unruly influence in the crowded, septic modern city. But can one look upon this gem of a tomb in quite the same way? Just as surely as the Russian Orthodox church, the Wainwright mausoleum implies a conservative streak in its architect. Far from being a revolutionary statement on behalf of modern architecture, it proclaims the validity of one of the oldest forms of building and does so with the clear help of ancient near-eastern sources.[23] The Wainwright tomb is important precisely because it does *not* figure in some polemical scheme of progressivist architectural theory. In the tomb projects, Sullivan was relieved of the duty to design structures that are appropriate to and expressive of the "modern age." Unlike the skyscrapers, which fulfill a basically mean purpose, the tombs by their very nature demand the ethereal character to which Sullivan's reductive forms and delicate ornament seem appropriate.

The Banks

The small midwestern banks, beginning with the National Farmer's Bank in Owatonna, Minnesota (1907–8), and ending with the Farmers and Merchants' Union Bank in Columbus, Wisconsin (1919), offer further evidence that when commissioned to design buildings whose purposes are uncomplicated and have clear and direct bearings on small numbers of individual lives, Sullivan was capable of applying his formal ideals in effective ways. No longer required in his later years to celebrate the tawdry and impersonal world of industrial capitalism, Sullivan trained his talents on an exposition of the ideals of personal security and responsibility that are the essence of rural financial organizations, ideals that seem far more consonant with his stylistic vocabulary than do the anonymous skyscrap-

ers. Unlike the giant industrial cities of Chicago, St. Louis, Buffalo, and New York, where he erected massive office buildings, the small country towns of the Midwest had retained that complexity and interdependence of social, religious, and mercantile intercourse that are so readily recognized in their individual buildings and town plans. Like other cities of the past, Owatonna, Columbus, Grinnell, and Sidney exhibit clear arrangements of individually differentiated structures—courthouse, church, bank, stores, houses, piazza—that denote the purposefulness of the varied aspects of city life. The sheer domination of life by mercantile interests that typifies the large industrial city is absent in these towns, and it fell to Sullivan in a handful of commissions at the end of his career to articulate both the importance of the economic order and, at the same time, its subservience to the various other facets of life in the community.

Whereas the office buildings were executed on behalf of wealthy individual clients or anonymous corporations (in either case, not for the individual tenants, whom he could never know), Sullivan designed the banks for small cooperatives whose purpose was to benefit the members both as a group and as individuals whose livelihoods depended on the quixotic moods of nature to which Sullivan professed a strong sentimental attachment. The success of these banks and of the towns themselves was the result of climatic vagaries that are the inevitable determinants of agricultural life. Here, at last, we find Louis Sullivan coming to grips with a problem whose necessary solution was quite literally organic. The banks, whose solvency hinged upon the harvest, demanded forms that could say something about the ageless relationship between man and earth. In this they are much like the tombs, whose functions are likewise ancient, and unlike the skyscrapers that bespeak a new spirit of material absolutism. Here are buildings that do not compete with or ignore the prairie upon which they rest. Instead, through simple, low forms and botanical ornament, they sing of their dependence on the soil and of the nobility of farming.

The Owatonna bank (Plate 46), the largest and perhaps finest of these buildings, is a case in point. Interestingly enough, the circumstances of its commission belie the old bromide about Sullivan the supposedly neglected genius (the same may be said of the other banks). The work came to him as a direct result of an article he had written for the *American Contractor* in 1906.[24] It was reprinted in *The Craftsman* that same year, where it was read by Carl Bennett, a vice-president of the bank. In this article, to which I have already referred—"What Is Architecture: A Study in the American People Today"—Sullivan expressed most succinctly his ideas about the relation between culture and architecture. Whatever the logical failings of the argument, Bennett concurred with Sullivan's belief that every problem

was unique and required its own solution rather than formulae taken from pattern books. Thus he found in Sullivan an "architect whose aim it was to express the thought or use underlying a building, adequately, without fear of precedent, like a virtuoso shaping his materials into new forms of use and beauty."[25] Like Sullivan, Bennett thought the small Roman temple was incapable of communicating the spirit of banking in the democratic world, and he was pleased to find an architect who was willing to experiment with forms that would render that spirit more effectively. The Owatonna bank is an impressive experiment in that direction, suggesting as it does a highly decorated but secure "cash box."[26]

While the Roman-temple bank (Latrobe's Bank of Pennsylvania from early in the Republic, for example) (Plate 47), with its imperial references, must have seemed dreadfully feudal to Sullivan, he obviously held that a bank should be templelike in majesty, since it stands for one of the chief American aspirations—economic stability and independence. To this end he gave the National Farmers' Bank building that same combination of monumental simplicity and ornamental richness that we saw in the tombs, and it hardly seems unjust to attribute a parareligious intent to the architect. The main structure, which houses both the facilities for ordinary financial transactions (vaults, tellers' windows) and the quarters for the company's officers, is a slightly truncated cube that is subdivided into three major parts: stone plinth, arched main story, and gently corbelled cornice. While some critics have seen Sullivan pursuing further than before his interest in the plain wall surface, it is clear that he wanted to suggest the very solidity and thickness of wall that is the natural allusion to financial security. The windows are deeply set (and, in the plinth, surrounded by heavy mouldings); and on the inside, when the surfaces intersect at the corners, they are always emphasized by projecting beams (Plate 48). One senses a powerful encasement of the bank's facilities. In this it is much like the Roman banks Sullivan disparaged. But, at the same time, the main room is both spacious and luxurious. Like any room whose vertical and horizontal dimensions are nearly equal, there is far more volume than can be used by earthhbound human beings. Thus, a certain ritualistic sense is imparted to the room, which is heightened by the translucent stained glass of the arches and skylight and by the richly polychromed archivolts, soffits, and lighting fixtures.

Indeed, Montgomery Schuyler's allusions to the fantastic in Sullivan's personality are nowhere more applicable than here, where the full range of his exoticism is displayed in pendulous arabesques and unpruned botanical motifs that threaten to dissolve the very geometric clarity presented in the exterior. Frustrated by the dearth of commissions in the years prior to the Owatonna bank, Sullivan seems to have poured all his energies into

one lyrical outburst. Here, he seems to say, it is appropriate that there should be a celebration in ornament of the urge for self-fulfillment and self-realization implicit in the actions of independent farmers. The decorations tend, of course, to be nonliteral: they are delirious abstractions of botanic forms rather than imitations of them, and it is crucial that Oskar Gross, the muralist of the bank, has given us large frescoes, under two of the arches, that depict the labors of the prairie farmer (Plate 49). They form important literal complements to Sullivan's highly personal ornament and serve to remind one of the quotidian aspects of rural life. The interior would tend to be extravagant and overwrought without them. Indeed, on the one hand, one might argue that Sullivan's decoration is inconsistent with the basically conservative economic persuasions of the midwestern farmer. On the other hand, no other institution would have been in a position to offer the farmer so exceptional a rhapsody on his own labors. Where else could he have found so romantic an evocation of his livelihood?

I would argue that the dichotomy inherent in the contrast between external plainness and internal lavishness is not a deficiency of the Owatonna building as it had been in the case of the Auditorium. While, as in most cases, Sullivan's ornament is very much applied and, therefore, not especially *of-the-thing*, still the conception seems purposeful: an austere, public facade gives way to a richly detailed "sanctuary" within. It is evident that Sullivan was possessed of the same paradigm one witnesses in any number of religious buildings in history—the Doric temple, the Constantinian basilica, the Touro Synagogue. In each case the more richly decorated interior is protected from the mundane world by an austere outer wall that defines the border between sacred and profane realms, and even the translucent glass of the Owatonna bank contributes to this effect. The light source is natural, but the light itself is transformed so as to create an independent inner realm. The city itself is not visible from within.

The formal composition of the bank is derived from many sources. At first the two main facades were to have been fenestrated with triple-arched openings, but Elmslie prevailed upon Sullivan to give each wall its single, large arcuation.[27] The revision is certainly more effective. Elmslie must have reminded Sullivan of his own earlier treatment of certain skyscraper portals (as in the Union Trust Building) (Plate 22). In essence, the arcuated portal has become the main motif of the Owatonna bank; and it seems to have been restored to the prominence it enjoyed in its ultimate source, the Roman triumphal arch or gateway. Sullivan might well object to this bit of art historical sleuthing, since it implies that even his work is not without its feudal reverberations. But, in fact, the Owatonna bank is quite Roman in flavor, even beyond its use of long, narrow "Roman"

bricks, as one recognizes by recalling the austere adaptations of antique forms devised by the French neoclassicists such as Ledoux and Boullée.

It would, perhaps, be farfetched to say that Sullivan consciously relied on the practitioners of eighteenth-century "revolutionary" design;[28] but it is clear that he shared their interest in the reductive geometry of certain ancient buildings. The avenue by which this interest in the large, solitary arch entered Sullivan's consciousness may be seen in the work of other Chicago architects—John Root's arcuated portal for the Rookery Building, for example. But Sullivan, in works like the Golden Door of the Transportation Pavilion (Plate 50) and the National Farmers' Bank, transforms the idea into a virtual leitmotiv. The point of making such comparisons is not to denigrate Sullivan for his apparent eclecticism, for his borrowings are usually transformed imaginatively. Rather, one acknowledges the Roman source by way of demonstrating Sullivan's fitting application of a universal form: the triumphal arch, which signals the passage from mundane to celebrational ground. The success of the concept lies in its thematic directness, not merely in its formal simplicity.

It is instructive to view Sullivan's banks within the context of the urban fabric to which they make important contributions. They almost always appear at street corners, and their prominent locations thus correspond to their importance in the life of the individual citizen. The banks stand metaphorically, as well as quite literally, at crossroads. Sullivan seized upon this circumstance to underscore the legitimacy of the banks' role in civic life. Formally quite distinctive, they stand with the nearby town halls, court houses, churches, stores, houses, and communal greens as separate but dependent entities, adequately expressing but not overstating their commercial functions. They cannot be confused with other buildings whose institutional charters are of a totally different nature. The Owatonna bank is exemplary in this connection. The adjacent building, which was also designed by Sullivan, rests on property owned by the bank but rented to independent clients who occupy stores, offices, and a small warehouse. Lower and less richly decorated than the bank, this structure stands in just relation to the larger one: the independent businesses housed within it owe their success to the stabilizing influence made possible by the capital and standardized currency of the bank.

The later banks are smaller and less costly, and their interiors are necessarily less impressive in the matter of heraldic ornament. But they retain the basic features of the Owatonna bank: simple rectangular masses with windows and skylights of translucent glass that give a diffuse illumination within. Each has its own decorative outburst. In the Merchants' National Bank in Grinnell (1914) (Plate 51), for example, the ornament is

concentrated in the complex devices that surround the door and oculus of the main facade, in what is perhaps the most glaring instance of Sullivan's occasional penchant for unintegrated decoration. One of the benefits derived from the slackened tempo of Sullivan's career after 1900 was that he "now had time to work out each commission freshly,"[29] perhaps the only situation in which a problem has time to reveal its own solution, as Sullivan would put it. It is a pleasant task to note the features that make each bank so individual.[30] While the two last commissions—the banks in Sidney, Ohio (1918), and Columbus, Wisconsin (1919) (Plate 52)—possess decorations that Paul Sprague terms "random, centrifugal, contradictory,"[31] they are certainly no more fantastic than any of Sullivan's previous designs. The shield-bearing lions of the Columbus building, for instance, may be traced back at least to the 1892 Union Trust Building (Plate 22), a structure possessing the same kind of baroque extroversion displayed in these late commissions. In fact, the leonine decorations (rejected by the client as too exotic for the interior of the Columbus bank[32]) suggest a curious fact about Sullivan: while his reputation rests in large measure on his democratic writings, his buildings are full of feudal references—heraldic lions chief among them. Possibly Sullivan intended to symbolize the strength of the bank in assuring the security of its depositors, but the imperial and medieval significations of such devices can hardly be ignored. Neither can the decorations be termed *functional* in the sense that usually accompanies that term when applied to Sullivan. The ceiling of the Home Building Association Bank at Newark, Ohio (Plate 53), for example, employs a repeated design that imitates the grid-work pattern of the ventilation ports, thus camouflaging the mechanical elements that serve the physical plant.

It is difficult to accept these usages as lighthearted or frivolous gestures from a man who took his architecture so seriously, and it may be seen that such ambiguities are at the heart of the problem of assessing Sullivan's contribution to American culture. Not all of his architectural efforts were as imprudently conceived as were the skyscrapers. Indeed, I would argue, despite the fact that the tombs, later banks, and the Russian Orthodox church comprise a fraction of his total output, that it is in this group of buildings that Sullivan made his most impressive contribution to the architectural art. Unencumbered by a need to build for "modern times," and in fact called upon to design structures that had little to do with technological innovation or corporate giantism, he was able to resolve the problems with which thoughtful architects have always found it necessary to wrestle. It seems unfortunate that so much of Sullivan's energy was devoted to the design and justification of skyscrapers, buildings

whose effects on human lives have often proved so mean and demoraliz-ing. It is disheartening to think that Sullivan himself did not, in all likeli-hood, recognize the significance of the small commissions; for by their very nature they occupied no high position in the hierarchy of buildings he formulated in his theory of architecture.

Plate 29. Halsted Residences, Chicago, Illinois, 1884.

Plate 30. West Chicago Club, Chicago, Illinois, 1886. Source: Morrison, *Louis Sullivan*.

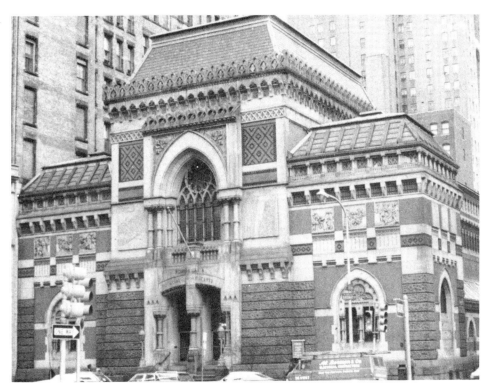

Plate 31. Frank Furness, Pennsylvania Academy, Philadelphia, Pennsylvania, 1872. Photograph by David S. Andrew.

Plate 32. Falkenau Residence, Chicago, Illinois, 1890. Source: Morrison, *Louis Sullivan.*

Plate 33. Frank Lloyd Wright, Charnley Residence, Chicago, Illinois, 1892. Source: Norris K. Smith, *Frank Lloyd Wright: A Study in Architectural Content* (Englewood Cliffs, N.J., 1966).

Plate 34. Bloomenfeld Residence, Chicago, Illinois, 1883. Source: Morrison, *Louis Sullivan*.

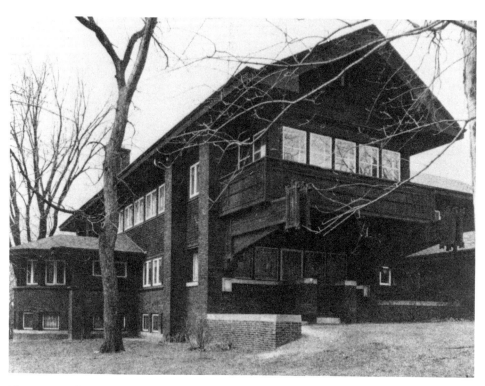

Plate 35. Bradley Residence, Madison, Wisconsin, 1909. Source: H. Allen Brooks, *The Prairie School* (Toronto, 1972).

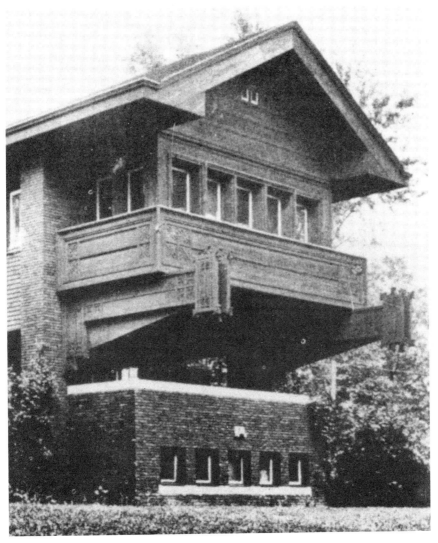

Plate 36. Bradley Residence, detail of porch. Source: Morrison, *Louis Sullivan*.

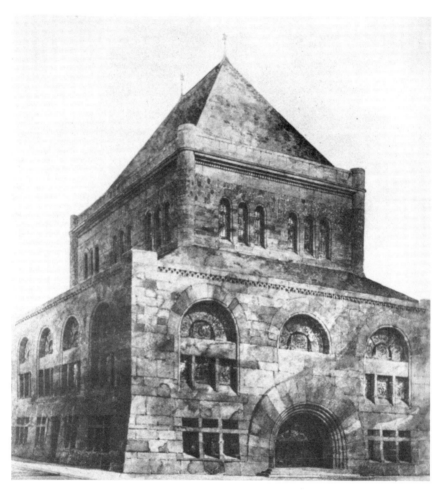

Plate 37. Anshe Ma'ariv Synagogue, Chicago, Illinois, 1890. Source: Bush-Brown, *Louis Sullivan*.

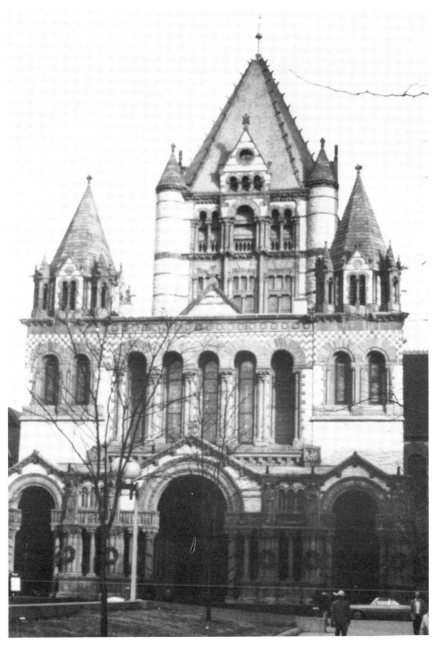

Plate 38. H. H. Richardson, Trinity Church, Boston, Massachusetts, 1872.
Photograph by David S. Andrew.

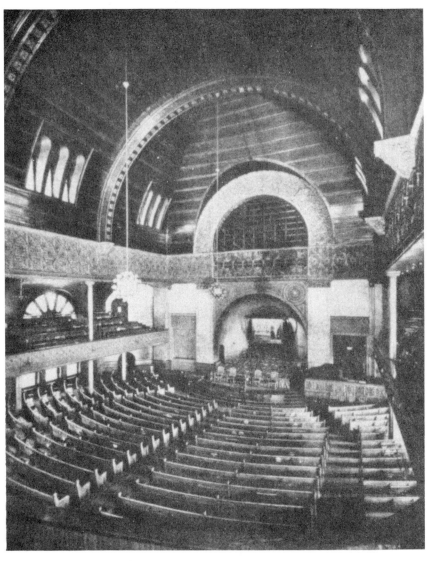

Plate 39. Anshe Ma'ariv Synagogue, interior. Source: Morrison, *Louis Sullivan*.

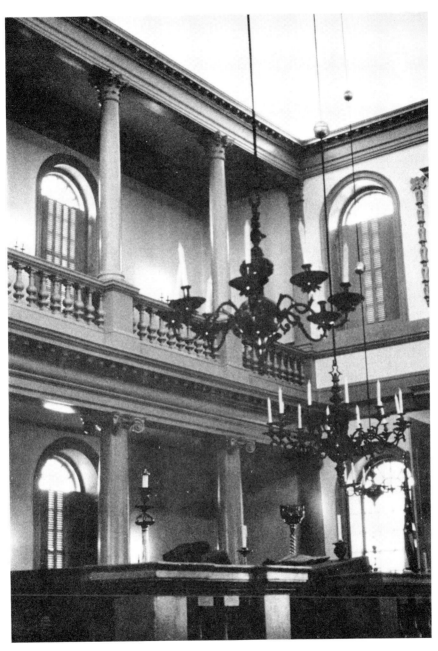

Plate 40. Peter Harrison, Touro Synagogue, Newport, Rhode Island, 1759–63, interior. Photograph by David S. Andrew.

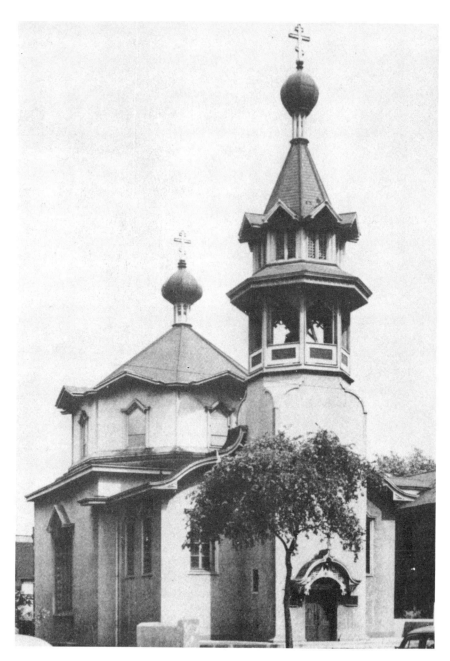

Plate 41. Holy Trinity Orthodox Church, Chicago, Illinois, 1903. Source: Louis Sullivan, *The Autobiography of an Idea* (1924; New York, 1956).

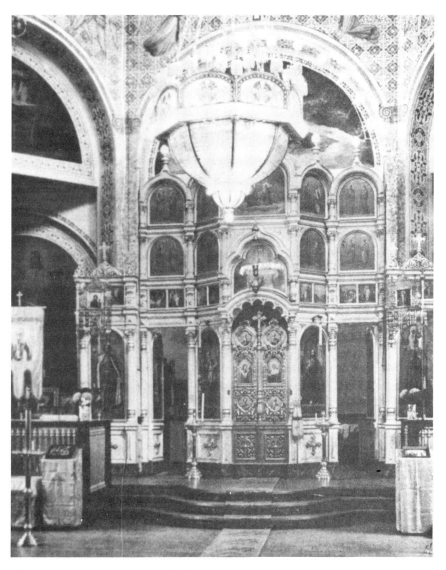

Plate 42. Holy Trinity Orthodox Church, interior. Source: Sullivan, *The Autobiography of an Idea.*

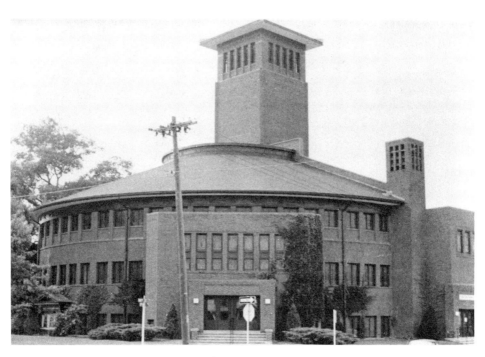

Plate 43. St. Paul's Methodist Church, Cedar Rapids, Iowa, 1910–14. Photograph by David S. Andrew.

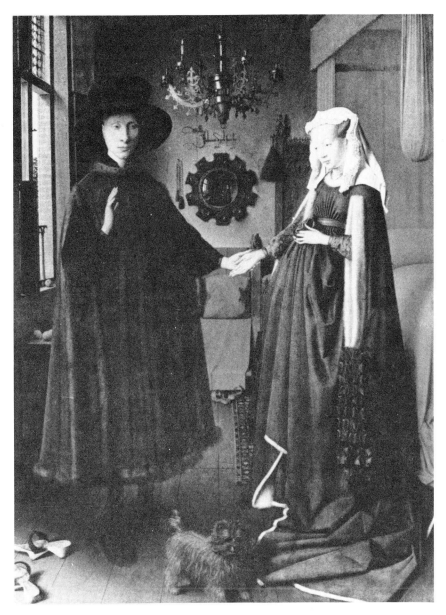

Plate 44. Jan van Eyck, *The Arnolfini Wedding*, 1434. Courtesy of National Gallery, London, England.

Plate 45. Wainwright Mausoleum, St. Louis, Missouri, 1892. Photograph by David S. Andrew.

Plate 46. National Farmers' Bank, Owatonna, Minnesota, 1907. Photograph by David S. Andrew.

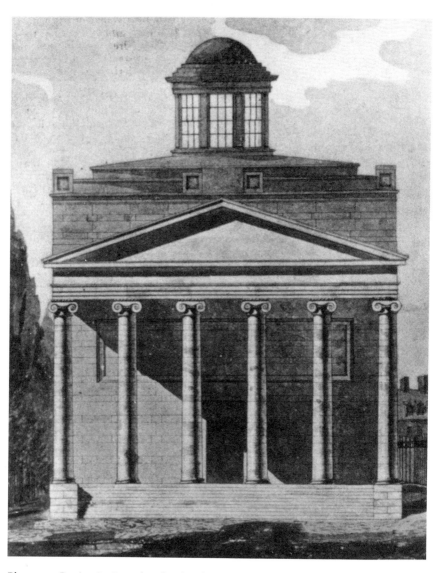

Plate 47. Benjamin Latrobe, Bank of Pennsylvania, 1799. Source: *Architectural Record*, August 1918.

Plate 48. National Farmers' Bank, interior. Photograph by David S. Andrew.

Plate 49. National Farmers' Bank, detail of fresco by Oskar Gross. Photograph by David S. Andrew.

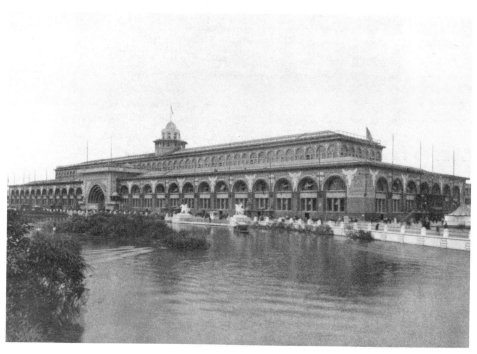

Plate 50. Transportation Pavilion, Columbian Exposition, Chicago, 1893. Source: *The Columbian Gallery: A Portfolio of Photographs from the World's Fair* (Chicago, 1894).

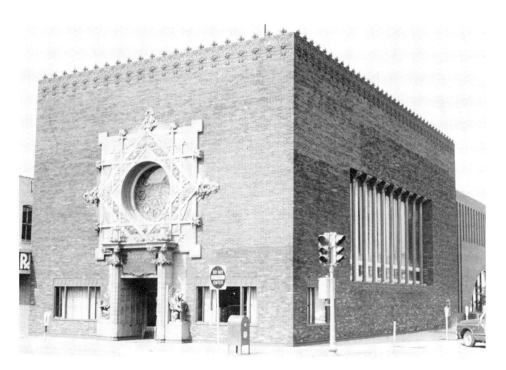

Plate 51. Merchants' National Bank, Grinnell, Iowa, 1914. Photograph by David S. Andrew.

Plate 52. Farmers' and Merchants' Union Bank, Columbus, Wisconsin, 1919, facade detail. Photograph by David S. Andrew.

Plate 53. Home Building Association Bank, Newark, Ohio, 1914, detail of ceiling decoration. Photograph by David S. Andrew.

Plate 54. Guaranty Building, detail of light court. Photograph by David S. Andrew.

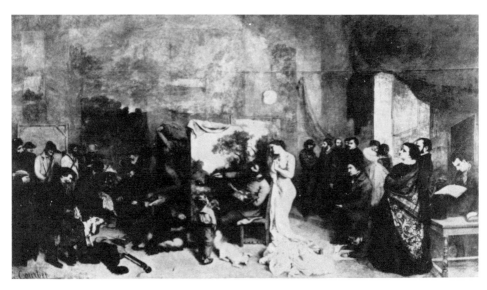

Plate 55. Gustave Courbet, *The Artist's Studio*, 1855. Courtesy of the Louvre, Paris.

7. Sullivan as Modern Architect

Why does man feel so sad in the twentieth century?

Why does man feel so bad in the very age when, more than in any other age, he has succeeded in satisfying his needs and making over the world for his own use? . . .

Why do people often feel bad in good environments and good in bad environments?

Why do people often feel so bad in good environoments that they prefer bad environments?

—Walker Percy[1]

Sometimes snakes can't slough. They can't burst their old skin. Then they go sick and die inside the old skin, and nobody ever sees the new pattern. . . .

But probably, one day America will be as beautiful in actuality as it is in Cooper. Not yet, however. When the factories have fallen down again.

—D. H. Lawrence[2]

In the preceding chapters I have discussed what I take to be the essential aspects of Louis Sullivan's philosophical and architectural work: his assumptions about history and nature; his belief in the uniqueness and the redemptive character of modern culture; and his efforts to design buildings specially suited to and expressive of that culture. I have argued that his efforts to demonstrate the validity of his philosophical position and to produce an architecture that articulated that position were hampered by his peculiarly narrow understanding both of history and of the complex nature of the architectural art. In this final chapter I present an interpretation of the man and of the significance of his career by viewing him within the context of late nineteenth-century thought. My interpretation

hinges on the idea that, although Sullivan may have been a certain kind of "representative man," he was not uniquely prophetic or heroic.

The high esteem in which Sullivan is held by some architectural and cultural historians is premised on a small number of assumptions, as I have already mentioned: that he created an "organic" architecture worthy of emulation; that the architecture itself is based on a coherent theoretical argument; that he was rejected during his lifetime but that his aesthetic and ethical convictions have been vindicated in the overwhelming victory of the "progressive" movement, i.e., the "ahistorical" architecture of the recent past. But I would argue that the following are the significant facts of Sullivan's life: that he was largely a private and an eccentric man, whose very character made it unlikely that he would produce either an architectural theory or a body of buildings that could bespeak a coherent view of the relationship between architecture and culture; that his philosophical speculations were intended to synthesize what were, in fact, a number of unrelated and often divergent sources; that while he claimed allegiance to an Emersonian view of nature, he actually stood in opposition to that view in his commitment to the ascendancy of the technological aspect of modern culture; that while he created a highly original and often beautiful ornamental style, the ornament itself seems to have been his chief architectural concern—the notion of community was for the most part incidental to his conception of architecture; that the decline of his career was not the result of a concerted effort by others to squelch or ignore him, but was partially his own doing; and, finally, that Sullivan, far from understanding his own position in American history, was to a degree unconscious of the forces at work in his world or of the effect they would have on the American people.

The Chicago Fair of 1893

It is appropriate to consider the matter of the 1893 Chicago fair, because it forms such a crucial link in Sullivan's recounting of his own story. Indeed, the popular interpretation of the planning, execution, and aftermath of the Columbian Exposition provides a clear example of the tendency to accept wholesale the architect's version of a given event and its ramifications. Faced with the humiliating turn in his career that began in 1893, Sullivan later fastened on the architecture of the fair as a scapegoat to explain his own passing from the scene as an important influence. It should be remembered, however, that the placing of blame was formulated not simultaneously with the exposition itself but, instead, thirty years afterward, when Sullivan was presented with the task of making sense of his life in the *Autobiography of an Idea*. Prior to 1922 he neither mentions

the fair in his other writings nor ridicules by name Daniel Burnham or the other architects of "high culture." But in the *Autobiography* Sullivan constructed his sentences so they seem to have been written at the time of the exposition, thus prophesying the resumption of interest in historical architecture that was to follow. He was actually composing his "predictions" with the aid of considerable hindsight.

The most frequently encountered interpretation of the fair is derived from Sullivan's spinning of the tale in 1922; it is one that has been reiterated numerous times by his biographers and critics. The story goes that Daniel Burnham, director of works for the fair, whose motto (according to Sullivan) was Make no small plans, felt culturally outranked by the eastern architects also working on the project (Richard M. Hunt, Stanford White, and others) and in obeisance to these "superior" tastemakers sold out the architects of the local commercial tradition by adopting hybrid classical styles for the exhibition buildings. By pandering to these feudal barons of design from the East, Sullivan contended, Burnham unleashed a "disease" in Chicago whose deleterious effects would "last for half a century from its date, if not longer."[3] Using his favorite metaphoric device— that of social or architectural pathology—Sullivan further noted that this infection had "penetrated deep into the constitution of the American mind, effecting there lesions significant of dementia." This famous passage, contrary to his claim that buildings are a reflex of culture, illustrates that Sullivan believed architectural styles themselves could actually influence broad social and historical currents.

But, in fact, there were important circumstances about the Chicago fair of 1893 that Sullivan ignored in his narrative. Recent investigations indicate that Burnham was guilty of no such sycophancy to eastern architects as Sullivan claimed, but was charged with coordinating plans within a group of architects, all of whom operated under the sanction of a national committee for the fair that was composed largely of nonarchitects. These laymen wanted an architecture reflective of "national character"; and the composite styles that resulted, far from copying the inherently commercial bent of the Chicago architects, possessed a grandeur and showy monumentality that were appropriate for a gala national celebration and were very much in keeping with the classical tradition, which had been the American preference in civic architecture from the start.

Sullivan thus made Burnham the scapegoat for the selection of a "decadent" style, when in fact he had been at pains to make a fair of *any* sort materialize amid the wrangling of various factions, bureaucratic and architectural. A sense of the extent of that infighting can be gained by recalling that the exposition, originally to have been held during the quadricentennial of Columbus's discovery of the New World, had to be

postponed until the following year, 1893. In this light, Burnham, given the national longing for an extravagant fair, emerges less as the perpetrator of a stylistic hypocrisy (what Giedion calls "an unexampled seduction of the public taste"[4]) than as a competent architect/administrator whose efforts finally saw the opening of a serviceable exposition grounds.[5]

Furthermore, it should be remembered that Sullivan's own contribution to the fair, the famous Transportation Pavilion with its Golden Door (an effort for which a rare distinction has been reserved by one historian— that of being "the building from which modern architecture as a movement is generally conceded to have begun"[6]), could hardly claim for itself a position outside the stream of historic revivals. It was very much a Romanesque building (Plate 50) with some near-eastern details applied; and its interior elevation, actually less advanced structurally than that of George B. Post's Manufactures Building, was a curious blend of the forms of the Early Christian basilica and of Notre Dame in Paris (as restored by Viollet-le-Duc).[7]

Having produced a pavilion for the fair that was as derivative as any of the others, Sullivan found it necessary to create a legend about the Transportation Building that claimed a unique significance for the structure. It was no less historical than Richard Hunt's Administration Building, but the argument evidently persists that the validity of Sullivan's pavilion rests on its supposedly endogenous character. The recognizably festive character of the Transportation Building is apprehended only through Sullivan's imaginative reworking of familiar patterns, no matter how exotic or reputedly unclassical. Its contribution to the glorification of Columbus's daring voyage is therefore the result of the same qualities that made all the pavilions appropriate to that end.

One of the attendant myths in this connection has to do with the importance of Chicago itself as the site of the fair. Sullivan's "lost cause" has been treated as a kind of synecdoche for the fickle rejection of Chicago's contribution to the culture of America. In fact, Chicago has been seen as the American counterpart, at least architecturally, of the great humanistic cities of the past—Athens and Florence, for example[8]—and the alleged triumph of "aristocratic," eastern ways has been judged a dastardly blow to the integrity of American realism and democracy. But Chicago only suffers in comparison with the other two cities.

With commerce based on industrial capitalism (and all its resultant excesses) as its chief reason for being, Chicago can hardly be placed in the same category with towns of such splendidly complex roots as Athens and Florence, both of which flowered in a rich soil of which commerce was only one component. Religious and mythic convictions and a firm fastening on the civic virtues associated with the independent city-state provided

the other crucial nutrients; and it might well be argued that the appearance of the likes of Ictinus, Phidias, Giotto, and Michelangelo could only have occurred in such a complex humus. Chicago was really without artists of comparable genius. How could a true appreciation of the intricate interplay of aspirations, disappointments, triumphs, and commiserations of national life have found expression in a town that, for all intents and purposes, was barely thirty years old in 1900?

The legend of Chicago, premised largely on the assumption that it was somehow more American than the cities of the eastern seaboard, is questionable to say the least; and Sullivan's contribution to the creation of that legend must be born in mind if his true position in American life is to be assessed. (Wright may be the exception that proves the rule in this case; but his devotion to the city of Chicago was of limited duration and intensity in any event. He sensed that the promise of American democracy would find expression outside the gigantic industrial cities, as his plan for Broadacre City suggests.)

In fact the "failure" of Sullivan's career after 1893 can be attributed to causes far more direct than any that might have been brought into play by the buildings of the Great White Way at the Columbian Exposition. The most important was the depression that followed the collapse of the stock market, an event—as fate would have it—that took place in the same year as the fair. This economic crisis triggered, in turn, a slackening in the building industry and the dissolution of the firm of Adler and Sullivan. What followed is now a familiar story: Sullivan's refusal to rejoin Adler, the retreat from social and professional intercourse typified by his dipsomania, and a growing inability to effect good relations with his clients. By the time the economy had recovered, Sullivan was no longer capable of sustaining the career he had once enjoyed. He was without question a tragic figure in his later years, but to disregard his own frailties or the economic realities of the period as factors crucial to his decline is to embrace a highly fanciful view of his life. Ultimately his work must be judged without the red herring of the world's fair and its lost cause to divert us.[9]

Henry Adams: The Skeptic at the Fair

As a theorist of culture Sullivan is bewildering. He took his ideas about the development of society from a number of unrelated (and sometimes contradictory) sources, and it is not surprising that he should have been unable to achieve a convincing synthesis of those ideas. He tried to argue a romantic intuition with the tools of empirical science, buttressing Zarathustran sentiments with Darwinian dialectics to arrive at an unlikely con-

clusion: that democracy is the ineluctable product of natural causes. The inadequacy of that position to explain the increasingly disjointed character of the modern world as Sullivan could observe it in his own lifetime does not seem to have dissuaded him from holding fast to it as an axiom of human existence. We are left wondering whether he was hopelessly naïve or whether he had succeeded in insulating himself so completely from the realities of industrial and political strife that he was incapable of grasping the significance, not to mention the fact, of World War I, for example. The *Autobiography of an Idea* suggests that he had become fixated upon an interpretation of American history that had been popular in his youth but had been drastically revised by 1900 at the latest by men like the Adams brothers.

Henry Adams, in a frequently quoted passage from his *Education*, says that "Chicago was the first expression of American thought as a unity."[10] Hugh Duncan has taken this to be a statement highly flattering to Chicago, whose skyscrapers, he believes, are the main expression of that unity.[11] But, in fact, the unity Adams refers to is neither meant to be a compliment nor to imply that the unity itself was good. To grasp Adams's meaning, one must read that portion of the paragraph which precedes the observation on "American thought": "Chicago asked in 1893 for the first time the question whether the American people knew where they were driving. Adams answered, for one, that he did not know, but would try to find out. On reflecting sufficiently deeply, under the shadow of Richard Hunt's architecture, he decided that the American people probably knew no more than he did." The one and only unity is that the 1893 fair asked the question Do we know where we are going? This is hardly a satisfying unity, for the question is an unsettling one, and the answer Adams implies is negative. To put it another way, Adams, like many of his friends, was baffled by the machinery and gadgetry of the fair.

> Education ran riot in Chicago, at least for retarded minds which had never faced in concrete form so many matters of which they were ignorant. Men who knew nothing whatever—who had never run a steam-engine, the simplest of forces—who had never put their hands on a lever—had never touched an electric battery—never talked through a telephone . . . had no choice but to sit down on the steps and brood as they had never brooded on the benches of Harvard College, . . . aghast at what they had said and done in all these years, and still more ashamed of the childlike ignorance and babbling futility of the society that let them say and do it. The historical mind can think only in historical processes, and probably this was the first time since historians existed, that any of them had sat down helpless before a mechanical sequence. Before a metaphysical or a theological or a political sequence, most historians had felt helpless, but the single clue to which they had hitherto trusted was the unity of natural force.[12]

In the absence of such a unity and in the confusion of "progress" at the fair, Adams was forced to see the only unity that applied, and it was a disturbingly unfocused one. It consisted of a question to which no one seemed to have the answer. It is precisely this jarring of historic continuity at the fair that Sullivan seems not to have noticed or minded. To him the unity of technological progress was paramount: he could not perceive, as Thoreau and Tocqueville had, the splintering and leveling of mankind that was the force buried within this fascination with the dynamo.

Henry Adams presents an instructive intellectual contrast with the architect of the Transportation Building, and his *Education* should be read by anyone who takes up Sullivan's portrayal of history in the *Autobiography of an Idea*. There would seem to be little doubt that Sullivan himself was aware of the *Education*. A letter to him from C. H. Whitaker, editor of the *Journal* of the American Institute of Architects (which was to publish the *Autobiography* in monthly installments), concludes with a striking assessment: "You know how I feel about the work. I think it is a masterly piece of literature, and one that will take its place in American letters. In many ways I think it is a greater work than Henry Adams', which is the only work to which I can intelligently compare it." [13] Sullivan's decision to narrate his story in the third person might even have been suggested by the *Education*, though Adams's use of the technique seems, by contrast to Sullivan's, rather self-effacing and sometimes self-ridiculing and expiatory.

Sullivan and Adams are alike in that their main concerns revolve about events before 1900, even though both lived long after that date. But the similarities end there, for their attitudes toward any given process or occurrence are almost always distinct from one another. Two examples may suffice to demonstrate this fact. As I have shown, Sullivan loved machines, and he thought Darwin's evolutionary theories explained a great deal—including the direction of man's social development. Adams had rather different views; he was far less sanguine in his appraisals. The chapter in the *Education* entitled "Darwinism" shows how ambivalent Adams was about the whole idea of evolution insofar as it applied to mankind. He seems to have understood Darwin's ideas well enough, but he could not accept their applicability to the sequence of events Darwin believed to have led to the appearance of Homo sapiens. He concluded that evolution brought about change but not progress.

Adams met Sir Charles Lyell, the "geological champion of Darwin," while in England with his father, who was United States minister to Great Britain during and after the Civil War. Adams and Lyell agreed that Adams should introduce Lyell's ideas in America. To do so, Adams realized he would have to master the theories of both Darwin and Lyell, but his effort to do so continually led to blind alleys, and he ended by abandoning the search for meaning in evolution:

Unbroken Evolution under uniform conditions pleased everyone—except curates and bishops; it was the very best substitute for religion; a safe, conservative, practical, thoroughly Common-Law deity. Such a working system for the universe suited a young man who had just helped to waste five or ten thousand million dollars and a million lives, more or less, to enforce unity and uniformity on people who objected to it; the idea was only too seductive in its perfection; it had the charm of art.[14]

Adams concluded that Lyell had "labored only to heap up the evidences of evolution; to cumulate them till the mass became irresistible . . . but, behind the lesson of the day, he was conscious that, in geology, as in theology, he could prove only Evolution that did not evolve; Uniformity that was not uniform; and Selection that did not select."[15] "All he could prove," Adams said, "was change."

What a striking contrast this complex profession of doubt makes with Sullivan's casual observation that "In Darwin he found much food."[16] It is the cavalier tone with which he accepts evolutionary theory that makes his devotion to or understanding of it so suspect. Adams had thoroughly immersed himself in Darwinian ideas and had subsequently expressed perplexity. Sullivan, grasping for any and all evidence to support his contentions about American redemptionism, declined to reflect upon the particulars of evolutionary theory. Hence he ignored the fact that history did not entirely support his progressivist view, but presented instead what could be interpreted as an endless stream of raw change.

One of the most striking chapters of the *Education* is "The Dynamo and the Virgin," in which Adams contrasts the limitless physical power of modern technology with the great reservoir of human feeling from which came the European cult of the Virgin, i.e., the love of womankind and the recognition of the redeeming power of sexual love:

> On one side, at the Louvre and at Chartres, as he knew by the record of work actually done and still before his eyes, was the highest energy ever known to man, the creator of four-fifths of his noblest art, exercising vastly more attraction over the human mind than all the steam-engines and dynamos ever dreamed of; and yet this energy was unknown to the American mind. An American Virgin would never dare to command; an American Venus would never dare to exist. . . . American art like the American language and American education, was as far as possible sexless.[17]

Adams concluded that "All the steam in the world could not, like the Virgin, build Chartres." Sullivan would have snickered at the idea. He held technology to be the handmaiden of democracy and seemed to think that our profoundest sentiments and aspirations have something to do intimately with mechanical contrivances. In fact, Sullivan's shortcomings as a philosopher are a direct result of his unwillingness to see the limitations

of scientific inquiry. He based his historical assumptions on those of an entire sequence of empirical investigators, such as Galileo, Newton, Locke, and Darwin, whose discoveries, while describing certain mechanisms and relationships in the universe, did not reveal anything about the meaning or significance of those mechanisms and relationships.

Adams's commitment to understand the forces at work in the cosmos ran somewhat deeper than Sullivan's. He could see that all was not necessarily goodness and light, even in evolution, and that technological innovation was not exactly achieving what the Darwinists had predicted for it. Should Sullivan receive apotheosis for having perceived far less?

As a philosopher of democracy, Sullivan was hardly profound. His notions about this inevitably political system were anything but political; and they were founded on the assumption of a kind of cosmic unity whose outlines had begun to reveal themselves, he thought, in modern times. Had he taken a closer look at American history, he might have concluded as Adams did that such unity was an intellectual construct often contradicted by historical actuality. The Civil War is a good example. Had the American people been unified by some collective understanding of the problems of economics and individual freedom, the war between the states would not have been possible. But Adams and Whitman, among others, were aware that the war signified something totally different—that the Union had been preserved through a mortal contest of wills, not through some process of amelioration fostered by the Infinite. To insure unity, as Adams noted, one must *impose* it: it hardly springs into existence autonomously. There really is no historical basis for Sullivan's optimistic pronouncements on American democracy. At every step of the way the history of the United States has been marked by conflict, debate, compromise, and further conflict; and Sullivan's call for a unified expression of American civilization in architecture may be seen to issue from an alarmingly naïve notion of how history actually happens. As Irving Pond put it:

> Had Louis Sullivan not slighted history in his school days, because its characters seemed unreal and its stories of wars and fighting were distressful to him (and he with his romantic Irish background!) he would have early learned that *POWER* has been a human concomitant throughout the entire life of the race; and the fact that men exercise power, even beneficent power, would not have burst upon him like a revelation in the form of a totally new and wonderful idea, so original with him that he had to make it *himself* and the subject of an entire autobiography. Had Louis Sullivan been a bit more tolerant toward history and the race he might have sensed Power, beneficent Power, in the builders of the Aqueducts and of the Cathedrals; in the lives of the Philosophers and of the Saints. Had he studied child nature more closely and sympathetically he would have learned long ago that The Child is Father to the Man and would not have needed chapters of words, which little more

than ornament the page, to deduce that fact from a wonder child which he had conjured up in the recesses of his adult brain. Had he possessed a sense of the true value of scale he would have viewed himself in a different relationship to the masses of mankind, whom he, even while waving a sentimental banner of *DEMOCRACY* from a newly discovered hill-top, regarded as mere non-entities.[18]

It seems never to have occurred to Sullivan, for example, that the Constitution was the expression of a calculated gamble of the most glaring sort. Its framers *believed* that men and women possessed certain rights by nature, but nothing in their own experience allowed them to *know* for a certainty that their assumptions were valid. What they put in motion was a form of republicanism for which there were no real precedents, at least not on a national scale, and it could hardly have escaped them that they were embarking on a highly risky business. It was one thing to guarantee rights, but the question of whether people would recognize and accept the obligations the rights implied was one that could only be answered in time. No one knew for sure that the answer would be affirmative, for the assumptions about inalienable rights were based on untested, abstract ideas. Sullivan seems to have believed that it would all turn out right as a matter of course, as if there were no other possibilities. Yet he knew that individuals have often failed to accept assumptions as being applicable to themselves and that the Wainwrights of the world are chief among these.

That Sullivan should have settled upon the tall office building as an appropriate vehicle for the expression of his supremely romantic ideas about democracy is therefore most peculiar. The skyscraper is not an apt metaphor for the democratic principle, because it is incapable of making any statement concerning the just relation between the individual and the group. Its very purpose is to mass large numbers of people and transactions into a relatively compact volume, as if efficiency and expediency were the highest goals of the race. The concerns of the investor-owner take precedence over every other matter, particularly the concerns of the individual worker. It is not in the nature of the skyscraper to prompt reflection on the part of those who must use it. We enter and leave such structures quickly, as soon as our business is done; and the act of getting to and from them is often an uncomfortable and demoralizing struggle, as it was in Sullivan's own day.

The argument that Sullivan, through his ornament and formal clarity, effected a more humane solution to the problem of the tall building than had been achieved by other architects of his day relies on the assumption that the skyscraper is susceptible to humanistic interpretation. The experience of most people in our large cities would seem not to support that assumption, though there are exceptions, mainly among those who con-

tinue to see the problem of the tall building in aesthetic rather than ethical terms. It is true that the Buffalo Guaranty Building (Plate 3) has two attractive facades encrusted with some of Sullivan's best decoration. But the light court is unornamented and is covered with the flaking paint of commercial advertisements applied through the years.

This aspect of the building, which is clearly visible from the street (Plate 54), reminds us of the realities behind the facades. Thus are we treated to the amusing irony presented by two articles in consecutive issues of the *New York Times* real estate section. One ponders the picturesque delights afforded by the reflections of city life in the glass of curtain-wall structures. The other takes note of creditors' foreclosures on forty-two Manhattan skyscrapers.[19]

Sullivan and the Jeffersonian View

The fact that Sullivan's theory of architecture did not present a lucid statement of the relation between the architect and the community, coupled with his fabrication of a self-serving interpretation of the fair of 1893, would seem to suggest that he was actually out of touch with the forces he claimed to know so well. Given his conviction that "as a people thinks, so does it build," it appears that Sullivan in fact did not know what his people *were thinking;* rather, he believed he knew what they *ought to be thinking.* This, I have said, is the central contradiction of Sullivan's thought, and I believe we might well ask how he came to hold it.

I mentioned in chapter 4 that Sullivan was heir, consciously or not, to a way of looking at the world that was formulated in America by Thomas Jefferson and members of his circle. Daniel Boorstin has shown that these men took the concrete manifestations of nature to be the only true determinants of significance in the cosmos. They were thoroughgoing empiricists. They argued that man's penchant for speculative and metaphysical thought had always led to unnatural—i.e., erroneous—conclusions about the nature of his being; and they further held that the moral faculty in man could only be developed through careful observation of and adjustment to the divinely ordered workings of natural law. Only that society which strove to imitate nature in her methods of operation could hope to establish governments that would concern themselves with *res publica.* The solutions to political problems did not lie in the study or imitation of historical precedent. Traditional forms of government were suspect, not only because the American colonies had suffered at the hands of one of those traditional forms—the absolutist monarchy of George III—but because somehow, as Rousseau had said, men had lost sight of the supreme importance of primitive nature as the basis for all acitivity,

human as well as nonhuman. Governments had become agencies of private and special interests and had refused to acknowledge the perfect clockwork of creation as the didactic paradigm that God had intended.

Boorstin has shown that such an interpretation of society inevitably led the Jeffersonians to emphasize what was animallike about man at the expense of what was truly or uniquely human. Thus the purpose of government was to insure the material well-being of the species above all else, because this was precisely what God did for ⚫is creations through the divine economy of the natural order. But beyond this Jefferson's theory of government did not proceed. He did not propose that government should undertake to provide moral leadership for its constituents or to promote a specific moral system as an exemplar of human conduct. Government should be instituted mainly as a prophylactic against the ascendancy of any particular system or interest or political philosophy. So suspect in Jefferson's eyes was man's tendency to institutionalize narrow interests within government that he recommended that the government of the United States be re-formed in toto every generation so as to keep those vested interests from becoming a permanent feature of our national life. He proposed that a new constitution should be written periodically to achieve this end.

In certain ways Sullivan's conception of society was much like that of the Jeffersonians. It was above all a nonpolitical conception. It did not recognize the validity of any one pattern of government, and it regarded specific political theories with disdain. The highest calling of government was to insure that individuals did not interfere with one another in the pursuit of life, liberty, and happiness. Government was not to recommend models of right behavior, for those models were already available in the world of nature. Sullivan, like Jefferson, concluded that the natural models commended to man one important thing: the life of concerted physical action. In the United States in Jefferson's day this meant the exploration and taming of the continent; in Sullivan's day it meant the triumph over nature in the creation of vast urban centers by the forces of industrial capitalism.

But it is in this regard that Jefferson and Sullivan part company, despite the similarity of their philosophies as they pertain to the supreme importance of the physical world. Whereas Jefferson's interpretation of nature led him to embrace agriculture as the most important basis of life and to look upon the growth of the cities as something to be avoided, Sullivan's fascination with "men who make things" prompted him to apotheosize the technologists of his day. Indeed, the mechanical marvels he catalogs so lovingly—the telegraph, the steam engine, the skyscraper—seem to have inspired his celebration of them as achievements superior to

those of nature herself. Whereas the pursuit of the agricultural life was the means by which Jefferson thought man might adjust himself to the divine mechanism of the cosmos, Sullivan had somewhat more ambitious goals for man. He thought that man should elevate himself above nature in the hierarchy of the universe, rather than live harmoniously within nature. This places his supposedly nature-loving ejaculations in *Kindergarten Chats* and elsewhere in a curious light, because they seem to have almost nothing to do with what was going on in the Chicago of his day.

As Boorstin puts it:

> The Jeffersonian had drawn his power from the horse or the waterfall, fixtures of the natural landscape obviously placed there by a superior Workman. But a century after Jefferson, men drew their power from mobile and artificial sources like the steam engine and the internal combustion engine. The urban Leviathan—the railroad, the factory and the encompassing city life—seemed to suggest that man somehow could actually build his own social universe. He could even produce new species of plants and animals. . . . The polarity of man and nature was disappearing. . . . Man's culture seemed his one and only place in the universe. Nature no longer was a fixed point of reference. . . . After Darwin and after the climax of American industrialism, the impressive fact about animate nature was competition among the members of the same species. In Sumner's Age, the adjustment of the whole species to the environment seemed no longer the primary biological fact about man. . . . The context of nature was displaced by that of the market place.[20]

Indeed, Sullivan's paeans to nature may now be seen as essentially rhetorical and pro forma evocations of the earlier romantic naturalism of Emerson and Whitman, a naturalism that was a form of nostalgia for the likes of Sullivan and his clients. He may have derived private satisfaction from his rose gardens in Mississippi, but in his professional career he did little to preserve a world in which others might enjoy the same pleasures. It seems foolhardy for Sullivan to have claimed any relationship with nature, since industrial man in general, and Sullivan in particular, had appropriated to themselves the very powers they often claimed to revere. Man and nature were no longer distinct entities, wherefore it became increasingly difficult for man to place himself in any true *relationship* with nature.

It might well be argued that Sullivan, like so many other ambitious Americans, fell prey to the most obvious and least inspiring aspects of nature in the New World. Leo Marx has shown with what frequency the theme of the despoiled Eden has occurred in American literature and in interpretations of American history.[21] In his analysis of the melancholic closing section of *The Great Gatsby*, Marx has demonstrated F. Scott Fitzgerald's unusual sensitivity to this theme, suggesting that few other pas-

sages in our literature express so poignantly the tragedy of the exploitative American love affair with the land.

As night descends on Long Island, Nick Carraway, the narrator of *The Great Gatsby*, reflects:

> And as the moon rose higher the inessential houses began to melt away until gradually I became aware of the old island here that flowered once for Dutch sailors' eyes—a fresh, green breast of the new world. Its vanished trees, the trees that had made way for Gatsby's house, had once pandered in whispers to the last and greatest of all human dreams; for a transitory enchanted moment man must have held his breath in the presence of this continent, compelled into an aesthetic contemplation he neither understood nor desired, face to face for the last time in history with something commensurate to his capacity for wonder.[22]

Marx sees this passage as Fitzgerald's argument that the new Americans responded to the indescribable loveliness of the continent as a client responds to the wiles and provocations of a whore. The imagery is that of prurience: the virgin breast, the pandering in whispers. Furthermore, the aesthetic or spiritual contemplation that might be prompted by the physical beauty of the land is precisely the one that is unwanted or evaded by the rapacious sailors. They have something quite different in mind. This has special significance in the case of Gatsby himself, but its general significance may be seen to include the entire class of men to which he belonged—the ambitious and not always ethical capitalist whose treatment of the natural world was essentially careless.

Sullivan's disclaimers to the contrary, he was a man who shared with the Jay Gatsbys and Ellis Wainwrights of America a singularly exploitative attitude toward nature. While he was evidently able to convince himself that he was a romantic philosopher in the tradition of the Concord transcendentalists, his creation of tall mercantile structures that dwarfed individual men and ridiculed the vast, flat expanses of the prairie, and his celebration of great bridges that nullified the natural contours and barriers of the land, indicate to what extent he was not such a man. To this extent do his botanical decorations therefore strike one as peculiar non sequiturs within the context of the modern city.

The Modern Architect as Self-Defined Man

In effect, Sullivan went about limiting, in a quite deliberate way, the relations with culture and nature that were available to him. Having rejected the possibility of a relationship with God and having placed himself outside the context of nature, Sullivan was forced to an effort that seems unique to modern man: he tried to define the significance of his life almost

completely in isolation from other men. Both in his professional career and in the other aspects of his life, Sullivan believed that the validity of his existence depended much more on his own privately conceived notions of significance than on any traditional sense of communal belonging. Ultimately his definition of what constituted a successful life did not include the cultivation of true relationships with other human beings or with institutions of any sort, and Sullivan therefore seems to have been a culturally unintegrated being.

In a study of modern life, Philip Rieff has discussed what he calls the "impoverishment of Western culture," by which he means the decline of Western man's belief that he can find a necessary and meaningful place within the body social. Rieff sees the modern techniques of psychotherapy as being trained upon the problem of making this social disconnectedness tolerable to the individual. He shows that what characterized most social theories in the Western world from the time of Plato and Aristotle to that of Burke and Tocqueville was the conviction that "an individual can exercise his gifts and powers fully only by participating in the common life. This is the classical ideal. The healthy man is in fact the good citizen. The therapeutic and the moral were thus connected in the Western tradition of social theory."[23] According to Rieff, real societies have always been able to give back to the individual more in the way of communal integration and purpose than they have required him to give up in his own private life as the price for communal membership. It is the therapeutic aspect of society (systems of symbolic belief, rituals of ecstasy or transcendence, demonstrations of the validity of moral authority) that allow the individual members of those societies to endure the uncertainties and the pain of existence. Tocqueville, Rieff notes,

> worried about what would happen to public life once individualism had sapped its virtues. For the individual would no longer feel committed to the "chain of all the members of the community." "Democracy," De Tocqueville concluded, "breaks that chain and severs every link of it." The individual is thus, in De Tocqueville's grand diagnosis, the defaulted citizen; he has cut off his feelings from communal affections.[24]

Thus Rieff identifies the two traditions of social theory that were contending at the time of Sullivan's birth. One was the classical ideal of the socially integrated citizen; the other "was that men must free themselves from the binding attachments to communal purposes to express more freely their individualities."[25] But Reiff asks, "within such privacies [as are afforded by the latter] can a man feel well?" He thinks not and believes that in recent times a third view of the matter has developed, namely, that "there is no positive community now within which the individual can merge himself therapeutically."[26] He believes Freud to have been the great

exponent of this new *tertium quid* and sees the analytic therapy of modern times as a method by which Freud thought the individual could once again function, not within a social context, but within an almost completely unattached and private one. Unlike the traditional "therapist" (priest, shaman, exemplary hero), the analyst seeks not the reintegration of the patient into society, but rather a strengthening of the individual ego so that it might face the lack of a constructive social situation without a debilitating sense of perdition. "With Freud, individualism took a great and perhaps final step: toward that mature and calm feeling which comes from having nothing to hide. The individual needs no longer keep a safe distance from the mass of his fellows. In therapy, developed as a social process, he will be so trained that vulnerability is minimized. To live on the surface prevents deep hurts."[27]

But *to live on the surface* also means to live alone for the most part, and Rieff perceives that the *culture* (if, indeed, that term is applicable) that has arisen from the analytic attitude is largely a negative one. "What binding address now describes our successor culture? In what does the self now try to find salvation, if not in the breaking of corporate identities and in an acute suspicion of all normative institutions?"[28] Those who subscribe exclusively to the analytic attitude are, for Rieff, "charter members of the negative community, in which membership carries precious few obligations and the corporate effort is devoted mainly to objecting to the rules."[29]

In the absence of the older therapies of integration, most Western cultures have substituted a belief "in wealth as the functional equivalent of a high civilization."

> Quantity has become quality. The answer to all questions of "what for?" is "more." The faith of the rich has always been in themselves. Rendered democratic, this religion proposes that every man become his own eleemosynary institution. Here is a redefinition of charity from which the inherited faith of Christianity may never recover. Out of this redefinition, Western culture is changing already into a symbol system unprecedented in its plasticity and absorptive capacity. Nothing much can oppose it really, and it welcomes all criticism, for, in a sense, it stands for nothing.[30]

Louis Sullivan, who was born in the same year as Freud, shared with the Viennese analyst certain habits of thought. The most important among them was the belief that institutions had tended to corrupt rather than to edify mankind, and both men saw the deepest instincts of the individual as having been opposed and often thwarted by the corporate bodies of society. Freud perceived the genesis of neurosis in this condition;[31] and Sullivan, who may or may not have heard of Freud's theories later in life, was convinced of a similar proposition, namely, that man, in his denial of

the promptings of his instinctive self, had brought to pass an immense inversion or contradiction of the Infinite.

The way of stating the problem by both Freud and Sullivan implied that its solution lay chiefly within the private and individual realm. Freud's therapy took the form of encouraging the patient to detach himself from and to fortify himself against, in the greatest measure possible, the unreasonable demands of an obsolete culture. Sullivan's "therapy" was not unrelated to this one. But, ironically, he took measures to isolate himself from the very culture whose great destiny he had prophesied. When not working for clients, he would either steal away to Ocean Springs, far from the city whose communal well-being was a matter of no great concern to him; or, in his later and less prosperous days, he would busy himself in his quarters with the composition of voluminous and eccentric commentaries on civilization. Rarely did he seek correspondence or intercourse with colleagues or others who might have been interested in or sympathetic toward his views. He was a recluse who developed his sociological ideas without making contact with the very communal realm he wished to reform.

Furthermore, his professional career was characterized by the same sort of unyielding isolation and individualism. Wright notes that, after the triumph of the Auditorium, Sullivan preferred not to work on the practical matters of the commissions that came his way. "He did not like to work unless drawing designs for ornament." [32] Mumford comments that "Sullivan's ornament was frequently not related to the forms and materials of the building: it was as arbitrarily applied as acanthus leaves. It was, moreover, a drafting-room ornament." [33] From these statements and from analysis of the ornament in situ, it can be concluded that Sullivan was happiest when working alone, isolated from the outside world inhabited by his draftsmen and his clients, and lost in the secret and inviolate realm of his own fantasies. The ornament really has nothing to do with the skyscraper, with evolution, or with the institutional aspects of the democratic order. Rather, it seems to argue for the sanctity of the private, inner man and woman; for the legitimacy of a sacred personal *temenos*, so to speak, that is recognized but not trespassed by the American social contract. (Just how truly social that contract is, of course, was questioned by Tocqueville.)

Sullivan is not unique among modern artists in his efforts to place the locus of meaning in life outside the sphere of social activity. Fiske Kimball, who wrote one of the first theoretically based appreciations of Sullivan, likened the architect to the French painter Claude Monet. [34] Kimball thought of Sullivan as an "old master" of realism in architecture, and he saw a kinship between this architect and various members of the nine-

teenth-century schools of realism—schools that included Monet and Ro-din, for example—which he took to be operating under the laws of sci-ence. "All sought characteristic beauty through truth to nature, rather than abstract beauty through relations of form."

For Kimball, Sullivan's art was realist because it tackled the "problem of expressing the steel frame," an issue, he says, that had been crucial in the 1890s but was by then (1925) dead. In its place had come pursuit of the formalism that had been ushered in by Cézanne (as early as the 1880s, Kimball points out, somewhat to the detriment of his dialectical argu-ment); and its exponents in architecture were the familiar scapegoats of the modern movement: J. M. Wells, Stanford White, and Charles McKim. Kimball's view of Sullivan's achievement is premised upon the idea that the principles of construction are what finally determine meaning in a building. Furthermore, he assumes that Monet's paintings were inherently scientific and realistic in their approach to conveying the sensible world. If anything, Monet's works exaggerate and augment various optical phe-nomena rather than record them with scientific objectivity; and Morrison is probably correct in taking issue with Kimball over this matter.[35]

But it might be possible to argue for another kind of connection be-tween Sullivan and Monet—indeed, between Sullivan and a very large body of modern artists. Both Sullivan and Monet possessed a view of the city that seems to have dispensed with the necessity of societal institutions, and both were equally disengaged from the traditions of Western civiliza-tion that had usually supplied the artist with his reason for being. Further-more, they both seem to have been committed to the achievement of a certain isolated completeness in their own work that was based on entirely private perceptions and that assumed the self-sufficient authenticity of a purely present modernity. It is probably no accident that wealthy industri-alists in the Midwest began to collect the landscape paintings of various nineteenth-century French artists at the time when Sullivan was at work. Without doubt the Wainwrights and their peers would have been attracted to these paintings for the same reason that their livelihoods required the sort of building that Sullivan wanted to design for them. The paintings, the skyscrapers, and the economic system of industrial capitalism all de-nied the validity of important traditions; all tended to claim a self-sufficient significance for life within the modern epoch. As Rieff says, industrial capitalism tends to ignore the importance of any institutions besides itself.

It might well be argued that the landscapes of the Barbizon painters and the impressionists were equally disengaged from any commitment to explore the human relationships that make up the fabric of civilization. Instead, these painters were content to immerse themselves in a world of

optical sensations that was pleasant enough but that lacked a philosophical stance on the question of what relationships real and ideal man might have with himself or with nature. Monet's landscapes and architectural views are not concerned with the matter of citizenship that was crucial to the classical ideal of culture proposed by Plato and Tocqueville. And Sullivan, like Monet, might be said to be the sole member of a culture entirely of his own devising. By definition each culture of individualism can really claim only one member, and in this light it might well be proposed that individualism is not truly a basis for culture at all.

Norris Smith has noted that Western man's conception of the "center" of meaning in his life has been changing slowly for the past several hundred years. Whereas in the epochs before 1500 men had tended to think of that center as being outside themselves (e.g., in various consecrated sites, in religious and political institutions, or in the cooperative efforts of the family), it is apparent in more recent times that the self has more and more come to be identified as the center of things. Gustave Courbet's famous contribution to the Paris Exposition of 1855, *The Artist's Studio* (Plate 55), is one of the most striking instances of this displacement of the center.

In this huge canvas Courbet literally places himself in the middle of his world, and he does so with a boldness that might well remind one of the similar self-assertiveness of Sullivan and Whitman. All these men wanted to define their modern realities in terms that did not involve membership in or subservience to an established institution of church, state, or family. Thus does it seem particularly arrogant that Sullivan, like other recent architects, should undertake to impress his own private "culture" upon the entire sphere of architecture, which by its very nature is bound up with the same institutions whose validity he denied.[36] Ultimately, as Rieff says, the problem of individual-centered culture is compounded by the pathetic inwardness that it fosters:

> The fundamentalists of rationalism with their ignorant irreligious are still with us; they are to be met specially among the most highly trained and culturally emancipated people. Despite the cruel failures which their counter-dogma of technological determinism has suffered, they refuse to realize that everything great and good springs ... from a new fusing of man's inner and outer life, not simply from further changes in social and technological arrangements. The product of such rearrangements will serve only to distract men temporarily from the prison of their inwardness.[37]

For Hugh Morrison, Sullivan's culture of individualism was significant because it allowed the architect to create buildings that were uniquely relevant to his times. Morrison took issue with Kimball over his claim that Sullivan was an old master of realism. For Morrison the architecture of

Kimball's formalists (McKim and the others) was not a manifestation of the pursuit of pure, abstract beauty, but instead exhibited a rank eclecticism that was both ostentatious and impractical. Morrison suggests that Sullivan's contribution lies in two main areas: (1) his influence on other architects, exercised more through his writing than through his buildings; and (2) his development of a functionalist method of design, in which every building is the solution to a unique problem, not merely an amalgam of historic motifs selected from this monument and that. He concludes by observing that "Sullivan did not lay down a style to follow, he proposed a system of thinking, a system which is finally bearing fruit in a genuine modern architecture."[38]

I have argued that Sullivan did not succeed in proposing what might rightly be called a "system of thinking," if what is meant is something coherent and consistent. Buildings are not truly like plants and animals in any significant way; and the effort to borrow from nature some organic principle in designing architecture is likely to overlook those nonstructural aspects that are the key to architectural meaning, i.e., the thematic and emblematic ones. The difficulty with Morrison's term *functionalism* is that it, like Sullivan's, is not inclusive enough: it does not permit that a caryatid porch projecting from a building, even though executed in this century, might well possess a crucial symbolic function, possibly one that cannot be expressed as well in any other way.

In general, both Sullivan and Morrison underestimate the value of traditional architectural symbolism: Sullivan, because he had a powerful phobia of things historical; Morrison, because the borrowing of such motifs smacks of unimaginative, pattern-book solutions to problems that need more specific treatment. In fact, as Jefferson demonstrated in his Richmond capitol (whose source was the little Roman temple at Nîmes called the Maison Carrée),[39] an architect, even a "modern" one, who desires to communicate ideas about institutions housed in the buildings he designs is prompted naturally to set forth those ideas in some universally apprehendable—i.e., historically valid—manner. In the same way that the arguments set forth on this page depend for their effectiveness on certain symbols whose meanings would be as apparent to Shakespeare as to us, so is the architect also asked to express cultural ideals and convictions through some recognizable vocabulary of forms. The creation of a truly ahistoric architecture would necessitate the wholesale fabrication of forms that, lacking identifiable references, would communicate abstract concepts about as well as a new language invented and used by only one person. In any event, eclecticism in architecture hardly precludes the possibility of a functionalist building, even within Morrison's narrow definition. New York's Grand Central Station is not at all hindered in the performance of its complex role by its references to the Roman bath.

The real difficulty with Morrison's argument resides in its emphasis on Sullivan's prophetic abilities. The works of Mies, Gropius, Oud, Le Corbusier, and others are seen as post facto vindications of Sullivan's principles, even though these buildings are quite unlike his in important respects. Duncan, Hitchcock, and several others have followed Morrison's lead in perceiving a magnification of Sullivan's accomplishment in the works of early twentieth-century Europeans. If the same argument were applied to Ictinus and Callicrates, it would emphasize the influence of the Parthenon on subsequent classical architecture to the exclusion of what was truly significant in that building: not its stylistic progeny, but its meaning in the lives of fifth-century Athenians. What we ought to be concerned with is Sullivan's efforts *in statu nascendi,* not with their effects on other architects whose works he did not produce and for which he cannot take credit. The real questions are How did Sullivan define the problems? and To what extent did those definitions reflect the architectural exigencies with which he was faced? Did Sullivan do the right thing, regardless of what later architects did with their *pilotis* and glass curtains?

Sullivan's inability to see that all architecture is, in a sense, conservative (i.e., that it is raised by institutions that have as their goal the preservation of certain ideals) made it inevitable that he should undertake his commissions as a private, unattached individual. His religious buildings are particularly indicative of this state of affairs, and it happens that his one significant contribution in the realm of church building was a success exactly for the reason that in creating it he ignored his own factitious theories of modernity. It might well be that the changing nature of church membership in the nineteenth century (as Dwight Moody's evangelistic and intensely personalistic Christianity or the church-social emphasis of the Methodists in Cedar Rapids would seem to indicate) made it impossible for that membership to be bodied forth in *any* kind of architecture. But Sullivan's interests lay elsewhere in any event. He thought it was both possible and appropriate to express in his skyscrapers profoundly idealistic notions whose emotional and spiritual depth was equal to or greater than that which had traditionally been associated with civic and ecclesiastical bodies. As Lewis Mumford said:

> More than anything, the mischief lay in the notion that on the foundation of practical needs the skyscraper could or should be translated into a "proud and soaring thing." This was giving the skyscraper a spiritual function to perform: whereas, in actuality, height in skyscrapers meant either a desire for centralized administration, a desire to increase ground rents, a desire for advertisement, or all three of these together.[40]

(It might be recalled here what was said earlier—that Sullivan's reaction to the skyscraper was like that of an eighteenth-century gentleman to some sublime experience: it was at the core aesthetic, not ethical.)

However, while Mumford was skeptical of the goals Sullivan sought to achieve in the commercial skyscraper, he, like Morrison, believed in the special nature of Sullivan's contribution to the modern world.

> Sullivan saw that the business of the architect was to organize the forces of modern society, discipline them for humane ends, express them in the plastic-utilitarian form of building. . . . While Sullivan manfully faced the problem of the tall building, he saw that the spirit that produced such congestion was "profoundly antisocial. . . . These buildings are not architecture but outlawry, and their authors criminals in the true sense of the word." So, though Sullivan respected the positive forces of his age, democracy, science, industry, he was not a go-getter, and he refused to accept an architecture which showed a "cynical contempt for all those qualities that real humans value."[41]

In reality Sullivan was as much a go-getter as any of his colleagues in the era before 1893, when the getting was good. His fundamental belief in the capitalist system and his enormous body of commercial structures attest to that fact; and it is important to remember that Sullivan had consciously cast himself in a particularly difficult role, one in which he tried to combine the attributes of the romantic poet with those of the no-nonsense businessman. Had he pondered more deeply the lesson of America's most important transcendentalist, Henry David Thoreau, he might have caught the contradiction inherent in that position. Thoreau, as he reports in *Walden*, began to look for ways of not selling the baskets he had woven for the purpose of supplementing his livelihood. Even this modest commercial venture seemed at odds with the larger goal he was seeking, i.e., "to live deliberately." Sullivan's glorification of the skyscraper as democratic poetry inevitably placed him in contradiction to his espoused romanticism. He may well have thought the world of commerce was the primary one that offered a sense of community to American citizens. If so, he failed to recognize the superficiality of that conception. Nora Watson, one of those interviewed by Studs Terkel in *Working*, puts it this way: "I think most of us are looking for a calling, not a job. Most of us, like the assembly line worker, have jobs that are too small for our spirit. Jobs are not big enough for people."[42]

Conclusion

I said at the beginning of this chapter that Sullivan was not really unique as a philosopher or as a personality, that he was a "representative man" of sorts. Yet I have also maintained that he was very much a private and an individual man and that this aspect of his character was responsible in large part for the difficulties he encountered as an architect. The two observations may seem contradictory at first, but I would assert that it was

precisely his individualism that made Sullivan a representative man, that made him like many other Americans who—as Tocqueville said—had no real interest in the body social or in trying to determine the nature of communal membership. Sullivan, like the others, thought of himself as a completely self-sufficient being, capable of defining the significance of his life without taking into consideration the necessity or the desirability of forming enduring relationships. Indeed, in this respect Sullivan is a striking example of the self-defined modern artist, and the lessons of his life are to be derived chiefly from this fact.

Henry Hope Reed may be correct in observing that Sullivan's ornament was far too personal ever to have been adopted as an American or a universal style. But this is not entirely a drawback. Given the intense spirit of individualism that is often seen as a main component of American life, Sullivan's ornament seems a powerful and reinforcing statement about the legitimacy of that individualism, even though it is often applied to the unlikely form of the commercial skyscraper. Perhaps the great lesson of the ornament is that we have a right and, indeed, ought to be ourselves. At a crucial moment in American history after the Civil War, when the entire matter of individuality was threatened by massive industrialization, standardization, and the leveling of differences, only a handful of American architects seem to have argued for a rashly independent kind of ornament, among them Furness, Sullivan, and Wright. For this achievement they deserve thanks, because they tried to preserve the ideal of the individual as sui generis, unlike the Robert Venturis of today who make a virtue of necessity in lauding the characterless homogeneity of much of our building.[43]

On the other hand, these men—Sullivan chief among them—showed that the job of integrating a highly personal and subjective persuasion into the coherent fabric of a society that depends, on occasion, on the suppression of that subjectivity, is immensely difficult. Perhaps it is impossible. Certainly the skyscraper tends to mock individuality as a sacred concept. Insofar as it was applied to the creatures of industrial capitalism, Sullivan's ornament seems misdirected; and if he was right in thinking of the tall office building as the necessary outcome of evolutionary forces, then one is forced to the conclusion that evolution is not an exclusively beneficent force. The good that resides in it must be identified and extrapolated by men and women; it does not come to them without effort and without selection. In this sense people live outside of evolution. Although we may be its products in a biological way, we still can stand back from it as a process and define it; and, within limits, we are capable of consenting to or rejecting the conditions it places on other organisms that lack both the understanding and the equipment for consent or rejection.

Sullivan thus offers a valuable object-lesson: having been naïvely accepting of the notion that society would inevitably improve, he cast his vote on the side of a kind of acquiescence to the forces that he and others[44] believed to lie beyond modification once set in motion. But was there reason for such passivity? Wright believed not; he continued to envision an America not far different from that of Thomas Jefferson's earlier conception—in which private, civic, and economic concerns were in balance with one another through the perpetual education of both the private and public self. The fact that we do not now seem to possess that balance does not mean the idea behind it was wrong. The success of the tall building in our large cities does not invalidate the kind of life led in Owatonna, where things bear some resemblance to the exemplars created by Jefferson and Wright. Sullivan's mistake lay in his too willing agreement with the industrialists' view of the big city, and herein one may identify Sullivan's contribution to the process by which republicanism was converted "from an animating ideology to a static buttress of the conservative industrial order."[45]

Louis Sullivan was content to see the sublimity of the prairie transformed into industrial wasteland while still reserving the personal freedom to retreat to Ocean Springs, to receive "therapy" among the roses. What a dreadful ambiguity typifies his attitudes toward nature: he treated it at once as a sanctuary for the spirit and as a rich treasure to be mined and overcome. Whether the natural world can long sustain both uses by man remains to be seen. It is not laws "so broad as to admit of no exception" that we seem to require nowadays; rather, it is the effort to separate from what can be done what should be done.

Appendix 1

CHRONOLOGY

1847 Patrick Sullivan arrives in Boston.

1850 Andrienne List arrives in Boston.

1852 Patrick Sullivan and Andrienne List are married.

1856 Louis Henri Sullivan is born on September 3, the second of two sons of Patrick and Andrienne Sullivan.

1860 Louis Sullivan enters grammar school.

1862- Sullivan summers with maternal grandparents on farm near South Reading,
70 Massachusetts.

1869 Patrick and Andrienne Sullivan move to Chicago. Louis Sullivan continues to live with his grandparents; decides to become an architect.

1870 Louis Sullivan enters Boston English High School, where he is taught by Moses Woolson and is introduced to the scientific method.

1872 Sullivan enrolls at MIT to take the course in architecture; hears lectures by William Ware.

1873 Sullivan moves to Philadelphia to live with his grandfather; works as draftsman for Frank Furness. Market Panic forces him to go to live with his parents in Chicago, where he is employed by the office of William Le Baron Jenney. John Edelmann, Jenney's foreman, becomes his mentor: introduces him to the music of Wagner and to German metaphysical idealism.

1874 In July Sullivan begins about nine months in Europe. He studies under Emil Vaudremer, architect of the Romanesque Revival, at the École des Beaux Arts in Paris. He travels to Rome and Florence, where he is struck by the work of Michelangelo.

1876 Sullivan returns to Chicago; reads Draper, Darwin, and Spencer; forms Lotos Club with Edelmann and others.

1879 Sullivan enters office of Dankmar Adler.

1881 Sullivan and Adler partnership is formed on May 1.

1885 Sullivan produces his first writings in architecture.

1886 Sullivan designs the Auditorium Building in Chicago; begins to write *Nature and the Poet: A Prose Song*.

1887 Frank Lloyd Wright joins the partnership.

1889 George Grant Elmslie joins the partnership.

1890 The Wainwright Building, by tradition the first skyscraper to find an appropriate external expression of the steel frame, is built in St. Louis.

1891 Sullivan draws plans for the Fraternity Temple project and proposal for his ideal city of setback skyscrapers.

1893 Sullivan designs the Transportation Pavilion for the Chicago Columbian Exposition. Stock market crash occurs. Sullivan dismisses Wright for moonlighting.

1895 Sullivan designs Guaranty Building in Buffalo. Adler and Sullivan partnership is dissolved in July.

1896 "The Tall Office Building Artistically Considered" is published; Sullivan coins the aphorism *form follows function*.

1897 The Bayard Building, Sullivan's only work in New York City, is built.

1899 The Schlesinger-Mayer Department Store, Sullivan's last skyscraper, is built in Chicago; Sullivan marries Margaret Hattabough.

1901 The *Kindergarten Chats* appear serially in *Interstate Architect*.

1905 Sullivan produces the essay "Natural Thinking: A Study in Democracy."

1906 Sullivan writes "What Is Architecture: A Study in the American People of Today," the clearest statement of his notion that architecture is a reflex of culture.

1907 Sullivan, with Elmslie, designs the National Farmers' Bank in Owatonna, Minnesota, the first of seven small midwestern banks; he also produces the first draft of *Democracy: A Man-Search*, his longest and densest book.

1909 Sullivan's career stagnates; he sells his library and other belongings in Chicago, gives up his office in the Auditorium Building tower, and retires Elmslie; he is left alone.

1914 Sullivan and Wright effect a reconciliation.

1917 Louis and Margaret Sullivan divorce after a ten-year separation.

1918 Sullivan revises the *Kindergarten Chats* at the behest of Claude Bragdon.

1922- *The Autobiography of an Idea* is serialized in the *Journal* of the American
23 Institute of Architects; Sullivan makes the drawings for *A System of Architectural Ornament*

1924 Sullivan sees the *Autobiography* in book form; dies of congestive heart failure in Chicago on April 14.

1935 The first monograph on Sullivan appears: Hugh Morrison's *Louis Sullivan: Prophet of Modern Architecture*.

Appendix 2

(Source: Williams, Barker & Severn Co., *Auction Catalogue No. 5533* [Chicago, November 29, 1909]. Courtesy of Burnham Library, Art Institute of Chicago. All idiosyncrasies, errors, and omissions in the original publication are retained herein.)

Books

1. Eve's Daughters. Portrayed by A. G. Lerned. 8vo. Boston, 1905. 1 Vol.
2. Japan and Its Art. By M. B. Hursh. 8vo. London, 1889. 1 Vol.
3. Mark Twain. Roughing It. 8vo. Hartford, 1888. 1 Vol.
4. Walt Whitman. Leaves of Grass. 8vo. Boston, 1860–61. 1 Vol.
5. Hearn. Lefcadio, Japan. 8vo. New York, 1904. 1 Vol.
6. Chicago and Its Suburbs. By E. Chamberlin. 8vo. Chicago, 1874. 1 Vol.
7. Another Copy. 1 Vol.
8. Rawlinson's Ancient Monarchies. 12mo. Cloth. New York. 5 Vols.
9. Playing Cards. The Devil's Picture Books. 8vo. New York, 1893. 1 Vol.
10. Arctic. Three Years of Arctic Service. By A. W. Greeley. 8vo. Half mor. New York, 1886. 2 Vols.
11. Four American Universities. 8vo. New York, 1895. 1 Vol.
12. Russia. The Empire of the Tsars. By A. Leroy-Beaulieu. 8vo. New York, 1893. 2 Vols.
13. Russia. The Truth About the Tsar. By C. Joubert. 8vo. Philadelphia, 1905. 1 Vol.
14. Fiction. Nancy Stair, The Jungle and four others. 6 Vols.
15. Higginson's U.S., Eggleston's U.S., King's U.S. and Indian Horrors. 4 Vols.
16. Archaeology. Egyptian, Maspero, Manual of. Ely. Oriental Antiquities, Babylon. 3 Vols.

17. American Railway, The. By C. F. Clarke and others. 8vo. Half roan. New York, 1899. 1 Vol.
18. Willis, A. E. Human Nature and Physiognomy. 8vo. Chicago. 1 Vol.
19. Bibliotheque des Merveilles. 12mo. Paris, 1870. 5 Vols.
20. Gems. Precious Stones and Gems. By E. W. Streeter. 8vo. London, 1892. 1 Vol.
21. Green, J. R. Short History of the English People. Illustrated Ed. 8vo. ¾ Morocco. New York, 1894. 4 Vols.
22. Illinois, Men of. 8vo. Morocco. Chicago, 1902. 1 Vol.
23. Gems. Handbook of Engraved Gems. Natural History of Gems. Precious Stones and Metals. By C. W. King. 12mo. London. 3 Vols.
24. Gems. Precious Stones and Gems. By E. W. Streeter. 8vo. London, 1884. 1 Vol.
25. Gems. Handbook of Precious Stones, Rothschild; Diamonds and Precious Stones, Emanuel. 2 Vols.
26. Limestones and Marbles. By S. H. Burnham. 8vo. Boston, 1883. 1 Vol.
27. Lavater. Essays on Physiognomy. 8vo. Calf. London, 1804. 3 Vols.
28. Brown, Gould. Grammar of Grammars. 8vo. Sheep. 1 Vol.
29. Taine's English Literature. 8vo. New York, 1868. 2 Vols.
30. Language. The English Language, Ramsey; History of Language, Strong; The Use of Words, Sedgwick, 8vo. 3 Vols.
31. Ibsen. Prose Dramas. 12mo. London, 1900. 2 Vols.
32. James, Wm. Principles of Psychology. 8vo. New York, 1905. 2 Vols.
33. Mahan, Capt. A. T. Influence of the Sea Power Upon the French Revolution. 8vo. Boston, 1894. 1 Vol.
34. Mahan. Influence of the Sea Power Upon History, 1660–1783. 8vo. Boston, 1894. 1 Vol.
35. Hayden's Dictionary of Dates, Outlines of Jewish History, Record of Scientific Progress; Creary's Decisive Battles; Figner's Ocean World. 5 Vols.
36. Shakespeare's Works. 8vo. Morocco. Philadelphia, 1880. 1 Vol.
37. Student's Atlas and 10 others; Maps and Guide Books. 11 Vols.
38. Remington, F. Pony Tracks. 8vo. New York, 1895. 1 Vol.
39. Music, History of. By Emil Naumann. 8vo. London. 2 Vols.
40. Music. Life of Gounod. Musical Composers. Music and Its Masters. 3 Vols.
41. Wyon, F. W. History of Great Britain During the Reign of Queen Anne. 8vo. London, 1876. 2 Vols.
42. McCullough, H. Men and Measures of Half a Century. 8vo. New York, 1888. 1 Vol.
43. Illinois History, Chapters From. By E. Y. Mason. 8vo. Chicago, 1901. 1 Vol.
44. Solar Biology. By E. H. Butler. 8vo. 1904. 1 Vol.
45. Bryce, James. The American Commonwealth. The scarce unexpurgated edition. 8vo. London, 1888. 2 Vols.
46. Camping in the Canadian Rockies. By W. D. Wilcox. 8vo. New York, 1896. 1 Vol.
47. Buckle, H. T. Civilization in England. 8vo. New York, 1906. 2 Vols.

48. Egypt, A History of. By J. H. Breasted. 8vo. New York, 1905. 1 Vol.
49. Appleton's Scientific Library. 5 Vols.
50. German Books. 7 Vols.
51. Hudson, Law of Psychic Phenomena. Strong, Why the Mind Has a Body. 2 Vols.
52. Music. Haweis, Music and Morals. Rubinstein, Musical Theory, and 2 others. 5 Vols.
53. Music. Musical Analysis. Harmony. Half a Century of Music. Why We Sing. 4 Vols.
54. Music. Richter's Harmony. Life of Wagner. Music Explained. Music Study in Germany. The Standard Operas. 5 Vols.
55. Music. Oratorios, etc. 14 Vols.
56. Japan, Industries of. By J. J. Rein. 8vo. New York, 1889. 1 Vol.
57. Ericsson, J., Life of. By W. C. Church. 8vo. New York, 1890. 2 Vols.
58. Japan in Art and Industry. By F. Regencey. 8vo. New York, 1893. 1 Vol.
59. French Dictionary. Little and Banjean. 8vo. Half Morocco. 1886. 1 Vol.
60. Foster, G. B. The Finality of the Christian Religion. 8vo. Chicago, 1906. 1 Vol.
61. Civilization, History of, Laughlin. Western Civilization, Kidd. 2 Vols.
62. Evolution, the Master Key, Saleelig. The New Knowledge, Duncan. 2 Vols.
63. Gems. Diamonds and Precious Stones, Dieulafait. The Moon. Electricity. 12mo. New York, 1872–6. 3 Vols.
64. Engineering and Architecture, H. Moseley. 8vo. New York, 1875. 1 Vol.
65. Sex and Character, Otto Wininger. 8vo. London, 1906. 1 Vol.
66. Wundt, W. Human and Animal Physiology. 8vo. London, 1894. 1 Vol.
67. Picturesque India, W. S. Cairne. 8vo. London, 1890. 1 Vol.
68. Electricity in Daily Life, 1890. Forbes' Lecture on Electricity, 1888. 2 Vols.
69. Moulton's Literary Study of the Bible. Crane's Right and Wrong Thinking. Weiss' Religion of the New Testament. 4 Vols.
70. Murray's Mythology. Seeman's Mythology, and 8 others. 10 Vols.
71. Hugo's Les Miserables, in French, 12mo. New York, 1887. 5 Vols.
72. Spiers' & Surreune's French Dictionary. 8vo. Half Morocco. 1870. 1 Vol.
73. French Books. 5 Vols.
74. Harckel's Riddle of the Universe. Renan's The Apostles. Huxley's American Addresses. 3 Vols.
75. The Child, Chamberlain. The Alternate Sex, C. T. Leland. 2 Vols.
76. Jesus, Van Nordan. Through Man to God, Gordon. Catholic Principles, Westcott, and 2 others. 5 Vols.
77. McMaster's History of the United States. 8vo. New York, 1890–1906. 6 Vols.
78. Grimm's Life of Goethe. 8vo. Boston, 1880. 2 Vols.
79. Lewis and Clark's Expedition. Edited by Elliott Cones. The Scarce Harper Edition. 8vo. New York, 1893. 4 Vols.
80. Fiske, John. The Critical Period of American History. 12mo. 1888. First Edition. 1 Vol.

81. Bryce, Holy Roman Empire. Guizot and Masson, History of France. 8vo. 2 Vols.
82. Rawlinson, Geo. History of Phoenicia. 8vo. London, 1889. 1 Vol.
83. Fisher, G. P. Outlines of Universal History. 8vo. Half Morocco. 1904. 1 Vol.
84. Industrial Progress of the Nation. Inside History of the Carnegie Steel Co. American Currency. A Decade of Civil Development. 4 Vols.
85. Bain, A. The Senses and the Intellect; The Emotions and the Will. 8vo. 2 Vols.
86. American Weather. A. W. Greeley. 8vo. 1 Vol.
87. Geikie, J. The Great Ice Age. 8vo. New York, 1895. 1 Vol.
88. Shaler, N. S. Aspects of the Earth. 8vo. New York, 1889. 1 Vol.
89. Control of Heredity. Redfield. 8vo. 1903. 1 Vol.
90. Medical. Flint's Psychology, Beale's Slight Ailments, and 3 others. 5 Vols.
91. Chevreul On Color. 12mo. London, 1872. 1 Vol.
92. Degeneration. Max Nordeau. 8vo. New York, 1895. 1 Vol.
93. Figner. The Human Race. 8vo. London, 1872. 1 Vol.
94. Text Books, Miscellaneous. 7 Vols.
95. Carus, Paul. Fundamental Problems; The Soul of Man. Schopenhauer's Essays. 3 Vols.
96. Memoirs of Barras. Edited by Geo. Durney. 8vo. New York, 1895. 3 Vols.
97. Isis Unveiled. Blavatsky. 8vo. New York, 1893. 2 Vols.
98. Cothran's Revised Statutes of Illinois, 1881. Municiple Code of Chicago, 1881. 8vo. 3 Vols.
99. Symons, J. A. Life of Michelangelo Buonarroti. 8vo. New York, 1893. 2 Vols.
100. Problems of the Future, S. Laing; and 6 others. 7 Vols.
101. Solar Energy, Natural Philosophy, Recent Development of Physical Science, Minute Marvels of Nature. 4 Vols.
102. Moliere's Dramatic Works. Translated by Van Laun. 8vo. New York, 1880. 3 Vols.
103. Ben King's Verse. 8vo. Chicago, 1894. The scarce first Edition. 1 Vol.
104. Mallory's Le Morte Darthur. The beautiful Dent Edition, illustrated by Beardsley. 4to. 1893. 2 Vols.
105. Nietzsche. Thus Spake Zarathustra. 8vo. New York, 1896. 1 Vol.
106. Whitman. With Walt Whitman in Camden, Traubel. Days With Walt Whitman, Carpenter. 2 Vols.
107. Swinburne. Laus Veneris. 12mo. New York, 1880. 1 Vol.
108. Chaucer's Canterbury Tales. Edited by A. W. Pollard. 12mo. London, 1894. 2 Vols.
109. Fiction. Hon. Peter Sterling, Helena Richie, and 3 others. 5 Vols.
110. Old Italian Masters. Engraved by Timothy Cole. Fol. New York, 1892. 1 Vol.
111. Old Dutch and Flemish Masters. Engraved by Timothy Cole. Fol. New York, 1895. 1 Vol.
112. Etchings by French Artists. Text by G. W. H. Ritchie. Fol. New York (1888.) 1 Vol.

113. French Illustrators. By Louis Morin. Fol. Half Morocco. New York, 1893. 1 Vol.
114. Figaro Exposition, 1889. Fol. Paris. 1 Vol.
115. Gibson, C. D. Drawings. Ob. Fol. New York, 1884. 1 Vol.
116. Puillaume, A. Le Repas a Travers Les Ages. Ob. Fol. Paris. 1 Vol.
117. Pennell, J. Pen Drawings and Pen Draughtsmen. Fol. New York, 1889. 1 Vol.
118. Richardson, Fred. Book of Drawings. Fol. Chicago, 1899. 1 Vol.
119. Flowers and Plants from Nature. Emile Favart. 60 plates. Fol. Half Morocco. New York. 1 Vol.
120. Mars. Places de Bretagne & Jersey. Fol. Paris. 1 Vol.
121. Coffin, C. C. Redeeming the Republic. 8vo. New York, 1890. 1 Vol.
122. Wonders of Alaska, Johnston's, H. S., History of the United States, and 6 others. 8 Vols.
123. Poetry. Geraldine, a Souvenir of the St. Lawrence. 8vo. Finely bound in full Levant. Boston, 1888. 1 Vol.
124. Poetry. English Poems, Le Gallienne; The Passing Show, Harrit Monroe; and 5 others. 7 Vols.
125. Johnston's Gazetteer, Elements of the Laws, Lighthouses and Lightships, The Atlantic Ferry, The Spirit of Sacrifice. 5 Vols.
126. Max Muller, Life and Religion; Gouin's Art of Teaching Languages; Seignobos' Ancient Civilization. 3 Vols.
127. Paths to Power, Sanity of Mind, Things of the Mind, Thinking and Learning to Think. 4 Vols.
128. Kipling. From Sea to Sea. 12mo. New York, 1889.
129. Lawson's Frenzied Finance, Russell's Greatest Trust in the World, Lee's Inspired Millionaires. 3 Vols.
130. Man, the Social Creator; The Young Man and the World, Men Who Sell Things. 3 Vols.
131. The Nation. Elisha Mulford. 8vo. Boston, 1898. 1 Vol.
132. Diseases of Society. G. F. Lydston. 8vo. Philadelphia, 1904. 1 Vol.
133. The Bitter Cry of the Children, The Theory of the Leisure Class, The City, A Hundred Years Hence. 4 Vols.
134. Echoes From Mist Land, By the Way, Abe Martin's Almanac, Prose Fancies. 4 Vols.
135. Better World Philosophy, Socialism and Modern Science, Triumphant Democracy, Taxation and Work. 4 Vols.
136. Theory of Business Enterprise, Cost of Something for Nothing, The Fat of the Land. 3 Vols.
137. Triggs' The Changing Order, Addams' Newer Ideals of Peace, Liberty, Union and Democracy. 3 Vols.
138. Political Science, Leacock; Poverty, Socialism, Religion of Democracy. 4 Vols.
139. Paul De Koch's Works. Translated by Norris. Boston, 1904. Limited Edition. 25 Vols.
140. Evolution of Sex. Education and the Larger Life. 2 Vols.
141. Mrs. Lincoln's Boston Cook Book, and 3 others. 4 Vols.

142. Eugene Field. With Trumpet and Drum, and 4 others. 5 Vols.
143. Rosseau's Social Contract, The Affirmative Intellect, In Peril of Change. 3 Vols.
144. Andreas' History of Chicago. 4to. Half Morocco. 3 Vols.
145. Richard Wagner. Sa Vie et Ses Oeuvres. A Jullien. 4to. Half Morocco. Paris, 1886. 1 Vol.
146. Goethe's Faust. Translated by Bayard Taylor. 8vo. Boston, 1879. Large paper. 2 Vols.
147. Goethe's Werke. 8vo. Half Morocco. Stuttgart. 5 Vols.
148. Adolescence. G. S. Hall. 8vo. New York, 1904. 2 Vols.
149. Congress of Arts and Science, St. Louis, 1904. 8vo. Boston, 1905. 8 Vols.
150. Encyclopaedia Britannica, Ninth Edition. 8vo. Half Morocco. A nice set of the original edition, with Hall imprint. 25 Vols.
151. Littre's French Dictionary. Fol. Half Morocco. Paris, 1878. 5 Vols.
152. Van Nostrand's Science Series. 18mo. Bds. 10 Vols.
153–161. The same series, different volumes.

Architectural Books

162. Giles' Chinese Literature and six others. 7 Vols.
163. Odd Volumes. 8 Vols.
164. Architectural Compositions, H. P. Kirby, Lunchet Ed., No. 43. Fol., Boston. 1 Vol.
165. Animal Locomotion. E. Muybridge. About 100 folio plates in case. Phila., 1887. 1 Vol.
166. Ferguson, James. Architecture in all Countries; Modern Styles of Architecture; Indian and Eastern Arch.; Stone Monuments. Half Russia; London, 1874–6. 5 Vols.
167. Henry Hobson Richardson and His Works, by Mrs. Schuyler Van Rensselaer. No. 281 of 500 copies. Fol., Boston, 1888. 1 Vol.
168. Mrs. Oliphant's Makers of Florence. 8vo, large paper; London, 1891. 1 Vol.
169. History of French Painting, by C. H. Stranahan. 8vo.; N.Y., 1888. 1 Vol.
170. Architectural Studies in France, by J. L. Petit. 8vo. London, 1890. 1 Vol.
171. Architecture for General Readers, by H. H. Statham. 8vo.; N.Y., 1895. 1 Vol.
172. Marshall's Anatomy for Artists. 8vo; N.Y., 1878. 1 Vol.
173. Convenient Houses, with Plans, by L. H. Gibson. 8vo.; N.Y., 1889. 1 Vol.
174. Beautiful Houses, by L. H. Gibson. 8vo.; N.Y., 1895. 1 Vol.
175. History of Painting, by Woltman and Woermann. 8vo.; Half Morocco; Binding Scuffed. N.Y., 1888. 2 Vols.
176. Hamburg und Seine Bauten. Architechten und Jugenieur-Verein zu Hamburg. 8vo.; Half Morocco. Hamburg, 1890. 1 Vol.
177. Fire Insurance and How to Build, by F. C. Moore. 8vo.; N.Y., 1903. 1 Vol.
178. L'Architecture et Construction. Ramer, and 3 others. 4 Vols.
179. Minifie's Mechanical Drawing, 1871; Hulme's Geometrical Drawing. 1882. 2 Vols.

180. Narjoux, Journey of an Architect; The Choice of a Dwelling; Clement's Legendary Art. 3 Vols.
181. Wilkinson's Ancient Egyptians. Colored plates. 8vo. New York, 1878. 5 Vols.
182. The Modern Poster. Japan paper ed., No. 127. 8vo. 1 Vol.
183. American Gardens. Ed. by Guy Lowell. 4to. Boston, 1902. 1 Vol.
184. Reber's History of Mediaeval Art. 8vo. New York, 1887. 1 Vol.
185. Rambles in Old Boston. By E. G. Porter. Illustrated by Geo. R. Tolman. 8vo. Half seal. Boston, 1871. 1 Vol.
186. American Architecture. By Montgomery Schuyler. 8vo. Ooze calf. New York, 1892. 1 Vol.
187. En Campagne. Par A. De Neuville. Folio. Pris. 1 Vol.
188. Encampagne. Par Meissonier, de Neuville, Detaille, etc. 2d series. Fol. Paris. 1 Vol.
189. Revue Generale de L'Architecture, et des Travaux Publics. Vols. 9 to 28 inclusive, except Vol. 26. Paris, 1851–70. Folio. Half Morocco. 19 Vols.
190. Encyclopedia D'Architecture. Par Victor Calliat et Adolphe Lance. Vols. 1, 2, 3, 5, 6, 11 and 12. 4to. Half Morocco. Paris, 1851–62. 8 Vols.
191. Artistic Country-Seats. Types of Recent American Villa and Cottage Architecture. Printed for the subscribers. Folio. New York, 1886. 5 Vols.
192. Encyclopedia de L'Architecture et de La Construction. P. Planet. Royal 8vo., wrappers. Paris. Lacks 1 Vol. 11 Vols.
193. Croquis D'Architecture. Intime Club. About 200 plates in binder. 1 Vol.
194. Architectural Studies in Italy. By W. J. Anderson. No. 129 of 150 copies. Folio. Glasgow, 1890. 1 Vol.
195. Oakeshott. Detail and Ornament of the Italian Renaissance. Folio. London, 1888. 1 Vol.
196. Jules Gailhaband. L'Architecture du ve an XVII Siecle et les Arts qui en Dependent. Folio. Half Morocco. Paris, 1869. 4 Vols.
197. Mansions of England in the Olden Time. By Jos. Nash. Folio. London, 1869. 4 Vols.
198. Palast-Architektur von Ober-Italien und Toscana. Toscana. Folio. Berlin, 1883. 1 Vol.
199. ———. Geneva. Folio. Berlin, 1884. 1 Vol.
200. Ferd Ongania. Calli E Canali in Venecia. Folio. Half Morocco. Venezia, 1890–1. 1 Vol.
201. Die Architecture. von Prof. J. Buhiman. Folio. Stuttgart. 3 Vols.
202. Fantasies Decoratives. Par Halbert Dys. Colored Plates. 11 folio parts in binder. 1 Vol.
203. Edifices de Rome Moderne. Par P. Letarouilly. Folio. Boston. 1 Vol.
204. Style Empire, after designs by Percier and Fontaine. Folio. New York, 1 Vol.
205. Ancient Sepulchral Monuments. By Brindley and Weatherby. Folio. London, 1887. 1 Vol.
206. The "Builder Album" of Royal Academy of Architecture. Folio. London, 1894. 1 Vol.
207. Hirth. Das Deutsche Zimmer. Dritte Auflaga. 4to. Folio. Stuttgart, 1889. 1 Vol.

208. Der Ornamentenschatz. Von H. Dalmetsch. Colored plates. Folio. Stuttgart, 1889. 1 Vol.
209. Byzantine Architecture and Ornament. By Le Comte Melchoir de Vogue and others. Folio. Boston. 1 Vol.
210. Das Farbige Malerbuch. Von Karl Eyth. Colored Plates. 4to. Half Morocco. Leipzig, 1901. 1 Vol.
211. Lubke, Wm. Geschichte der Deutchen Kunst. 8vo. Half Morocco. Stuttgart, 1890. 1 Vol.
212. Lubke. Grundriss der Kunstgeschichte. 2 Vols. in 1. 8vo. Half Morocco. Stuttgart, 1887. 1 Vol.
213. Violet-Le-Duc. Discourses on Architecture. 8vo. Boston. 2 Vols.
214. Early Christian Architecture in Ireland. By Margaret Stokes. 8vo. London, 1878. 1 Vol.
215. Italian Renaissance. By J. Kinross. Folio. New York. 1 Vol.
216. Lows' Art Tile. 4to. Boston, 1884. 1 Vol.
217. Iron Work, Catalogue of Gebounder Armbruster. Folio. Frankfurt. 1 Vol.
218. Specimens of Mediaeval Architecture. Drawn by W. E. Nesfield. Folio. London, 1862. Some leaves loose. 1 Vol.
219. Another copy, poor condition. 1 Vol.
220. Taylor's Architectural Photographs, Store Fronts (Chicago). Folio, in case. 1 Vol.
221. Levy's Arch. Photographs, Country Dwellings. Folio, in case. 1 Vol.
222. A Parallel of the Ancient Architecture, with the Modern. From the French of R. Freart, with additions by John Evelyn. Small Folio. Old Calf (unbroken.) London, 1707. 1 Vol.
223. Reports of the New York Aqueduct Commission on New Croton Aqueduct, 1883 to 1887. Maps and Plates. 4to. New York. 1 Vol.
224. Lows' Art Tile. 4to. Boston, 1884. 1 Vol.
225. The World's Columbian Exposition Reproduced. Ob. Folio. Chicago, 1894. 1 Vol.
226. The Architectural Annual. Ed. by A. Kelsey, 1901. 8vo. Philadelphia. 1 Vol.
237. Lambert and Stahl. Motive der Deutschen Architektur. Folio. Half Morocco. Stuttgart, 1890. 1 Vol.
238. Les Concours D'Ecole, Section D'Architecture. 2me. Annee. Folio. Paris, 1901. 1 Vol.
239. Denkmaler Deutscher Renaissance. Von K. E. O. Fritsch. Folio. Boston, 1882. 5 Vols.
240. Zieglebauwerke des Mittel.
241. K. R. Reighsraths' Gebaude. T. von Hansen. Large Folio. Half Morocco. Wien, 1890. 1 Vol.
242. Die Votivkirche. H. von Ferstel. Large Folio. Half Morocco. Wien, 1892. 1 Vol.
243. Artistic Wrought Iron Works, from the Middle Ages and Renaissance Periods. By H. Alteneck. 4to. New York. 2 Vols.
244. Byzantine Ornament. Selection of. By Arne Dehli. 4to. New York, 1880. 1 Vol.

245. La Pienture Decorative en France du XI au XVI Siecle. Par P. Gelis-Didot et H. Laffillee. Folio. Half Morocco. Paris. 1 Vol.

246. Das Ornament der Italienischen Kunst des XV Jahrhunderts. Von H. G. Nicolai. Folio. Boston. 1 Vol.

247. Architectural Sketches from the Continent. By R. N. Shaw. Folio. Half Morocco. London, 1858. 1 Vol.

248. Arch. Details und Ornamente. Von A. Hartel. Folio. Boston, 1896. 1 Vol.

249. English Cathedrals. By Mrs. Schuyler von Rensselaer. Illustrated by Jos. Pennell. Limited to 250 copies. 4to. 2 Vols. New York, 1892. 2 Vols.

250. Enrois of the Rotch Traveling Scholarship, 1885–92. Folio. Boston, 1896. 1 Vol.

251. Barock und Rococo Architektur. Von R. Dohme. Berlin, 1884. 8 Vols.

252. Das Opernhaus zu Frankfurt A. M. Von R. Lucas and others. Folio. Berlin, 1883. 1 Vol.

253. Austin Hall, Harvard Law School. H. H. Richardson, Arch. Folio. Boston. 1 Vol.

254. Ames Memorial Building. H. H. Richardson, Arch. Folio. Boston. 1 Vol.

254a. Chateau de Heidelberg. Par R. Pinar. Folio. Half Morocco. Paris, 1859. 1 Vol.

255. Die Baukunst Spaniens. Max Junghandel. Folio. Dresden. 8 Vols.

256. Le Nouvel Opera de Paris. Par Chas. Garnier. Large Folio. Paris, 1880. 2 Vols.

257. Croquis D'Architecture. From the First Year, 1866 to 1877. Folio. Half Morocco. Paris. 11 Vols.

258. Plates from London Building News, 1884; from Am. Arch, 1884–85. Folio. Half Morocco. 3 Vols.

259. Romanesque Architecture in the South of France. By H. Revoil. Vol. 2. Folio. New York. 1 Vol.

260. The Georgian Period. Measured drawings of Colonial Work. 8vo. New York, 1900. 1 Vol.

261. Arch. Drawing, Spiers; Lawrence's Perspective; T Square Club; Academy Architecture. 4 Vols.

262. A Large Country House, Bruce Price; The Arch, Annual. 1900. 2 Vols.

263. Materiaux et Documents D'Architecture et de Sculpture. Par Mr. Raquenet. 8vo. 1 Vol.

264. Viollet-le-Duc. Compositions et Dessine. Folio. Wrappers. Sold as one. 1 Lot.

265. Rathaus zu Wiesbaden, 1883; Empfangs-Gebaude fur [. . .] Central—Bahuhaf zu Frankfurt A. M. 1881. Wrappers. 2 Vols.

266. Fragments D'Architecture. Par Pierre Chabat. Folio. Paris, 1868. 1 Vol.

267. Allegories and Emblems, Part 1, Allegories. Folio. Wien. 1 Vol.

268. Das K. K. Haf-Openhaus in Wien. Von Van der Null und Von Siccardsburg. Folio. Wien. 1 Vol.

269. Official Views of the World's Columbian Exposition. C. D. Arnold, H. D. Higginbotham. Auto Copy. Ob. 8vo. 1 Vol.

270. The Inland Architect and Builder. Vols. 1 to 6 inc. 8vo. Chicago, 1883–86. 2 Vols.

271. Sanitary Engineer. 4 Volumes and 3 others. 4to. Half Leather. 7 Vols.
272. The Building News, London. 9 volumes text and 5 volumes plates. 14 Vols.
273. Engineering, London. 14 Vols.
274. American Architect and Builder [. . .]

Notes

Chapter 1: The Legend of Louis Sullivan

1. Joan Didion, *The White Album* (New York, 1979), p. 11.

2. José Ortega y Gasset, *The Revolt of the Masses* (New York, 1957), quoted in Ernest Becker, *The Denial of Death* (New York, 1973), p. 47.

3. See Cole's warnings about Town as a difficult patron to his friend Asher Durand, another Hudson River painter, in Louis L. Noble, *The Course of Empire, Voyage of Life, and Other Pictures of Thomas Cole, N.A.* (New York, 1853), p. 285. For other interpretations of this particular painting by Cole, see Robert Rosenblum, *Transformations in Late Eighteenth Century Art* (Princeton, 1967), p. 107; and William H. Pierson, *American Buildings and Their Architects: Technology and the Picturesque, the Corporate and the Early Gothic Styles* (Garden City, 1980), pp. 127–29.

4. For representative works in this vein, see Albert Bush-Brown, *Louis Sullivan* (New York, 1960); Maurice English, *Testament of Stone* (Evanston, 1963); William H. Jordy, *American Buildings and Their Architects: Progressive and Academic Ideals at the Turn of the Century* (Garden City, 1972); Hugh Morrison, *Louis Sullivan: Prophet of Modern Architecture* (New York, 1935); Sherman Paul, *Louis Sullivan: An Architect in American Thought* (Englewood Cliffs, N.J., 1964); and Mervyn Kaufman, *Father of Skyscrapers: A Biography of Louis Sullivan* (Boston, 1969).

5. Louis Sullivan, *The Autobiography of an Idea* (New York, 1956), foreword by Claude Bragdon, p. 5.

6. Fiske Kimball, "Louis Sullivan—An Old Master," *Architectural Record* 57 (1925): 289–304.

7. See Esther McCoy, "Letters from Louis H. Sullivan to R. M. Schindler," *Journal of the Society of Architectural Historians* 20 (1961): 180.

8. For Sullivan's alleged influences upon Berlage, see Leonard Eaton, *American Architecture Comes of Age* (Cambridge, 1972), ch. 7.

9. Vincent Scully, *Modern Architecture: The Architecture of Democracy* (New York, 1961), p. 19.

10. See note 4 above.

11. The broadcast was on June 12, 1978.

12. The program, entitled "Toward Human Architecture," was broadcast on May 29, 1979.

13. Willard Connelly, *Louis Sullivan as He Lived* (New York, 1960), p. 150.

14. Frank Lloyd Wright, *Genius and the Mobocracy* (New York, 1949), p. 72.

15. Ibid., 77.

16. John Szarkowski, *The Idea of Louis Sullivan* (Minneapolis, 1956); English, *Testament of Stone;* Donald Egbert, "The Idea of Organic Expression and American Architecture," in *Evolutionary Thought in America,* ed. Stow Persons (New Haven, 1950); Paul Sprague, "The Architectural Ornament of Louis Sullivan and His Chief Draftsmen" (Ph.D. diss., Princeton University, 1968).

17. After the two AIA printings, Louis Sullivan, *The Autobiography of an Idea,* was published by Norton & Co. (New York, 1934) and by Dover (paperback, New York, 1956). Further references to this work are to the Dover edition.

18. Ibid., p. 16.

19. Ibid., p. 9 and passim thereafter. For Wright's comments on Sullivan in this connection, see Wright, *Genius and the Mobocracy,* p. 70; and Frank Lloyd Wright, *An Autobiography* (New York, 1932), pp. 96, 269. The unsatisfying character of Sullivan's relationship with his father is clearly seen in the early passages of his *Autobiography,* and Sullivan was adamant about having the unflattering references remain in the text. Witness his wrath (which may be inferred from the following letter) toward an editorial reader who tried to soften the harshness that must have seemed infelicitous to her: "I'm damned if I know who changed your father from a crank to an enthusiast, but I suspect Rosalie Goodyear, who is now in the hospital, but whom you would instantly forgive for she is a passionate admirer of your tale, a real Whitmanite, and worked with Horace Traubel for a long time. . . . Rosalie does things . . . for reasons only known to womankind!" C. H. Whitaker (editor of AIA *Journal*) to Louis Sullivan, 1 July 1922, Burnham Library, Chicago.

20. Sullivan, *Autobiography,* pp. 19–20.

21. Wright, *Autobiography,* p. 271.

22. Sullivan, *Autobiography,* chs. 2–4.

23. Ibid., p. 189.

24. For Sullivan in Philadelphia, see Winston Weisman, "Philadelphia Functionalism and Sullivan," *Journal of the Society of Architectural Historians* 20 (1961): 3–19.

25. Sullivan, *Autobiography,* p. 221.

26. Ibid., p. 240.

27. Ibid., p. 246. One also wonders if Sullivan's fascination with bridges might have been inspired by his parents, both of whom had drawn the chain-link suspension bridge across the Merrimack north of Newburyport. Both of these interesting drawings from the late 1860s are reproduced in Paul Sprague, *The*

Drawings of Louis Sullivan (Princeton, 1979), figs. 1 and 2 of the "Comparative Illustrations."

28. Sullivan, *Autobiography*, pp. 247–48. Emphasis in the original.

29. Ibid., pp. 260–62.

30. Ibid., p. 267. Emphasis in the original.

31. Ibid., pp. 272, 279.

32. Ibid., p. 279.

33. Louis Sullivan, "The Tall Office Building Artistically Considered," in *Kindergarten Chats and Other Writings,* ed. Isabella Athey (New York, 1947), p. 206. Further references to this work are to this edition.

34. Sullivan, *Autobiography*, p. 298.

35. Ibid., pp. 324–25.

36. Louis Sullivan, "Emotional Architecture as Compared with Intellectual," *Inland Architect and News Record* 24 (1894): 33. Emphasis in the original.

37. For references to Sullivan's aristocratic "haughtiness," see Connelly, *Louis Sullivan as He Lived,* pp. 118, 208.

38. Louis Sullivan, "What Is Architecture: A Study in the American People of Today," in *Kindergarten Chats,* pp. 228–29.

39. Kimball, "Louis Sullivan—An Old Master," p. 300; Henry-Russell Hitchcock, *Architecture: Nineteenth and Twentieth Centuries* (Baltimore, 1971), p. 344; Richard McLanathan, *The American Tradition in the Arts* (New York, 1968), p. 374; Jordy, *American Buildings and Their Architects,* pp. 126–35; Bush-Brown, *Louis Sullivan,* pp. 8–9; Montgomery Schuyler, "Adler and Sullivan," in *American Architecture and Other Writings* (New York, 1964), p. 187; and H. H. Arnason, *History of Modern Art* (New York, n.d.), p. 54.

40. Hitchcock, *Architecture,* p. 494. *Pilotis* are the cylindrical, ground-level columns that "lift" the building and thus make possible, according to Le Corbusier, a properly above-ground setting for man's activities (as opposed to the supposedly underground location used by primitive man).

41. Sprague, *Drawings of Louis Sullivan,* p. 34.

42. Jordy, *American Buildings and Their Architects,* pp. 164–74.

43. See Norris Smith, review of *American Buildings and Their Architects,* by William H. Jordy, *Journal of the Society of Architectural Historians* 33 (1974): 88–89.

44. For example, Jordy, *American Buildings and Their Architects;* Elaine Hedges, introduction to *Democracy: A Man-Search,* by Louis Sullivan (Detroit, 1961); and English, *Testament of Stone.*

45. See Wright, *Genius and the Mobocracy,* p. 18, for example.

Chapter 2: Sullivan the Writer

1. Jordy, *American Buildings and Their Architects,* pp. 178–79.

2. Max Nordau, *Degeneration* (New York, 1895), p. 182.

3. "Words are most malignant, the most treacherous possession of mankind," Sullivan wrote in the *Autobiography,* p. 198.

4. See Donald Hoffman, "The Setback Skyscraper City of 1891: An Unknown Essay by Louis H. Sullivan," *Journal of the Society of Architecturual Historians* 29 (1970): 181–87.

5. *Inland Architect* 9 (1887): 51–54.

6. See John Szarkowski, *The Idea of Louis Sullivan* (Minneapolis, 1956), foreword.

7. Louis Sullivan, "Ornament in Architecture," *Engineering Magazine* 3 (1892): 634–44.

8. Louis Sullivan, "Emotional Architecture as Compared with Intellectual," pp. 32–34.

9. Louis Sullivan, *Nature and the Poet,* complete manuscript, Burnham Library, Chicago. "Inspiration" was published in brochure by Inland Architect Press (Chicago, 1886).

10. Lewis Mumford, *The Brown Decades* (New York, 1931), p. 72.

11. Jordy, *American Buildings and Their Architects,* p. 84.

12. Louis Sullivan, "The Tall Office Building Artistically Considered," *Inland Architect* 27 (1896): 32–34.

13. Louis Sullivan, "The Chicago Tribune Competition," *Architectural Record* 53 (1923): 151–57.

14. Louis Sullivan, "Concerning the Imperial Hotel, Tokyo," ibid., pp. 333–52; and id., "Reflections on the Tokyo Disaster," ibid., 55 (1924): 113–17.

15. Louis Sullivan, "Kindergarten Chats," *Interstate Architect and Builder* 2–3 (1901–2); id., *Kindergarten Chats:* ed. Claude Bragdon (Lawrence, 1934), ed. Isabella Athey (New York, 1947).

16. Louis Sullivan, *Democracy: A Man-Search,* ed. Elaine Hedges (Detroit, 1961).

17. Wallace Rice, "Louis Sullivan as Author," *Western Architect* 33 (1924): 70.

18. See David Gebhard, review of *Louis Sullivan: An Architect in American Thought,* by Sherman Paul, *Journal of the Society of Architecturual Historians* 23 (1964): 51–52.

19. Williams, Barker, Severn Co., *Auction Catalogue #5533* (Chicago, Nov. 29, 1909), Burnham Library, Chicago.

20. Morrison, *Louis Sullivan,* p. 225; Connelly, *Louis Sullivan as He Lived,* p. 221.

21. See esp. John F. Kasson, *Civilizing the Machine* (New York, 1976), ch. 1.

22. Ibid., p. 46.

23. Ibid., pp. 44–45.

24. Ibid., p. 50.

25. Henry David Thoreau, *Walden* (New York, 1968), p. 38.

26. John Draper, *A History of the Conflict between Religion and Science* (New York, 1874). Sullivan records his completion of this book on July 27, 1875, in the Lotos Club Notebook. See note 32 below.

27. Sullivan, *Autobiography,* p. 167.

28. Ibid., p. 233.

29. Sullivan, *Kindergarten Chats,* pp. 228–29.

30. Norris K. Smith, *Frank Lloyd Wright: A Study in Architectural Content* (Englewood Cliffs, N.J., 1966), p. 3.

31. Sullivan, *Autobiography*, p. 209.

32. This notebook originally belonged to Sullivan but was later appropriated by the Lotos Club to record the athletic achievements of its members. It at one time contained Sullivan's "Notes on Professor Ware's Lectures on Architecture" at MIT, where he had his first architectural training in 1872. The first two pages remain, but pages 3 through 22 have been torn out. Sherman Paul (*Louis Sullivan*, p. 15) suspects that Sullivan himself was the culprit, reasoning that the drawings of the five orders that he was required to do would have repulsed him later. This would not account, however, for the two pages of class notes still in situ. The notebook is now in the Avery Library, Columbia University, New York City.

33. Sullivan, *Autobiography*, p. 206.

34. Ibid., pp. 18, 104, 207, 231, 250, 267.

35. Frederick Copleston, *A History of Philosophy*, 8 vols. (New York, 1965), vol. 7, pt. 2, p. 38.

36. Williams, *Auction Catalogue #5533*, no. 95.

37. Morrison, *Louis Sullivan*, p. 255; Hedges, intro. to *Democracy*, by Louis Sullivan, p. xiv; Egbert, "Idea of Organic Expression in American Architecture," p. 363; and Gebhard, review of *Louis Sullivan*, by Sherman Paul, pp. 51–52.

38. Jordy, *American Buildings and Their Architects*, p. 165.

39. Friedrich Nietzsche, *The Portable Nietzsche*, ed. Walter Kaufmann (New York, 1954), p. 107.

40. Ibid., pp. 138–39.

41. Louis Sullivan to Walt Whitman, February 3, 1887, in Horace Traubel, *With Walt Whitman in Camden*, 3 vols. (New York, 1914), vol. 3, pp. 25–26.

42. Sullivan, *Autobiography*, p. 271, for example.

43. Walt Whitman, *The Portable Walt Whitman*, ed. Mark Van Doren (New York, 1945), p. 408.

44. Ibid., p. 404.

45. Nordau, *Degeneration*, p. 29.

46. Ibid., p. 34.

47. William A. Williams, "Brooks Adams and American Expansion," in *History as a Way of Learning* (New York, 1973), pp. 23–38.

48. Didion, *White Album*, p. 123.

Chapter 3: Sullivan's Theory of History

(All works cited in this chapter are by Louis Sullivan unless specifically noted otherwise.)

1. D. H. Lawrence, *Studies in Classic American Literature* (New York, 1923), pp. 52–53.

2. *Democracy*, p. 132.

3. "Natural Thinking: A Study in Democracy," manuscript, Burnham Library, Chicago, p. 46.

4. Ibid., pp. 28–34.

5. Ibid., p. 30.
6. *Democracy,* pp. 142–43.
7. "Natural Thinking," p. 31.
8. *Democracy,* pp. 359–60.
9. Ibid., p. 142.
10. See, for example, ibid., pp. 47, 268.
11. See Darwin, *Descent of Man,* esp. ch. 3.
12. *Democracy,* p. 360.
13. "Natural Thinking," pp. 43–46.
14. Ibid., pp. 6–7.
15. Ibid., p. 33.
16. Ibid., p. 32.
17. Ibid., p. 48.
18. Ibid. In light of Sullivan's adulation of the child, this seems to be a peculiar way of demeaning chivalry.
19. Ibid., pp. 50–51.
20. Ibid., p. 57.
21. *Democracy,* p. 134.
22. Ibid., p. 186.
23. Ibid.
24. Ibid.
25. Ibid., pp. 186–87.
26. Ibid., p. 338.
27. Ibid., p. 195.
28. Ibid., p. 197.
29. Ibid., p. 200.
30. Ibid., pp. 202–3.
31. Ibid., p. 204. The particular significance Sullivan attaches to the word *publicity* will become apparent below.
32. Ibid., p. 203.
33. "Natural Thinking," p. 48.
34. Ibid., pp. 52–58.
35. *Democracy,* pp. 197–98.
36. Ibid., p. 195.
37. Ibid., pp. 3–4.
38. Ibid., p. 51.
39. Ibid., pp. 135–36.
40. Ibid., pp. 224–25.
41. Ibid., pp. 226–27.
42. Ibid., p. 225.
43. Emphasis is Sullivan's. "Concerning the Imperial Hotel, Tokyo," p. 333.
44. "Natural Thinking," p. 7.
45. Ibid., p. 8.
46. *Democracy,* p. 40.
47. Ibid., p. 139.
48. "Natural Thinking," p. 53.

49. Ibid.

50. Ibid., p. 159.

51. Ibid., pp. 61–63.

52. For extended discussions of graft by Sullivan, see *Democracy,* "Group V"; and "Natural Thinking," pp. 65–67.

53. E.g., "Natural Thinking," p. 111; *Democracy,* p. 52.

54. "Natural Thinking," pp. 95–101.

55. *Democracy,* p. 102.

56. "Natural Thinking," p. 111.

57. Ibid., pp. 71–72.

58. *Democracy,* p. 140.

59. "Natural Thinking," p. 178.

60. *Democracy,* p. 59.

61. E.g., two volumes by Alexander Bain: *The Senses and the Intellect* (London, 1855) and *The Emotions and the Will* (London, 1888).

62. "Natural Thinking," p. 37.

63. Ralph Waldo Emerson, "Nature," in *Selections from Ralph Waldo Emerson,* ed. Stephen E. Whicher (Boston, 1957), p. 31.

64. "Natural Thinking," p. 16.

65. Ibid., pp. 18–19.

66. Ibid., pp. 16–17. In all likelihood *the Infinite* is not Sullivan's own coinage. He may well have borrowed it from Ralph Waldo Trine, author of an optimistic philosophical tract entitled *In Tune with the Infinite; or, Fullness of Peace, Power, and Plenty* (New York, 1896), a work popular both here and in Europe. (Johan Huizinga, *America* [New York, 1972], p. 201.) As Sullivan neglected to credit Nietzsche as a source, so did he also slight Trine; but there can be little question that several of Sullivan's characteristic concerns and phrases owe something to the author of *In Tune with the Infinite.* Thoughts as forces, the Infinite as the source of good, its working by means of unchanging laws, and the health of mind and body are all concepts Sullivan treats after 1896.

67. "Natural Thinking," p. 18.

68. Ibid., p. 17.

69. Ibid., p. 18.

70. Ibid., p. 83. The biblical quotation is taken from 1 Cor. 13:12.

71. "Natural Thinking," p. 84.

72. Ibid., pp. 82–83.

73. Sullivan would be horrified by any truly objective analysis of the chief features of organic life, e.g., the following by Ernest Becker, in *Escape from Evil* (New York, 1975), p. 2:

> Life cannot go on without the mutual devouring of organisms. If at the end of each person's life he were to be presented with the living spectacle of all that he had organismically incorporated in order to stay alive, he might well feel horrified by the living energy he had ingested. The horizon of a gourmet, or even the average person, would be taken up with hundreds of chickens, flocks of lambs and sheep, a small herd of steers, sties full of pigs, and rivers

of fish. The din alone would be deafening. To paraphrase Elias Canetti, each organism raises its head over a field of corpses, smiles into the sun, and declares life good.

74. See "Sullivan, the Tall Building, and Nature" in ch. 5 and "Sullivan and the Jeffersonian View" in ch. 7 below.

75. "Natural Thinking," p. 98.

76. Ibid., p. 11.

77. Ibid., p. 77.

78. *Autobiography*, pp. 210–12.

79. Friedrich Nietzsche, *Thus Spake Zarathustra*, in *The Portable Nietzsche*, p. 130.

80. "Natural Thinking," p. 61. It is precisely this sort of comical, self-alienated high-mindedness that Stanley Kubrick seems to be lampooning in *Doctor Strangelove*. Compare Sullivan's phrases with those of General Jack D. Ripper (*Purity of Essence, precious bodily fluids*). Furthermore, Sullivan's obsession with mental and physical hygiene is precisely the preoccupation that leads to the feelings of alienation experienced by antisepsis-seeking modern man. Walker Percy notes in the intriguing essay "The Man on the Train," in *The Message in the Bottle* (New York, 1975), p. 85: "One has only to let the mental-health savants set forth their own ideal of sane living, the composite reader who reads their books seriously and devotes every ounce of his strength to the pursuit of the goals erected: emotional maturity, inclusiveness, productivity, creativity, belongingness—there will emerge, far more faithfully than I could portray him, the candidate for suicide."

81. "Natural Thinking," p. 61.

82. Ibid., p. 70.

83. Ibid., p. 71.

84. Karl Popper, *The Poverty of Historicism* (Boston, 1957), pp. ix–x.

Chapter 4: Sullivan's Theory of Architecture

1. Sullivan, *Autobiography*, p. 257.

2. Ibid., p. 233.

3. Sullivan, *Kindergarten Chats*, pp. 228–29.

4. Ibid., p. 203.

5. Ibid., p. 43.

6. Ibid., p. 208.

7. Peter Collins, *Changing Ideals in Modern Architecture* (Montreal, 1967), ch. 14.

8. Reproduced in Sullivan, *Kindergarten Chats*, pp. 177–81.

9. For example, Smith, *Frank Lloyd Wright*, p. 3.

10. Emil Kaufmann, *Architecture in the Age of Reason* (New York, 1968), esp. ch. 8.

11. Horatio Greenough, *Form and Function*, ed. Harold A. Small (Berkeley, 1947), pp. 57–62.

12. Ibid., p. 118.

13. Egbert, "Idea of Organic Expression and American Architecture." Sprague, "Architectural Ornament of Louis Sullivan," follows Egbert's terminology.

14. Sullivan, *Kindergarten Chats,* p. 203.

15. Ibid., p. 141.

16. Sullivan, *Autobiography,* p. 257.

17. Sullivan, *Kindergarten Chats,* pp. 202–13.

18. Ibid., p. 207.

19. Ibid., p. 202.

20. Ibid., p. 206.

21. Ibid., pp. 206–7.

22. Ibid., p. 213. Emphasis added.

23. Wright, *Genius and the Mobocracy,* p. 72.

24. Smith, *Frank Lloyd Wright,* p. 10.

25. Daniel Boorstin, *The Lost World of Thomas Jefferson* (New York, 1948).

26. Ibid., p. 204.

27. Sullivan, *Kindergarten Chats,* p. 51. Emphasis is Sullivan's.

28. Boorstin, *Lost World of Thomas Jefferson,* p. 181.

29. Ibid., p. 165.

30. Ibid., p. 171.

31. Ibid., p. 170.

32. Ibid., p. 165.

33. William W. Savage, "What You'd Like the World To Be: The West and the American Mind," *Journal of American Culture* 3 (1980): 302.

Chapter 5: "The High-Building Question"

1. Friedrich Nietzsche, *Thus Spake Zarathustra,* ed. and trans. Alexander Tille (New York, 1896), p. 139. This is the edition owned by Sullivan.

2. Upton Sinclair, *The Jungle* (New York, 1960), pp. 28–29.

3. For the somewhat different antebellum situation in this regard, however, see Kasson, *Civilizing the Machine* (New York, 1976), esp. ch. 2.

4. Sullivan, "Chicago Tribune Competition," pp. 151–57. Sullivan called Saarinen's project a "priceless pearl" (p. 156).

5. A copy of this brochure is in the Burnham Library at the Art Institute of Chicago.

6. Hoffmann, "Setback Skyscraper City of 1891," pp. 181–87.

7. Connelly, *Louis Sullivan as He Lived,* pp. 149, 308.

8. Quoted by Hoffmann, "Setback Skyscraper City of 1891," p. 186.

9. Ibid., p. 187.

10. Ibid. But Connelly (*Louis Sullivan as He Lived,* p. 290) claims this distinction for Sullivan.

11. Quoted in Connelly, *Louis Sullivan as He Lived,* p. 295.

12. Quoted in Frank G. Tyrrell, *Political Thuggery; or, Missouri's Battle with the Boodlers* (St. Louis, 1904), p. 202.

13. Louis Sullivan, "The High-Building Question," *Graphic* 5 (December 1891): 104; reprinted in Hoffmann, "Setback Skyscraper City of 1891, p. 186.

14. Whitman, *Portable Walt Whitman,* pp. 416–17.

15. For the sources of Sullivan's ornament, see Sprague, "Architectural Ornament of Louis Sullivan," esp. ch. 2.

16. Morrison, *Louis Sullivan,* ch. 3.

17. Sullivan, *Kindergarten Chats,* p. 29.

18. Wright, *Genius and the Mobocracy,* p. 77. The emphasis is Wright's.

19. For Sullivan's reliance on Islamic sources, see Dimitri Tselos, "The Chicago Fair and the Myth of the 'Lost Cause,'" *Journal of the Society of Architectural Historians* 26 (1967): 259–68.

20. Albert Bush-Brown (*Louis Sullivan,* p. 16) is somewhat off the mark when he says the Auditorium was "structurally timid."

21. Morrison, *Louis Sullivan,* p. 85.

22. Ibid., p. 108.

23. Sullivan, *Kindergarten Chats,* ch. 5, "An Hotel."

24. See p. 24 above.

25. Irving K. Pond, "Louis Sullivan's *The Autobiography of an Idea,*" *Western Architect* 33 (1924): 67–69.

26. "Nature and the Poet: A Prose Song," manuscript, Burnham Library, Chicago.

27. Quoted in Morrison, *Louis Sullivan,* p. 89.

28. Sullivan, *Autobiography,* p. 243.

29. Ibid., p. 244.

30. Sullivan, *Kindergarten Chats,* p. 107.

31. Ibid., pp. 109–10.

32. Sullivan, *Autobiography,* p. 298.

33. Wright, *Genius and the Mobocracy,* p. 75.

34. Morrison, *Louis Sullivan,* p. 154.

35. For an interesting discussion of this modern obsession with the "moral" aspects of design, see Henry Hope Reed, *The Golden City* (New York, 1970), ch. 2, app. 1.

36. Morrison, *Louis Sullivan,* p. 154.

37. Ibid., pp. 153–54.

38. *Missouri Republican,* May 17, 1849.

39. Connelly, *Louis Sullivan as He Lived,* p. 129.

40. Unidentified clipping: *St. Louis Globe Democrat* or *Missouri Republican,* April 15, 1891, Missouri Historical Society, St. Louis.

41. *St. Louis Globe Democrat,* November 11, 1911.

42. Ibid.

43. For a fuller discussion of the St. Louis Union Trust Building, see David S. Andrew, "Adler and Sullivan's 'Other' Skyscraper in St. Louis: The Unacclaimed Union Trust Building," *Architectura* (1972): 153–66.

44. E.g., Sullivan, "The High-Building Question" (reprinted in Hoffmann, "Setback Skyscraper City of 1891"); and Dankmar Adler, "Light in Tall Office Buildings," *Engineering Magazine* 4 (1892): 171–86.

45. See Winston Weisman, "The Commercial Architecture of George B. Post," *Journal of the Society of Architectural Historians* 31 (1972): 176–203.

46. Hugh D. Duncan, *Culture and Democracy* (Totowa, 1965), p. xx.

47. Philip Johnson, "Is Sullivan the Father of Functionalism?" *Art News* 55 (1956): 56.

48. Hans Peter l'Orange, *Art Forms and Civic Life in the Late Roman Empire* (Princeton, 1965).

49. Sprague, "Architectural Ornament of Louis Sullivan," p. 127.

50. Egbert, "Idea of Organic Expression and American Architecture," passim.

51. See, for example, John Fiske, *The Destiny of Man Viewed in Light of His Origin* (New York, 1884), p. 34. Fiske is one of many authors read by Sullivan who would have convinced the architect of the idea that man had replaced or superseded nature as the chief evolutionary force of the world.

52. Sullivan, *Autobiography*, p. 247.

53. Ibid., p. 265.

54. Ibid., pp. 132–33.

55. Morrison, *Louis Sullivan*, p. 112.

56. Sullivan, *Autobiography*, p. 295.

57. Duncan, *Culture and Democracy*, p. xiii.

58. Ibid., 151.

59. Ibid., p. 145.

60. Ibid., p. 571.

61. Henry B. Fuller, *The Cliffdwellers* (1893; Ridgewood, 1968), pp. 2–4.

62. By this time it must be a commonplace that skyscrapers are particularly inefficient in their use of energy: it takes far more trouble to move people vertically (in elevators) than horizontally; and the huge volumes of these buildings must be supplied with artificially processed air, often year-round, resulting in the absurdity that air conditioning often needs to be turned on in January to counteract the greenhouse effect of sealed glass walls. I hope it is also generally known how dangerous the skyscraper is in a fire. Most rescue efforts above the level reached by hook-and-ladder trucks are fruitless; and the fire is spread rapidly by the various conduits and shafts.

63. Sullivan, *Autobiography*, p. 313.

64. Dorothy Nelkin, "The Science-Textbook Controversies," *Scientific American* 234 (1976): 34.

65. It will be recalled from chapter 2 that Sullivan read and admired two works by Draper (see Bibliography), the second of which the architect identifies as having had a powerful influence upon him. Sullivan, *Autobiography*, p. 253.

66. Ibid., p. 314.

67. Reed, *Golden City*, p. 135.

68. Nietzsche, *Portable Nietzsche*, pp. 287–90.

Chapter 6: Buildings Other Than Tall

1. Wright, *Genius and the Mobocracy*, p. 70.

2. Wright, *Autobiography*, p. 269.

3. Montgomery Schuyler, *American Architecture and Other Writings,* 2 vols. (Cambridge, 1961), 2:393.

4. Morrison, *Louis Sullivan,* p. 72.

5. Smith, *Frank Lloyd Wright,* pp. 17–23.

6. Quoted ibid., p. 7.

7. Sullivan, Lotos Club Notebook, p. 200.

8. Connelly, *Louis Sullivan as He Lived,* p. 294.

9. Sullivan, *Autobiography,* ch. 8.

10. The plans for these two houses were published in the *Souvenir* of the Chicago Architectural Club (Chicago, 1902).

11. Morrison, *Louis Sullivan,* pp. 202–4.

12. For the development and iconography of the prairie house, see Smith, *Frank Lloyd Wright;* and H. Allen Brooks, *The Prairie School: Frank Lloyd Wright and His Midwestern Contemporaries* (Toronto, 1971).

13. Connelly, *Louis Sullivan,* pp. 80–85.

14. Sullivan, Lotos Club Notebook, p. 162.

15. Morrison, *Louis Sullivan,* p. 124.

16. Smith, *Frank Lloyd Wright,* ch. 2, discusses the foundation of Sullivan and Wright's architectural aesthetics on Hebraic as opposed to Graeco-Roman assumptions. Their romanticism, Smith argues, derives from a Biblical sense of feeling for rhythm and materials and not from the classical interest in the perfection of plastic form regardless of material. Nonetheless, if we take Sullivan at his word, the specific features of orthodox Judaism held no attraction for him: he found the idea of a personal God repugnant.

17. For some reason Morrison did not know this building. It receives fullest treatment in Theodore Turak, "A Celt among Slavs: Louis Sullivan's Holy Trinity Cathedral," *Prairie School Review* 9 (1972): 5–22. Turak explores the congenial relation between Sullivan and the priest of the congregation, but he says nothing of the problem Sullivan encountered in working for a "feudal" institution.

18. Williams, *Auction Catalogue #5533,* nos. 209 and 244.

19. Hendrik Berlage would probably not have concurred with this assessment. Eaton, *American Architecture Comes of Age,* ch. 7, notes that the Dutch architect was impressed by this church during a visit to Cedar Rapids and that he was particularly taken by the placement of the tower near the pulpit. He believed this to be a highly effective treatment for a Protestant building, inasmuch as it emphasized the importance of the sermon; and Eaton asserts that Berlage borrowed the idea from Sullivan in his own Christian Science Church in the Hague (1925). But, since the campanile is not visible from within the church, it is difficult to see how such an arrangement might actually reinforce this aspect of the rite.

20. Morrison, *Louis Sullivan,* p. 128.

21. Wright, quoted ibid.

22. By Norris Smith, in his comments upon an early draft of this work.

23. See above, ch. 5, n. 19.

24. *American Contractor* 27 (1906): 48–54.

25. Carl Bennett, quoted in Morrison, *Louis Sullivan,* p. 207.

26. I am not unaware of theories having to do with money as an age-old

symbol of the denial of death, or more specifically as a symbolic rejection of feces, animality, and physicality in general. See Becker, *Escape from Evil*, pp. 73–90, for a discussion of money as an "immortality ideology." Becker, from his perspective, might see no difference between Sullivan's skyscrapers and his banks as far as symbolic meaning is concerned. Yet one cannot help perceiving these buildings as different in the fundamentals of form, size, and purpose. Ellis Wainwright and Carl Bennett might both have been prompted by unconscious reasons to enter the money business, but these don't seem to have been exactly the *same* unconscious reasons! The megalomania of the first and the modest, measured professionalism of the other have given rise to two highly contrasting buildings.

27. Morrison, *Louis Sullivan*, p. 210.

28. For innumerable examples of the works of these architects, see Rosenblum, *Transformations in Late Eighteenth Century Art;* and Kaufmann, *Architecture in the Age of Reason.*

29. Morrison, *Louis Sullivan*, p. 210.

30. And so full of welcome contradictions. See Robert Venturi, *Complexity and Contradiction in Architecture* (New York, 1966), p. 90.

31. Sprague, "Architectural Ornament of Louis Sullivan," p. 168.

32. J. R. Wheeler, president of the bank, said about the lions: "I just could not accustom myself to the idea of our customers coming in with their milking clothes and standing between those two lions. I really thought that they would feel intimidated." Quoted in Szarkowski, *Idea of Louis Sullivan*, p. 8.

Chapter 7: Sullivan as Modern Architect

1. Walker Percy, "The Delta Factor," in *The Message in the Bottle* (New York, 1975), pp. 3–4.

2. Lawrence, *Classic American Literature*, pp. 51, 53.

3. Sullivan, *Autobiography*, p. 325.

4. Sigfried Giedion, *Space, Time, and Architecture* (Cambridge, 1967), p. 394.

5. See Titus Karlowicz, "D. H. Burnham's Role in the Selection of Architects for the World's Columbian Exposition," *Journal of the Society of Architectural Historians* 29 (1970): 247–54.

6. Assertion made by Ralph Marlowe Line in his introduction to Sullivan, *Autobiography*, p. 3.

7. Dimitri Tselos, "The Chicago Fair and the Myth of the 'Lost Cause,'" *Journal of the Society of Architectural Historians* 26 (1967): 263.

8. Buford Pickens, "Poet in the Great City," review of *The Testament of Stone*, by Maurice English, *Chicago Review* 17 (1965), pp. 147–51.

9. Critics such as Giedion (see n. 4 above) leave the impression that the fair called for some architectural embodiment quite unlike the one it received, but it is difficult to imagine what sort of buildings would have been preferable. Surely the Chicago commercial "style" would have been singularly unequipped for the task of supplying the fair with an appropriately celebrational character.

10. Henry Adams, *The Education of Henry Adams* (Boston, 1961), p. 343.

11. Duncan, *Culture and Democracy*, p. 83.

12. Adams, *Education*, p. 342.
13. C. H. Whittaker to Louis Sullivan, September 26, 1923, Burnham Library, Art Institute of Chicago.
14. Adams, *Education*, pp. 225–26.
15. Ibid., p. 231.
16. Sullivan, *Autobiography*, p. 254.
17. Adams, *Education*, pp. 384–85.
18. Irving K. Pond, "Louis Sullivan's 'The Autobiography of an Idea,'" *Western Architect* 33 (1924): 68. AIA *Journal* editor C. H. Whittaker was also dismayed by Sullivan's device of the wonder child: "Even the most ardent admirers of the *Autobiography* feel that the 'wonder child' pictures do not carry. They recognize, as I do, that it is very difficult for an idea to speak and still preserve the personality as an idea. The mind of the reader unconsciously prefers personality to the actual writer, and thus the writer appears to be vain of himself as the 'wonder child.'" Whittaker to Sullivan, September 26, 1923.
19. Carter B. Horsley, "In Glass Walls, a Reflected City Stands Beside the Real One," *New York Times,* November 30, 1975, sec. 8, pp. 1, 4; Charles Kaiser, "Office Buildings in City Falling to Foreclosure at Quicker Pace: Arrearages Up," *New York Times,* November 7, 1975, sec. 8, pp. 1, 9.
20. Boorstin, *Lost World of Thomas Jefferson*, pp. 244–47.
21. Leo Marx, *The Machine in the Garden* (New York, 1964). I became acquainted with Marx's interpretation of Fitzgerald in a lecture given by Marx at the Ann Arbor campus of the University of Michigan in March 1976.
22. F. Scott Fitzgerald, *The Great Gatsby* (New York, 1953), p. 182.
23. Philip Rieff, *The Triumph of the Therapeutic* (New York, 1966), p. 68.
24. Ibid., p. 70.
25. Ibid., p. 71.
26. Ibid.
27. Ibid., p. 60.
28. Ibid., p. 19.
29. Ibid., p. 33.
30. Ibid., p. 65.
31. Sigmund Freud, *Civilization and Its Discontents* (New York, 1961).
32. Wright, *Genius and the Mobocracy*, p. 70.
33. Mumford, *Brown Decades*, p. 70.
34. Kimball, "Louis Sullivan—An Old Master," pp. 289–304.
35. Morrison, *Louis Sullivan*, pp. 262–68.
36. Smith, *Frank Lloyd Wright*, pp. 168–71.
37. Rieff, *Triumph of the Therapeutic*, p. 202.
38. Morrison, *Louis Sullivan*, p. 280.
39. In his reference to the Maison Carrée, Jefferson seems to have been paying homage to the Roman notion of republican idealism as the source of American political optimism. In light of Boorstin's assessment of Jeffersonian philosophy, however (see n. 21 above), it seems unlikely that Jefferson would have embraced classical architecture as lovingly as he did. Boorstin says that the lessons of history were mainly negative for Jefferson: history shows what *not* to do. But I think it is

possible to interpolate into Boorstin's analysis Jefferson's actual defense of classical architecture on the grounds of its universal relevance, i.e., its natural, aboriginal, organic basis as defined by the revolutionary and visionary architects of the late eighteenth century. For Jefferson there was no "battle of the styles." Architecture is now, as it was in the "beginning," classical; and in the same way that there was no need to change nature, Jefferson must have thought it foolhardy to tamper with the formal and proportional absolutes of "natural" architecture.

40. Mumford, *Brown Decades*, pp. 69–70.

41. Ibid., p. 74.

42. Studs Terkel, *Working* (New York, 1974), p. xxiv.

43. Robert Venturi, *Learning from Las Vegas* (Cambridge, Mass., 1972).

44. Sullivan seems to have accepted more or less unquestioningly the deterministic viewpoint of the Spencerians. Here is a section he underlined in his copy of Draper's *History of the Intellectual Development of Europe* (pp. 16–17): "In individual life we also accept a like deception, living in the belief that everything we do is determined by the volition of ourselves or of those around us; nor is it until the close of our days that we discern how great is the illusion, and that we have been swimming—playing and struggling—in a stream which, in spite of all our voluntary motions, has silently and resistlessly borne us to a predetermined shore." It seems not to have occurred to Draper or to Sullivan that they were involved in efforts to observe and alter the course of that stream. The great irony of their writings is that they both seem to have claimed a perspective that is actually available only to someone *outside* the stream!

45. Kasson, *Civilizing the Machine*, p. 233.

Selected Bibliography

A. WRITINGS BY LOUIS SULLIVAN

1. Books and Longer Works

Lotos Club Notebook [1872–81]. Avery Library, Columbia University, New York, N.Y.

Nature and the Poet [1886–99]. Manuscript. Burnham Library, Art Institute of Chicago.

Kindergarten Chats [1901–2; revised 1918]. In *Kindergarten Chats and Other Writings*. Edited by Isabella Athey. New York, 1947.

"Natural Thinking: A Study in Democracy" [1905]. Manuscript. Burnham Library, Art Institute of Chicago.

Democracy: A Man-Search [1908]. Edited by Elaine Hedges. Detroit, 1961.

The Autobiography of an Idea [1924]. New York, 1956.

A System of Architectural Ornament according with a Philosophy of Man's Powers. New York, 1924.

2. Articles

"What Is the Just Subordination, in Architectural Design, of Details to Mass?" *Inland Architect and News Letter* 9 (April 1887): 51–54.

"The High-Building Question." *Graphic* 5 (December 1891): 404. Reprinted in Donald Hoffmann, "The Setback Skyscraper City of 1891," *Journal of the Society of Architectural Historians* 29 (May 1970): 186.

"Ornament in Architecture." *Engineering Magazine* 3 (August 1892): 633–44.

"Emotional Architecture as Compared with Intellectual." *Inland Architect and News Letter* 24 (November 1894): 32–34.

"The Tall Office Building Artistically Considered." *Inland Architect and News Letter* 27 (May 1896): 32–34.

"What Is Architecture: A Study in the American People of Today" [1906]. In *Kindergarten Chats and Other Writings*. Edited by Isabella Athey. New York, 1947.

"The Chicago Tribune Competition." *Architectural Record* 53 (February 1923): 151–57.

"Concerning the Imperial Hotel, Tokyo." *Architectural Record* 53 (April 1923): 333–52.

"Reflections on the Tokyo Disaster." *Architectural Record* 55 (February 1924): 113–17.

3. Letters

To Walt Whitman [February 3, 1887]. In Horace Traubel. *With Walt Whitman in Camden*. 3 vols. New York, 1914. 3:25–26.

To R. M. Schindler [1918–23]. In Esther McCoy. "Letters from Louis H. Sullivan to R. M. Schindler." *Journal of the Society of Architectural Historians* 20 (December 1961): 179–84.

B. WRITINGS BY OTHERS

1. Books

Adams, Henry. *The Education of Henry Adams* [1907]. Boston, 1961.

Arnason, H. H. *History of Modern Art*. New York, n.d.

Bain, Alexander. *The Emotions and the Will*. London, 1888.

———. *The Senses and the Intellect*. London, 1855.

Becker, Ernest. *Escape from Evil*. New York, 1975.

Boorstin, Daniel. *The Lost World of Thomas Jefferson*. New York, 1948.

Brooks, H. Allen. *The Prairie School*. Toronto, 1972.

Bush-Brown, Albert. *Louis Sullivan*. New York, 1960.

Collins, Peter. *Changing Ideals in Modern Architecture*. Montreal, 1967.

Condit, Carl. *The Chicago School of Architecture*. Chicago, 1964.

Connelly, Willard. *Louis Sullivan as He Lived*. New York, 1960.

Copleston, Frederick. *A History of Philosophy*. New York, 1965.

Darwin, Charles. *The Descent of Man*. New York, 1897.

Didion, Joan. *The White Album*. New York, 1979.

Draper, John. *History of the Conflict between Religion and Science*. New York, 1874.

———. *History of the Intellectual Development of Europe*. 2 vols. New York, 1876.

Duncan, Hugh D. *Culture and Democracy*. Totowa, 1965.

Eaton, Leonard. *American Architecture Comes of Age*. Cambridge, 1972.

English, Maurice. *Testament of Stone*. Evanston, 1963.

Fiske, John. *The Destiny of Man Viewed in Light of His Origin*. New York, 1884.

Fitzgerald, F. Scott. *The Great Gatsby* [1925]. New York, 1953.

Fuller, Henry B. *The Cliffdwellers* [1893]. Ridgewood, 1968.

Giedion, Sigfried. *Space, Time, and Architecture*. Cambridge, 1967.

Greenough, Horatio. *Form and Function*. Edited by Harold A. Small. Berkeley, 1947.

Hitchcock, Henry-Russell. *Architecture: Nineteenth and Twentieth Centuries*. Baltimore, 1971.

Huizinga, Johan. *America*. New York, 1972.

Jordy, William H. *American Buildings and Their Architects: Progressive and Academic Ideals at the Turn of the Century*. New York, 1972.

Kasson, John F. *Civilizing the Machine: Technology and Republican Values in America, 1776–1900*. Middlesex and New York, 1976.

Kaufman, Mervyn. *Father of Skyscrapers: A Biography of Louis Sullivan*. Boston, 1969.

Kaufmann, Emil. *Architecture in the Age of Reason*. New York, 1968.

Lawrence, D. H. *Studies in Classic American Literature* [1923]. New York, 1971.

McLanathan, Richard. *The American Tradition in the Arts*. New York, 1968.

Marx, Leo. *The Machine in the Garden*. New York, 1964.

Menocal, Narciso. *Architecture as Nature: The Transcendentalist Idea of Louis Sullivan*. Madison, 1981.

Morrison, Hugh. *Louis Sullivan: Prophet of Modern Architecture*. New York, 1935.

Mumford, Lewis. *The Brown Decades*. New York, 1931.

Nietzsche, Friedrich. *Thus Spake Zarathustra*. Edited and translated by Alexander Tille. New York, 1896.

———. *Thus Spoke Zarathustra*. Edited and translated by Walter Kaufmann. In *The Portable Nietzsche*. New York, 1954.

Noble, Louis L. *The Course of Empire, Voyage of Life, and Other Pictures of Thomas Cole, N.A.* New York, 1853.

Nordau, Max. *Degeneration*. New York, 1895.

Norris, Frank. *The Octopus* [1901]. Cambridge, Mass., 1958.

l'Orange, Hans Peter. *Art Forms and Civic Life in the Late Roman Empire*. Princeton, 1965.

Paul, Sherman. *Louis Sullivan: An Architect in American Thought*. Englewood Cliffs, 1968.

Percy, Walker. *The Message in the Bottle*. New York, 1975.

Pierson, William H. *American Buildings and Their Architects: Technology and the Picturesque, the Corporate and the Early Gothic Styles*. Garden City, 1980.

Popper, Karl. *The Poverty of Historicism*. Boston, 1957.

Reed, Henry Hope. *The Golden City*. New York, 1970.

Rieff, Philip. *The Triumph of the Therapeutic*. New York, 1966.

Rosenblum, Robert. *Transformations in Late Eighteenth Century Art*. Princeton, 1967.

Schuyler, Montgomery. *American Architecture and Other Writings*. Edited by William Jordy and Ralph Coe. 2 vols. Cambridge, 1961.

Scully, Vincent. *Modern Architecture: The Architecture of Democracy*. New York, 1961.

Sinclair, Upton. *The Jungle* [1906]. New York, 1960.

Smith, Norris K. *Frank Lloyd Wright: A Study in Architectural Content.* Englewood Cliffs, 1966.

Spencer, Herbert. *First Principles of a New System of Philosophy.* New York, 1873.

Sprague, Paul. *The Drawings of Louis Henry Sullivan.* Princeton, 1979.

Szarkowski, John. *The Idea of Louis Sullivan.* Minneapolis, 1956.

Terkel, Studs. *Working.* New York, 1974.

Thoreau, Henry David. *Walden* [1854]. New York, 1968.

de Tocqueville, Alexis. *Democracy in America* [1835–40]. New York, 1964.

Trine, Ralph Waldo. *In Tune with The Infinite; or, Fullness of Peace, Power, and Plenty.* New York, 1896.

Tyrell, Frank G. *Political Thuggery; or, Missouri's Battle with the Boodlers.* St. Louis, 1904.

Venturi, Robert. *Complexity and Contradiction in Architecture.* New York, 1966.

———. *Learning from Las Vegas.* Cambridge, 1972.

Whitman, Walt. *Democratic Vistas* [1871]. In *The Portable Walt Whitman.* Edited by Mark van Doren. New York, 1945.

Wright, Frank Lloyd. *An Autobiography.* New York, 1932.

———. *Genius and the Mobocracy.* New York, 1949.

2. *Articles and Essays*

Adler, Dankmar. "Light in Tall Office Buildings." *Engineering Magazine* 4 (November 1892): 171–86.

Andrew, David S. "Adler and Sullivan's 'Other' Skyscraper in St. Louis: The Unacclaimed Union Trust Building." *Architectura* (1972), no. 2, pp. 153–66.

Egbert, Donald. "The Idea of Organic Expression and American Architecture." In *Evolutionary Thought in America.* Edited by Stow Persons. New Haven, 1950.

Emerson, Ralph Waldo. "Nature" [1836] and "Self-Reliance" [1839]. In *Selections from Ralph Waldo Emerson.* Edited by Stephen E. Whicher. Boston, 1960.

Gebhard, David. Review of Louis Sullivan: An Architect in American Thought, by Sherman Paul. *Journal of the Society of Architectural Historians* 23 (March 1964): 51–52.

Greenough, Horatio. "American Architecture" [1843]. In *Form and Function.* Edited by Harold A. Small. Berkeley, 1947.

Hoffman, Donald. "The Setback Skyscraper City of 1891: An Unknown Essay by Louis H. Sullivan." *Journal of the Society of Architectural Historians* 29 (May 1970): 181–87.

Johnson, Philip. "Is Sullivan the Father of Functionalism?" *Art News* 55 (December 1956): 44–57.

Karlowicz, Titus. "D. H. Burnham's Role in the Selection of the Architects for the World's Columbian Exposition." *Journal of the Society of Architectural Historians* 29 (October 1970): 247–54.

Kimball, Fiske. "Louis Sullivan: An Old Master." *Architectural Record* 57 (April 1925): 289–304.

McAndrew, John. "Who Was Louis Sullivan?" *Arts* 31 (November 1956): 22–27.

Nelkin, Dorothy. "The Science-Textbook Controversies." *Scientific American* 234 (April 1976): 33–39.

Pickens, Buford. "Poet in the Great City." Review of *The Testament of Stone*, by Maurice English. *Chicago Review* 17 (1965): 147–51.

Pond, Irving K. "Louis Sullivan's 'The Autobiography of an Idea.'" *Western Architect* 33 (June 1924): 67–69.

Rice, Wallace. "Louis Sullivan as Author." *Western Architect* 33 (June 1924): 70–71.

Savage, William W. "What You'd Like the World To Be: The West and the American Mind." *Journal of American Culture* 3 (Summer 1980): 302–10.

Smith, Norris K. Review of *American Buildings and Their Architects* (2 vols.), by William Jordy. *Journal of the Society of Architectural Historians* 33 (March 1974): 88–89.

Turak, Theodore. "A Celt among Slavs: Louis Sullivan's Holy Trinity Cathedral." *Prairie School Review* 9 (1972): 5–22.

Tselos, Dimitri. "The Chicago Fair and the Myth of the 'Lost Cause.'" *Journal of the Society of Architectural Historians* 26 (December 1967): 259–68.

Weisman, Winston. "The Commercial Architecture of George B. Post." *Journal of the Society of Architectural Historians* 31 (October 1972): 176–203.

———. "Philadelphia Functionalism and Sullivan." *Journal of the Society of Architectural Historians* 20 (March 1961): 3–19.

Williams, William A. "Brooks Adams and American Expansion." In *History as a Way of Learning*. New York, 1973.

3. Theses

Andrew, David S. "Louis Sullivan and the Problem of Meaning in Architecture." Ph.D. diss., Washington University, 1976.

Sprague, Paul. "The Architectural Ornament of Louis Sullivan and His Chief Draftsmen." Ph.D. diss., Princeton University, 1968.

4. Newspapers

Horsley, Carter. "In Glass Walls: A Reflected City Stands beside the Real One." *New York Times*, November 30, 1975.

Kaiser, Charles. "Office Buildings in City Falling to Foreclosure at Quicker Pace; Arrearages Up." *New York Times*, November 7, 1975.

Missouri Republican, May 17, 1849; April 15, 1891.

St. Louis Globe Democrat, November 11, 1911.

St. Louis Republic, February 5, 1909.

5. Pamphlets and Brochures

Chicago Architectural Club. *Souvenir*. Chicago, 1902.

Fraternity Temple. *Rental Brochure*. Chicago, 1891.

St. Paul's United Methodist Church. *Visitor's Guide*. Cedar Rapids, Iowa, 1974.

Williams, Barker, & Severn Co. *Auction Catalogue No. 5533*. Chicago, November 29, 1909.

6. Letters

Whittaker, C. H., to Louis Sullivan. July 1, 1922; September 26, 1923. Burnham Library, Art Institute of Chicago.

Index

About the Author

DAVID S. ANDREW holds graduate degrees in art history from the University of Michigan and Washington University. He is a recipient of the Founder's Award of the Society of Architectural Historians and has published works in the area of American architectural history. Andrew is on the faculty of the University of New Hampshire, where he is professor of art history and chairman of the department of the arts. He is also a musician and composer, whose works have been published and performed in various cities.